Hopi Basket Weaving

Hopi Basket Weaving

ARTISTRY IN NATURAL FIBERS

Helga Teiwes

With Photographs by the Author

THE UNIVERSITY OF ARIZONA PRESS / TUCSON

Publication of this book is made possible in part by proceeds of the
Clara Lee Tanner Fund of the permanent endowment established as a
result of a Challenge Grant from the National Endowment for the
Humanities, a federal agency that promotes knowledge of human
history, thought, and culture and enhances the role of the humanities
throughout the nation.

The University of Arizona Press
Copyright © 1996
The Arizona Board of Regents
All rights reserved
♾ This book is printed on acid-free, archival-quality paper.
Manufactured in the United States of America
04 03 02 01 00 99 6 5 4 3 2
Library of Congress Cataloging-in-Publication Data
Teiwes, Helga.
Hopi basket weaving : artistry in natural fibers / Helga Teiwes ;
with photographs by the author.
p. cm.
Includes bibliographical references (p.) and index.
ISBN 0-8165-1613-8 (cloth : acid-free paper).
—ISBN 0-8165-1615-4 (pbk. : acid-free paper)
1. Hopi baskets. 2. Basket making—Arizona. 3. Hopi women.
I. Title.
E99.H7T25 1996 96-4497
746.41'2'089974—dc20 CIP

British Cataloguing-in-Publication Data
A catalogue record for this book is available from the British Library.

To Emil W. Haury,
 my friend and mentor,
 who taught me to love the past and present
 of the American Southwest

Contents

Figures

Plates

Acknowledgments

A printed book is never the result of one person's efforts alone. The author puts facts, ideas, and thoughts onto paper, which is a big task indeed. But an ethnographic documentation is a combination of the factual knowledge, experience, and wisdom of many. For this book, my main collaborators have been the Hopi basket weavers who shared their knowledge of technique and tradition with me. They deserve my gratitude for their participation. They generously showed me their work, guided me, advised and corrected me, and shared thoughts, meals, and occasionally hugs with me. Almost all made me welcome and invited me into their homes, and sometimes they allowed me to watch their ceremonies. I was invited to go along on plant collecting trips, and they let me photograph them while they were working.

All of them understood that the documentation is meant to bring a better understanding of Hopi basket weaving to the readers of this book. They agreed that most people have no idea of the difficulties, time-consuming tedium, and intricacies of both plant preparation and the actual weaving process. Only with this understanding can Hopi basketry be properly appreciated.

In every village, I worked with a team of researchers who helped me gather accurate and comprehensible information. I hope I recorded everything correctly and can make all basket weavers proud of our accomplishment. I thank them all very, very much. *Askwali*!

To carry out my work on the reservation, I needed approval from the Hopi Tribe. I would like to thank Leigh Jenkins of the Cultural Preservation Office of The Hopi Tribe for granting me this approval and for giving me his invaluable support.

But I need to thank other collaborators as well. I was privileged to have the steady support of Dr. R. Gwinn Vivian, who advised me in preparing my application for a grant from the Arizona Humanities Council to complete the documentation and writing. Dr. Vivian also took it upon himself to help me edit

repeated drafts of the manuscript, a form of support that I immensely appreciate. I would also like to thank Juliana Yoder, the Assistant Director of Administration for the Arizona Humanities Council, who knows how much I appreciate the council's financial support.

The scholarly advice I received from Clara Lee Tanner and her husband, John, was of tremendous help, and I am indebted to them both. Dr. Emory Sekaquaptewa at the Bureau of Applied Anthropology of the University of Arizona has always answered my abundant and diverse questions, which only he, being Hopi, could answer. Here in Tucson, he was of immense help in my gaining an understanding of complex Hopi customs and traditions. To him also go my thanks. *Askwali!*

My colleagues at the Arizona State Museum were, of course, of great help. In particular, I would like to thank Diane Dittemore, Curator of Ethnographic Collections, who pulled older Hopi baskets from storage for photographing; and Mike Jacobs, Curator of Archaeological Material, who showed me many basketry fragments from prehistoric sites in the Southwest and who arranged them for photographing. In addition, Kathy Hubenschmidt, Curator of Photographic Collections, and Ted Bundy, her assistant, helped me find historical Hopi photographs pertaining to baskets, filed the numerous negatives and slides that I brought into the collection over the years, and helped me find the necessary negatives for the black-and-white illustrations in this book. I owe them all many thanks for completing the additional work for them that I created by undertaking this project. Dr. E. Charles Adams willingly shared his expertise in Hopi history and tradition whenever I needed it, and I thank him.

For additional help in my research into the prehistoric origins of Hopi basketry, I would like to thank Dr. J. M. Adovasio and Laurie Webster, who wrote her Ph.D. dissertation on prehistoric southwestern textiles. Brenda Shears, the project manager of the Roosevelt Project in the Anthropology Department at Arizona State University, shared with me the project's latest finds in basketry. Dr. David R. Wilcox, the Senior Research Archaeologist and Special Assistant to the Deputy Director at the Museum of Northern Arizona, arranged access for me to the Hopi basketry collection of his museum. Gwenn Gallenstein, Assistant Collections Manager at the Museum of Northern Arizona, was of great help in allowing me to examine the collection and in securing

certain basketry items for photographing. To all these wonderful people I offer my thanks.

In all my research, I have always had the wonderful cooperation of the owners and managers of Indian art galleries and stores. I am particularly grateful to Dan Garland, Steve Mattoon, Mike Krajnak, and Sandy Winborne at Garland's Navajo Rugs in Sedona. My photographic requirements were always graciously met with friendly smiles and lots of help. Equally helpful was Richard A. Mehagian, owner of Kópavi International in Sedona.

Milland Lomakema, Sr., Director and Manager of the Hopi Arts and Crafts Silvercraft Cooperative Guild on Second Mesa was kind enough to let me photograph baskets for this documentation, and I thank him for his generosity. My heartfelt thanks go to my old friends, William Bruce McGee, the owner of the Beyond Native Tradition Gallery in Holbrook, and his brother Ron McGee, the owner and manager of McGees Indian Art Gallery in Keams Canyon and his assistants Verlinda Adams and Claudia James. They all accommodated me in my repeated requests for information and permission to photograph baskets they had for sale, always giving me the feeling they liked to see me. I am very grateful and thank them all from the bottom of my heart.

After all the fieldwork, research, photographing, and printing were done, there came months of writing. At the end of that process, I owe two staff members at the Arizona State Museum tremendous gratitude: Sue Ruiz, who entered the early part of the text into the computer, and Rose Slavin, who entered the latter part. With the enormous help of Gwinn Vivian, we obtained a computer printout that really looked like a finished manuscript. Last but not least, I express my thanks to the University of Arizona Press for publishing this book.

This book is dedicated to Emil W. Haury, who—with the financial support he gave to the Arizona State Museum for my trips to the Hopi country—provided the most important basis for my documentation. His lasting friendship, his support for my efforts in ethnographic photography, and his encouragement to convert the documentation into a readable text gave me the stimulus to complete my endeavors. I deeply regret that he cannot see the results of his encouragement, but as I promised him shortly before his death, I can at least show my gratitude by dedicating this book to him.

Introduction

The night of October 31, 1993, was mysterious. It was Halloween night, and I was on the Hopi Reservation. The night sky shimmered above me in a seemingly endless expanse, illuminated by a bright moon hidden behind a thin layer of clouds. A dark line separated the clouds, making it look like a dangerous tunnel into eternity looming above me. As I approached Wepo Wash, it slowly shifted to the north, out of view from my windshield. Then, suddenly, right over Polacca, it happened: a brilliant, long, descending shooting star brightened the dark, hazy sky for a full second. The thin cloud cover made it much more spectacular, giving its streaking path a wondrous glow. A great burst of intense light ended its entry into the Earth's atmosphere. I was too fascinated to make a wish, but I could sense goodness wrapped in wonder.

Actually, my wish had been granted the day before, when a good friend had invited me to the Lalkont society basket dance in Shungopovi. The home into which I had been invited is located near a large kiva where the members of the Lalkont society, one of the Hopi women's societies, had held its secret rituals for several days. October 30 was *tiikive*, the day of the Lalkont basket dance in the plaza, when everyone from the village and the surrounding villages could come and participate. It was on this day that the newly initiated girls and young women would be introduced by the priest (the Lalkontaka) into the circle of dancing women and then would throw presents and baskets to the audience.

From one window of my friend's house, I could see women in traditional dark-blue wool dresses and white *mantas* going to and from the kiva, the first dance of this day having just concluded. The crisp, cool air made them hurry to their homes for the few minutes between dances. Three young women of this family had been initiated in previous years and now danced in the circle with the other Lalkont members. While the family was having break-

fast, I noticed that the window had been decorated with a display
of black stick-on Halloween designs—stuff that any red-blooded
U.S. citizen would put in a window for Halloween. On the
windowsill below squatted the most gloriously carved pumpkin
I have ever seen, a hilariously funny Hano Clown in black and
white stripes and with a huge laughing mouth. He was adorned,
of course, with two characteristic horns, with corn-husk tassels
at their ends—a true and authentic Hopi jack-o'-lantern. Here
on the windowsill, two cultures embraced each other. To me, it
was just another example of Hopi artistic ingenuity, using traits
of another culture as a creative stimulus. While I was still pon-
dering this delight, a newly arrived relative placed three kachina
sculptures and one Palhikwmana doll on the windowsill. Now the
balance was heavily tipped toward Hopi. On tiikive, dance day,
this felt right to me.

I had been prompted to document Hopi basket weaving by my
interest in Hopi arts and crafts. I had met several basket weavers
during the years I had documented Hopi kachina-doll carvers,
and I was particularly attracted by the fact that Hopi women pro-
duce basketry in three totally different techniques, and today they
often create true works of art.

During many centuries of cultural development, the meaning
of Hopi basketry has surpassed its original purely utilitarian pur-
pose and now plays a role in social functions that serve to rein-
force clan and kinship relationships. The basket weavers of Third
Mesa specialize in wicker basketry, the women on Second Mesa
in coiled basketry, and on First Mesa, where basketry production
was never extensive, it has declined to plaiting sifter baskets for
occasional basket dances or wedding paybacks and, among a very
few women, piiki trays.

In the hands of Hopi women, natural fibers from plants that
grow on and around the Hopi Mesas are transformed into items
to meet daily needs and to serve as personal gifts. Plaques have
great value attached to them when they serve as gifts given by
Katsinam to children and adults. Plaques also serve in the rites
of Hopi religious events, when they hold prayer feathers (*pahos*),
prayer sticks, and sacred cornmeal. In the literature of the late
nineteenth century, plaques were usually referred to as sacred bas-
kets or sacred trays.

Hopi basketry is closely linked to the social interactions of
Hopi families and clans. One could say that the natural fibers of

which basketry items are made are symbols of the fibers that bind Hopi society and culture together. Basketry provides the wares for Hopi generosity, for giving thanks and appreciation, and for carrying and presenting food and good intentions to interrelated families and clans.

Today, the Hopis occupy twelve villages, nine of which are situated on the fingerlike southern extensions of Black Mesa in northern Arizona. These extensions are known as the Hopi Mesas. They are at an elevation of 5,500 to 6,000 feet and are located between the Dinnebito Wash and the Polacca Wash. Even though Black Mesa spreads its southern extensions over more than three rocky outcroppings, the locations of the Hopi villages are referred to, starting from the east, as First, Second, and Third Mesa. Two villages, Polacca and Kykotsmovi, were established at the foot of First Mesa and Third Mesa respectively in the latter part of the nineteenth century. Another village, Moenkopi, lies about fifty miles west of Oraibi and just south of Tuba City. Moenkopi was established long ago as a seasonal farming community for the village of Oraibi. Perennial streams in nearby Pasture Canyon and Moenkopi Wash brought water to the fields in those canyons and to Moenkopi. The crops harvested so far away from the main community added substantially to the food supply of Oraibi. Within the past few decades, Moenkopi has grown into two villages: Lower Moenkopi and Upper Moenkopi. The eastern boundary of the relatively small Hopi Reservation (1.5 million acres surrounded by the much larger Navajo Reservation of almost 15 million acres) is marked by the Indian Health Care Agency and Hospital in Keams Canyon.

Alluvial valleys between and below the Hopi Mesas provide sandy soil for dry (unirrigated) farming of corn and beans. Terraced gardens on the sides of the mesas, which are tended by women, and fields irrigated by ditches fed from springs in the cliffs yield vegetables, peaches, apricots, and apples. Terraced gardening has declined in recent decades and has almost totally disappeared on Second Mesa, which is surprising, because the villages of Second Mesa, Shungopovi in particular, have maintained the strongest ceremonial structure.

Hopi mythology tells of the emergence of all people from an underground world, the Third World, into the present world, the Fourth World. Hopi clans relate their mythological stories faithfully from generation to generation, and in one published version Edmund Nequatewa described how, after emerging into the

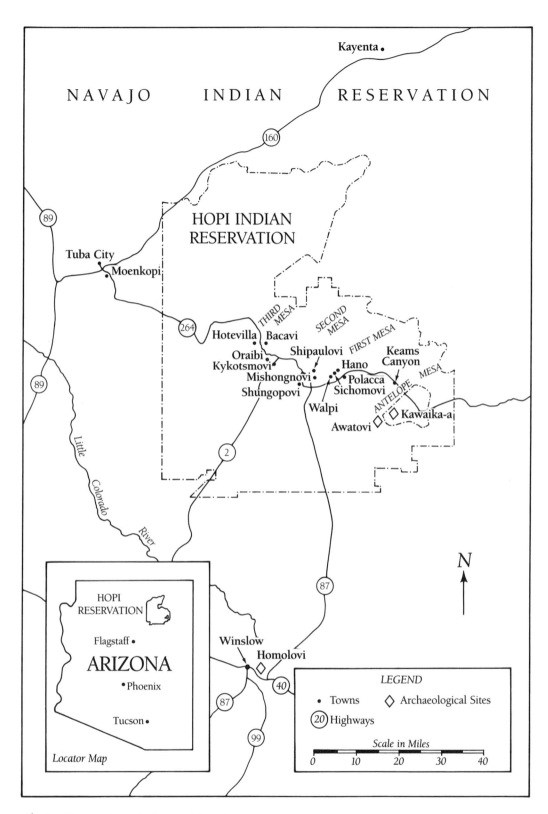

The Hopi Reservation. (Map by Nora L. Voutas)

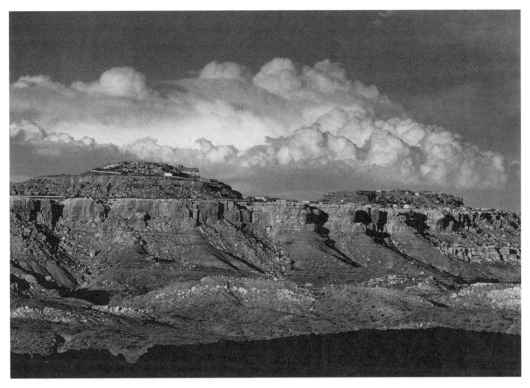

Fourth World, the various groups took on new names, separated into clans, and dispersed in different directions, with the understanding that one day they would all meet again right there where they are today, on the Hopi Mesas.

Hopi society has a complex structure woven into a tight fabric by a complicated web of religious ceremonies and social obligations of reciprocity. We know from archaeological evidence that the village of Oraibi on Third Mesa is the oldest settlement continually inhabited by the same people in the United States, so the Hopi way of life must be the right one for the environment and climate. For many centuries, Hopis have secured an existence in a harsh environment in which prayers for rain and food must be sent to the deities continually. Every year, with the cycle of seasons, the intervention of the Katsinam must be secured from the spirit world before and during the planting and growing seasons. Soon after the Katsinam leave in July, other religious rituals of first the men's societies and then the women's societies take over and continue until November, the last month of harvest. The annual ceremonies end with the public basket dances of the Lalkont and O'waqölt women's societies. The basket dances are intended

Second Mesa. The villages of Shipaulovi and Mishongnovi perch on the two highest points of the mesa. (1994)

partly as celebrations to portend the prosperity of the coming season.

With the inborn wisdom that has guided them for so long through so many obstacles, Hopi men and women perpetuate their proven rituals, strongly encouraging those who attempt to neglect or disrespect their obligations to uphold them. One of these obligations is to respect the flora and fauna of our planet. The Hopi closeness to the Earth is represented in the arts of all three mesas, whether in clay or natural fibers. What the earth produces becomes art in the hands of Hopi artists. I have watched many Hopi basket weavers and potters and cannot help but feel that they cherish their closeness to the Earth and use their produce not only to sustain the body but also to nourish the soul.

What clay is to a potter's hands, natural fibers are to a basket weaver. Could it be that the feel in their hands gives the artists a sense of interconnectedness with their natural surroundings? This feeling provides, quite unconsciously perhaps, an added satisfaction to the pride of a finished piece of basketry or pottery.

Compared to other Hopi artistic creations—like silver-overlay jewelry, kachina dolls, and pottery—basketry items are less numerous in Indian art stores and galleries on the Hopi Reservation and are rare off the reservation. I wondered why Hopi basketry was so underrepresented in the sales market, because in many years of visiting the Second and Third Mesa villages I had seen numerous women working on plaques and baskets. This was before I started to document basket making, and I had never asked any pertinent questions about the activity. Neither did I have the money to buy any of their wares, though on Third Mesa I had been told by friends that *pahaanas* (white people) regularly came to the villages and went from house to house, trying to buy basketry items, particularly plaques. So I was not very surprised when, on occasion, I was told right off, "These plaques are not for sale at this time. They are for paybacks."

When I started my basketry documentation three years ago, it did not take very long before I understood that there was more to these beautiful plaques than their excellent weaving and intricate designs. Very soon a rather complicated social network of reciprocal activities became apparent. With every trip to the Hopi Mesas, my interest grew, and with it the questions I posed to my Hopi friends and acquaintances, though I kept well in mind that I could not probe too deeply. Even though I had obtained the

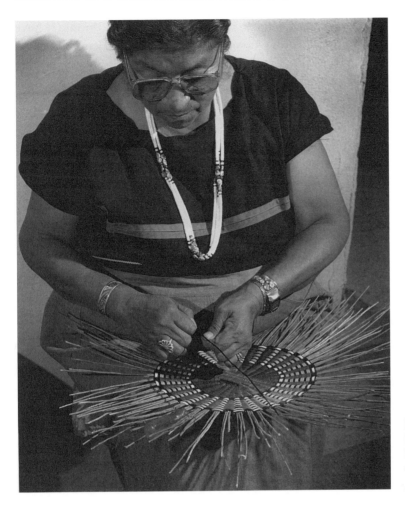

Dora Tawahongva of Hotevilla weaves one of her excellently executed wicker plaques. (1991; ASM no. 86333)

permission and support of Leigh Jenkins of the Hopi Cultural Preservation Office (one of the tribal offices in Kykotsmovi), I also obtained permission from each basket weaver I contacted before I proceeded to ask questions and take photographs. Questions regarding weaving techniques, necessary materials, and the preparation of materials were answered fairly freely. But my success in gathering information was markedly reduced for questions dealing with the use of baskets in group activities or plaques in baby name-giving, gifts of plaques by the Katsinam, and finally the social implications of the use of basketry in ceremonies and in the rituals of the women's societies.

Generally I had to establish a relationship with each individual basket weaver, one woman to another, to win her trust and make her understand that I wanted to know something of her culture,

which I could then try to explain to my culture. I firmly believe
that if cultures know more about each other, understanding and
respect will grow. In this case, by describing the time-consuming
effort that goes into gathering and preparing the weaving fibers
and the equally laborious process of weaving, I hope to increase
the appreciation of Hopi basketry items in non-Hopi society.

Hopi Basket Weaving

A Glimpse of a Hopi Woman's Life

The daily activities in a Hopi woman's life are filled with the procurement and preparation of food, not only for her immediate family but also for her whole kinship group. In an extensive clan system, help is expected from all members in family events like weddings, baby name-giving ceremonies, engagements, and certainly in religious ceremonies. Considering that all Hopis are somewhat related by blood or clan affiliation, it is easy to understand that women have to spend a lot of time making *piiki* (a wafer-thin cornbread), *somiviki* (small tamales), stews, yeast breads, and numerous other dishes for such occasions. One of the busiest times is at the harvest, when men bring crops from the fields into the villages and to their homes. It is up to the women to spread out the beans, winnow them, and store them for the coming months. They also have to burn the dry bean stalks to obtain the ashes necessary for making piiki, which is produced in great amounts for seemingly endless occasions.

Hopi corn—which comes in all those wonderful colors of white, yellow, blue, red, rust red, and mottled white and blue, echoing the palette of colorful basketry plaques—has to be husked and spread out in front or behind the house to dry and then stacked for further drying. Every Hopi woman knows when her corn has dried sufficiently by slightly twisting an ear of corn and listening to it. A silent ear is ready to be stacked in the storage bin, where it can be kept for several years. Earlier in summer, when ripe sweet corn is brought in, it has to be roasted and then tied in bundles and hung on rafters, conserving it for later use. In between, the Hopi woman has to remember when certain wild foodstuffs are ready to be gathered. Usually, wild leafy green plants are cooked right away as vegetables or perhaps sun dried. Not too many years ago, peaches were preserved by spreading them out to dry in the sun on rooftops and rock shelves. Men harvested the peaches on the slopes below the mesas and brought them home on their backs in large peach baskets. Unfortunately,

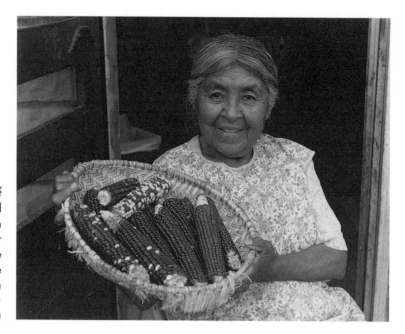

Abigail Kaursgowva of Hotevilla holds a plaited sifter basket filled with ears of blue corn from her corn storage room. She has to shell and grind the corn to prepare the dough for making piiki, a wafer-thin corn bread. (1985)

not many peach trees are alive today, and the younger men don't have the time or interest to plant new ones and care for them.

This busy preoccupation with food is an obligation that was thrust upon Hopi women centuries ago. It is their age-old role to nurture, provide care, and feed children and men. In Hopi society this is their main obligation, and a great task it is. When I found one basket weaver during harvest time running between kitchen, garden, and outside, taking care of the drying crops without any letup in sight for days, I could not help but ask why the women have to do all this work. Her husband, who was sitting in a chair, replied matter of factly: "Women give life and have to always be working hard. Men don't have to work anymore after the harvest." The harvest belongs to the women, and it is their task to process it for winter storage. Needless to say, the wife could not think about her basketry until she had taken care of her obligations.

Women, much more than men, are restricted in their spontaneity, their free self-expression, and their creativity, mainly due to their restricted free time. A Hopi woman is aware that she cannot digress from the rules within her group. If she did, she would feel unhappy about their disapproval of her actions. Hopi men work on their artistic creations always undisturbed—formerly in the seclusion of the kiva, now mostly in their homes.

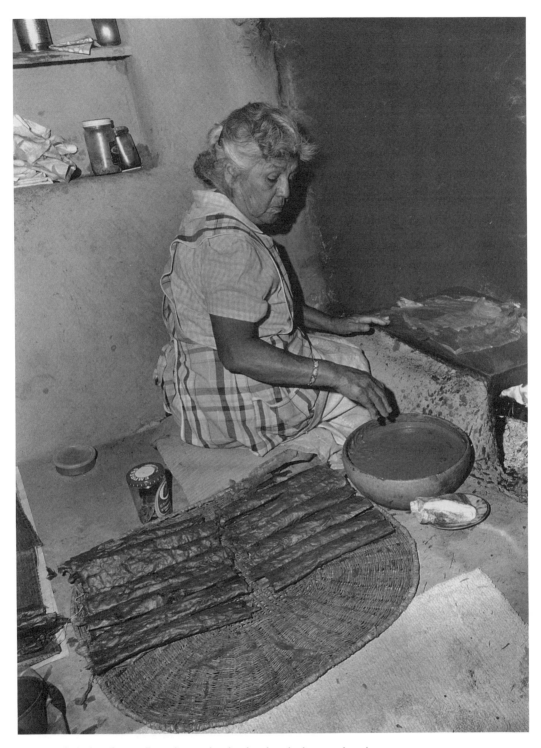

Marcia Balenguha of Hotevilla making piiki. The dough is thinly spread on the hot stone griddle, and after a few seconds it is done and peels off easily. The sheets are then rolled up and arranged on a large piiki tray, or *pik'inpi*. (1973; ASM no. 37662)

When I worked with Hopi kachina-doll carvers some years ago, they were more relaxed and had more time to become absorbed in their work, experimenting with materials, tools, and techniques. Their innovations allowed the carvers to reach a wider market outside Hopi society, and they usually had more time for outsiders like me. Hopi women artists—particularly basket weavers—are less inclined to engage in casual conversation, partly because they must meet the responsibilities mentioned above but also because they are simply less open about their work. Specific questions about the relationship between the women's societies and basket weaving are answered only obliquely or not at all, since much of this knowledge is open only to those who have been initiated into these societies. Almost all women dutifully observe their obligations to clan and community, but they are also forced into a certain dependency on the cash economy they are a part of today, and it is often difficult for them to hold up both ends of these obligations. On more than a few occasions I came to the home of an old friend or new acquaintance and found her too busy to accommodate my wish for an interview or a photography session. But I cherished just that much more those occasions when I was accepted and was allowed to document the weavers' lives, especially when trusting hospitality grew into warm friendship.

Considering that Hopi women are first and foremost bound by their cultural traditions and also by their roles as wife, mother, and grandmother, it is perhaps remarkable that they produce any basketry items for the non-Hopi market at all. People who appreciate Hopi basketry should consider the difficulty with which a basketry item is made and under what circumstances it reaches the market. In particular, the items that the artists submit to juried shows can never be regarded as overpriced, considering the difficulty the basket weavers have to overcome to get this piece into the show in the first place. Each piece must be planned long in advance of a juried show because it has to be of particularly fine craftsmanship and must have an unusually intricate design. The weaver often spends long nights in weaving to complete the basket by the deadline.

Once a woman reaches the age of Hopi grandmothers, she may find more time to make her basketry. Several basket weavers I have met are happy to be able to sit and weave more hours now. However, later in life they may develop eye problems, and their eyesight may decline. This trouble is quite often caused, or at

least accelerated, by the many hours they have spent making piiki, when the smoke from the cooking fire gets into their eyes. Often, excellent weavers experience a decline in the quality of their work when they get older, sadly at just the time when they can finally enjoy the satisfaction of spending more hours at their favorite work.

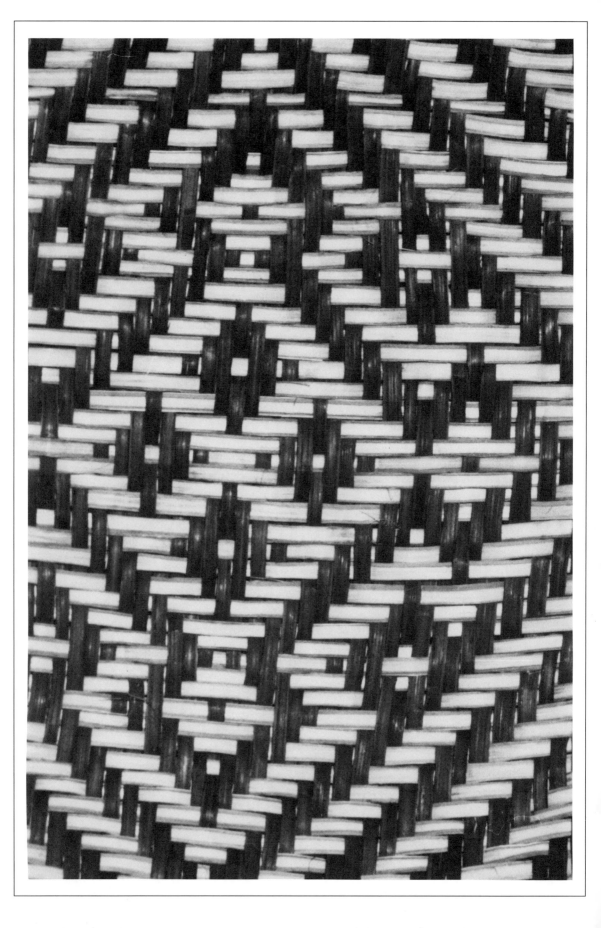

Contemporary Hopi Basket Weaving Techniques

Hopi basket weavers employ three different techniques: plaiting, coiling, and wicker weaving. Some basketry experts say that wicker weaving is a form of plaiting, but I agree with those who consider it such a distinctive variation that it deserves its own category. Certainly Hopi wicker weaving is in a class of its own.

Most people are interested in where things come from and when they originated. For myself, I have long been interested in exploring the possible origins of contemporary Hopi basket weaving techniques. My research has led to interesting, sometimes even intriguing, readings of Hopi oral history, as well as reports of discoveries by anthropologists and archaeologists. My conclusions and speculations are included in more detail in the appendix, but they can be at least outlined here as a background for the chapters to come.

Contemporary Hopi plaited basket weaving is a continuation of the prehistoric plaiting technique used in the Southwest since some time before the first century A.D. In contrast, Hopi coiled and wicker basketry is not a direct continuation of prehistoric techniques. The three prehistoric cultures of the Southwest—the Mogollon, the Hohokam, and the Anasazi—did make coiled basketry of a very high quality, but the Hopi techniques differ substantially from those of the three earlier cultures in the use of plant material, the size of the coils, and the finish on the rim. The current evidence about these differences suggests that some Hopi clans brought their coiling techniques with them on their migrations from southern locations sometime between the fourteenth and seventeenth centuries.

The exact origin of Hopi wicker weaving remains a mystery, but the contemporary technique can be traced back unchanged to at least the beginning of the fourteenth century. Wicker weave basketry that closely resembles Hopi wicker plaques has been found in a fourteenth-century cliff ruin belonging to the Mogollon culture.

Plants that produce the natural fibers for basketry are close at hand for the basket weavers but are utilized to their full potential only on Second and Third Mesa. Most likely this was not always the case, but today nobody knows for sure when the strong division of crafts was established between the three mesas. It probably did not happen very long ago, yet none of the elders I talked to could tell me when. To their knowledge, it has always been this way: On First Mesa pottery is made, and a few women still make plaited sifter baskets and piiki trays. On Second Mesa the women make coiled plaques and baskets, as well as sifter baskets. A few know how to make piiki trays, and less than a handful still make baby cradles and burden baskets. On Third Mesa the women make only wicker basketry, mainly plaques, though a few make wicker baskets. Very few of them make piiki trays, baby cradles, or carrying baskets.

THE COILING TECHNIQUE

For more than a hundred years, the Hopi art of coiled basket weaving has been followed mainly in the Second Mesa villages—Shungopovi, Shipaulovi, and Mishongnovi. Generally speaking, the weaving process employs two elements that work together at a ninety-degree angle. As in textile weaving, the two elements are called the warp and the weft. In basketry they can be either of the same plant material, as in plaiting, or they may consist of the stems, twigs, or leaf materials of different plants, as in coiled and wicker basketry. In the coiled and wicker techniques, using different plant materials for the warp and weft is advantageous because the warp can then consist of a less flexible element, which contributes to the sturdiness of the basket's structure, while the more flexible weft material supplies the "busy" element, passing over and under (or in coiling, around) the warp to produce intricate designs.

In coiled basketry the warp is the foundation material, while the weft is the coiling material, which is coiled around the foundation. This coiling process is sometimes referred to as stitching or sewing, which is reasonable since the motion of coiling is the same as in overhand stitching. From the sewing analogy, we also get the terms *interlocking stitch* and *noninterlocking stitch*. Hopi coiled basketry consists of very tightly spaced noninterlocking stitches on the reverse side and, very rarely, interlocked stitches

on the viewer's side with the sole purpose of producing a decorative design.

The foundation can consist of stems and twigs (usually referred to as rods) or split leaf material, or a combination of the two. The Anasazi used a combination of these materials, with the so-called two-rod-and-bundle foundation predominating. Since at least 1820, however, the Hopis have used a bundle foundation of a different plant material, and they make larger coils and use different finishes for the rim.

Generations of Hopi basket weavers have accumulated a wealth of knowledge about the plant world they live in. For centuries they have depended on plants for food, medicine, tools, building material, and personal ornamentation, and they have transferred their knowledge from mother to daughter and granddaughter, goddaughter, or niece. It must give each Hopi woman comfort and a sense of self-reliance to be knowledgeable about what she needs to support her existence.

Traditionally, all the plant materials needed to make the fibers for basket weaving come from wild plants; none of them are domesticated. The major source for Hopi coiled basketry material is the yucca plant, which once grew in greater abundance around the Hopi Mesas than it does today. An intimate knowledge of nature and its products involves a sense of dependence on the cycles of the seasons. Each plant has its time of collecting during the year, and each time is carefully observed by the basket weaver.

The colors in coiled plaques and baskets are limited to a palette of white, yellow, green, red, and black. But from these five colors Hopi women produce a multitude of colorful and difficult designs. The colors white, yellow, and green are natural colors that come from yucca leaves. Red (or orange-red) and black materials are dyed yucca leaves. To achieve two of the three natural colors—white and yellow—the yucca leaves have to be collected at specific times of the year. For green, leaves from the outer part of the yucca plant are selected during the entire year.

To achieve the white color for the sewing fibers, the fresh shoots from the center of the yucca plant have to be gathered from late July through August and September. These young leaves are almost white and need little if any bleaching in the sun. The goal of the weaver is to get as white a yucca leaf for coiling as possible before she starts her white design. In addition, the whiter

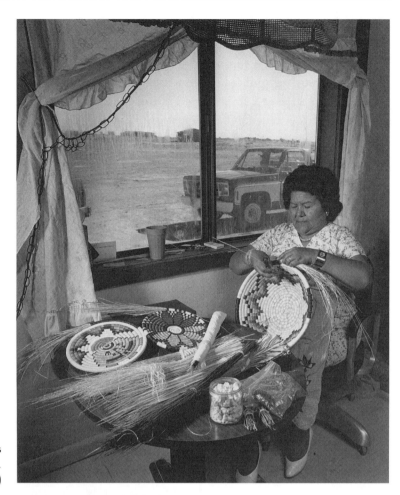

Joyce Ann Saufkie weaves
a basket in her home.
(1991; ASM no. 85205)

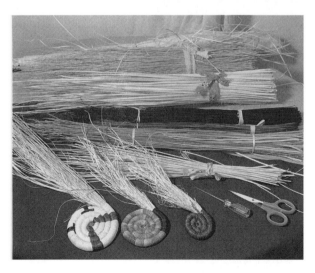

Three beginnings of coiled plaques that
show an almost perfectly round start. To
make the first four or five tightly wound
coils, weavers use the discarded fibers
from cleaning their sewing splints. These
very fine yucca fibers are almost as thin as
horsehair and are very pliable. The only
tools a weaver of coiled basketry uses are
an awl and small scissors to cut off the pro-
truding ends of sewing splints. Behind the
plaques are bundles of yucca strips. All
but the largest have been cleaned and
sliced and are ready for use. Farthest in
back is a bundle of galleta grass. (1992;
ASM no. 87098A)

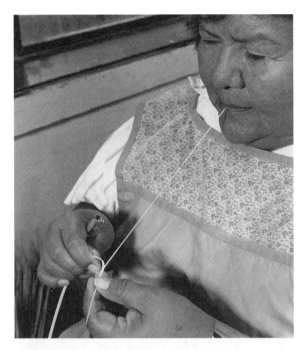

The preparation of the sewing material is the most time-consuming and tedious task in making coiled basketry. Each yucca fiber splint has to be prepared to perfection—that is, split so that it is as thin and narrow as possible. The width is about an eighth of an inch, and the thinness approaches that of rice paper. Hopi coiled-basket weavers take pride in producing the most delicate sewing splints, the most equally spaced stitches, and the most compact and even coils in width and height.

Here, Joyce Ann Saufkie uses her teeth to slice off a very thin portion from the inside of the yucca splint she wants to use. The splint had already been prepared but was not quite thin enough. Other weavers told me that a great amount of time and effort is used in cleaning their materials right at the time they work on their coiling. This is in addition to the hours they have already spent in cleaning and splitting. (1992; ASM no. 87088)

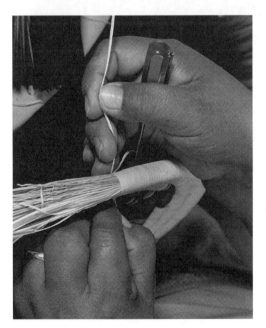

To start a new yucca sewing splint, the weaver makes a hole with her awl through the top of the preceding coil and feeds the yucca splint through, keeping the end (the fag end) sticking out. The end of the previous splint (the moving end) sticks out on the opposite side. (1992; ASM no. 87090)

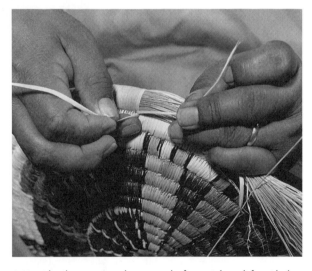

A Hopi basket weaver always works from right to left, with the inside of a plaque or the outside of a basket facing the weaver. The moving end of the preceding sewing splint and the fag end of the new splint are laid parallel to the coil in the direction of the work and hidden under several coiling stitches. The ends are cut off. (1992; ASM no. 87091)

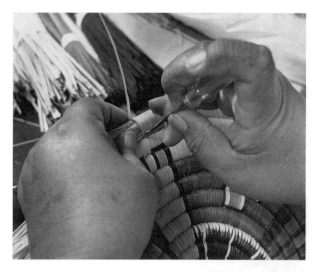

Hopi coiling is done very tightly, and it takes not only enormous patience to proceed diligently in attaining the precision the weavers impose on themselves but also a good deal of strength to push the awl through the preceding compact coil. This is not work for arthritic hands. The hole made by the awl does not split the previous stitch, so the result is called a noninterlocking stitch. However, for design purposes, stitches are sometimes purposely split, as in the white stitches in this photograph. (1992; ASM no. 87085)

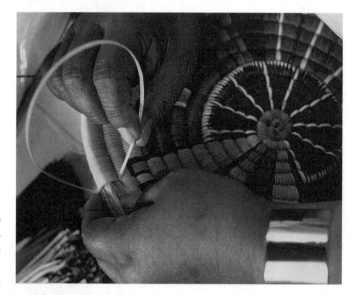

Feeding the yucca splint through the hole made by the awl. The tip of the yucca splint is tapered to facilitate easier passage through the hole. (1992; ASM no. 87084)

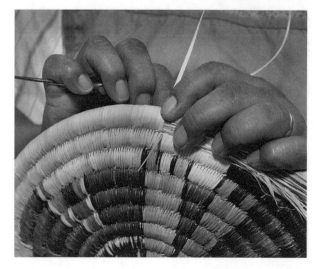

On the reverse side of the working surface, the placement of the stitches can be clearly seen. Each stitch grabs the very top of the grass bundle foundation of the preceding coil without splitting the yucca strips on either side. (1992; ASM no. 87081)

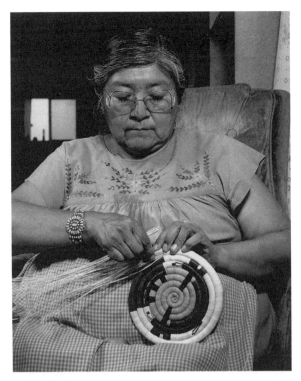

The weaver (here, Bertha Wadsworth) adds new galleta grass stems every few inches, pushing the lower end of the stems into the center of the foundation material. If it is necessary to make the coil more flexible, experienced basket weavers control the consistency of the coil by adding discarded yucca strips—the finely split pieces that were accumulated in cleaning the sewing splints. Galleta grass alone gives the coil its general stiffness. For extra stiffness, strips are added from the upper triangular part of the yucca leaf, which is sliced off in the initial cleaning and splitting procedure. This part has the stiffest fiber. It is amazing how much detailed botanical knowledge the Hopi women use in every step of their basket weaving. (1993)

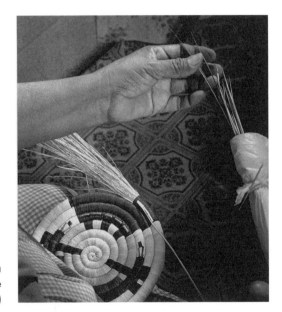

To indicate the design on the Corn Maiden's manta, Bertha Wadsworth uses overstitches of white yucca splints, which she lays horizontally across the red coiling stitches. (1993)

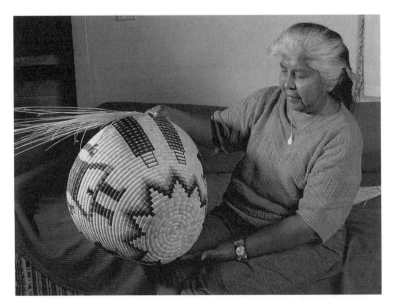

Remalda Lomayestewa of Shungopovi with a large, deep basket, which is half finished. It shows her beautiful start of a perfectly round spiral coil, emerging into the zig-zag band of a cloud design in black, red, and yellow. The yellow has an almost feathery effect when blending into the white of the wall coils. Corn Katsina figures and ears of colored corn grace the sides of this basket, which was commissioned by a collector. (1991; ASM no. 86165)

the leaves are, the easier they are to dye and transform into pleasing reds and blacks.

For the yellow color, Hopi women have to conduct gathering trips at a different time of the year. In the middle of winter or in early spring, when it is frequently very cold, green yucca leaves that had been subjected to numerous nights of frost are collected. The leaves are then spread out in the sun to bleach. With the ensuing rains, the leaves turn yellow in drying, providing the weavers with their third natural color.

Gathering Yucca Leaves

Because I live almost 400 miles south of the Hopi Mesas, it was difficult for me to be there when some of my friends engaged in activities that were pertinent to documenting basket weaving. I was never able to document a regular gathering of yucca leaves for coiled basketry, for example, because this process usually involves several women meeting in the morning, pooling their gasoline money, piling into a car, and taking off for a region well known to one of them where they could find large yucca plants in greater numbers than below Second Mesa.

By tradition, yucca leaves for coiled baskets should not be gathered during the period when the villages are visited by the Katsinam. This means that gathering should not be done until after the Niman ceremony, which ends with the Home dance and the departure of the Katsinam. Niman is held from mid to late July. One woman told me that many weavers now collect before Niman, so when she goes to her traditional places after the ceremony she cannot find suitable leaves. The last time she collected yucca leaves, she did so near Santa Fe on a visit to her daughter who lives in Santo Domingo Pueblo. Others told me they travel as far as Kaibito, northwest of Tuba City. All this brings to mind the questions, If basket weavers did not have the automobile, could they achieve the high quality of coiled basket weaving that they do now? Would fewer plaques be made, and would any large, deep baskets be made?

The willingness and cooperation of my friend Joyce Ann Saufkie made it possible for me to photograph yucca leaf collecting. On July 24, 1991, I drove Joyce and our mutual friend Annabelle Nequatewa for many miles until we reached the place where Joyce takes other weavers on occasional one-day excursions to gather

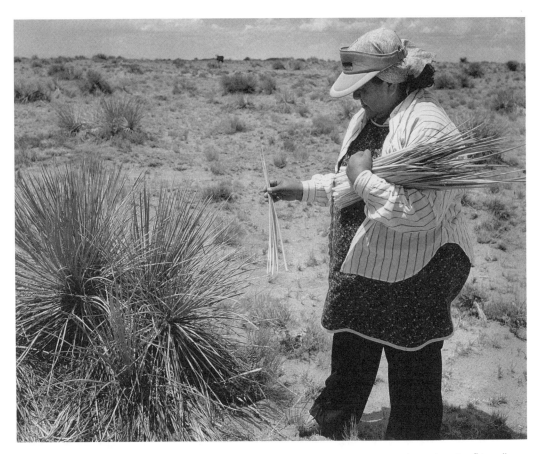

Joyce Ann Saufkie collects white yucca leaves. (1991; ASM no. 85719)

yucca leaves, and at the same time they have fun and delight in the camaraderie.

When we arrived at our destination, we were in a big field of yucca plants that grew in clusters like close-knit families gathering together at times of festivities. Some plants loomed gorgeously big and tall against the blue sky dotted with puffy white clouds. Joyce said that at one time yucca grew this abundantly below Second Mesa. She and Annabelle did not waste any time but immediately started reaching into the plants very carefully to avoid being cut by the sharp edges of the leaves. In picking, they searched for the inner, freshly grown white leaves in the center. Guided by long experience, they either pulled out a handful of leaves or selected only single leaves here and there. They said that the plants do not get hurt this way. Joyce was looking for the longer leaves so that she would have longer strips for coiling and would not have so many ends and beginnings during her coiling.

To make this trip as worthwhile as possible, both also selected

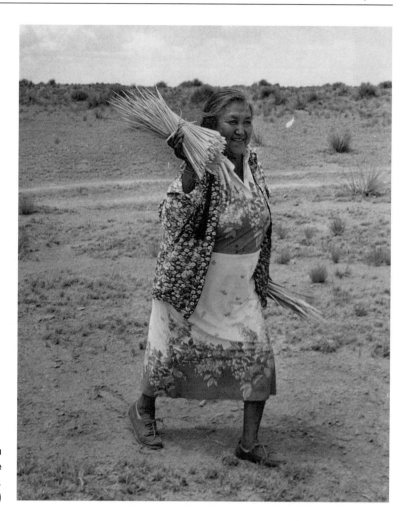

Annabelle Nequatewa
carries bundles of white
yucca leaves to the car.
(1991; ASM no. 85725)

green leaves that were to their liking. They dispersed widely in
search of just the right leaves, bypassing more than one plant to
look for better material. We gathered on this day for only about
fifty minutes to accommodate my picture taking because I had to
be back on First Mesa early in the afternoon. Both Joyce and
Annabelle collected two bundles of white yucca leaves, each
bundle about eight inches in diameter. Usually they gather at
least six to eight such bundles each and clean and split as many as
they can on the spot before returning home. Each bundle is
neatly tied with a narrow strip of cotton cloth and put in an old
bedsheet or other cloth that, when tied together, can be slung
over the shoulder and carried back to the car. Joyce had brought
a large canvas bag with shoulder straps for that purpose, since the
ladies often collect from a quarter to a half mile from the car.

Approaching Third Mesa on our way back to Second Mesa, Joyce and Annabelle looked out the windows to see if they could see any galleta grass (*söhö*), to use as foundation material. It had grown in profusion along the highway the year before, but for many miles their search was futile. Galleta grass seems to be very dependent on rainfall for its growth, and there had not been as much rain the past winter as in the previous year. Five miles west of Hotevilla on Third Mesa, simultaneous shouts of "Stop! Stop!" caused me to jam on the brakes, and there they were: pale beige grass stems in a shallow depression next to the road. To me it looked much like any other dried grass, and when I asked them why it has to be this grass and none of the others, they could not answer my question, casting it away, I am sure, like many of my other silly questions.

Galleta grass, about twelve inches high, grows closely together and breaks off easily, so it can be collected rather quickly. Joyce's and Annabelle's hands moved fast in a motion that resembled grazing, gathering a fistful before cradling the harvested grass in the other arm. According to Annabelle, the end of July through August is the right time to collect galleta grass; by the end of September the grass has become too dry. The lower part of the grass stem has to be still a bit green to be right for picking. Other basket weavers told me that galleta grass can be collected from August through December as long as no snow had covered it.

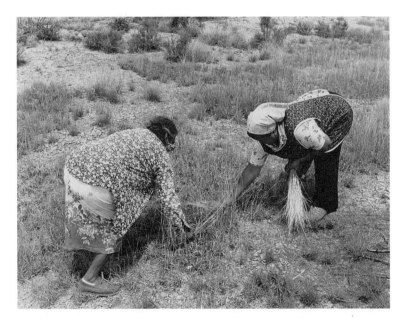

Annabelle Nequatewa and Joyce Ann Saufkie collect galleta grass (*söhö*), the bundle foundation material for coiled basketry. (1991; ASM no. 85732)

Splitting and Cleaning Yucca Leaves

One of the most time-consuming and tedious tasks in basket making is the preparation of the warp and weft materials. In Hopi coiled-basket weaving, the foundation material, galleta grass, needs no further preparation after gathering, but the yucca leaves—the sewing material, or weft—need a lot of work before they can be used for the delicate coiling accomplished by Hopi basket weavers. Regardless of what time of year the yucca leaves are collected, and before they are spread out to begin the process of turning yellow or bleaching white, the leaves have to be split and cleaned.

In cross section a yucca leaf has the form of a triangle in which the baseline is the longest of the three sides. Hopi women strip off the upper part of this triangle with their awls, leaving the lower part as a flat strip. The sharp edges of this strip are also stripped off with the awl, and an additional layer of the inside of the leaf is removed, leaving an almost paper-thin strip of sewing

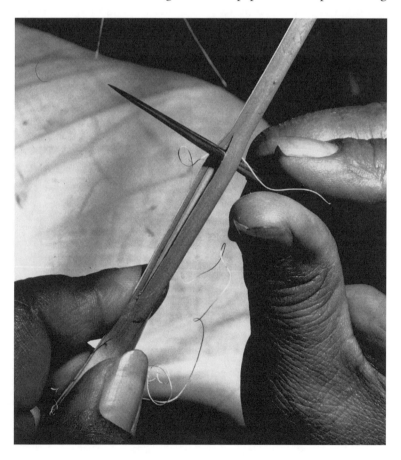

The first step in cleaning a yucca leaf is to separate the upper portion with an awl. (1993)

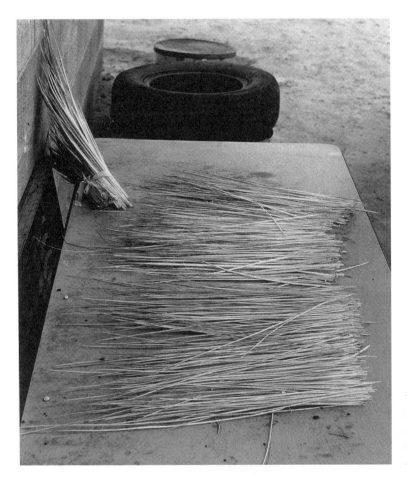

Yucca leaves that have been thinly split and spread out to dry but not yet cleaned. (1992; ASM no. 85824)

material. The sliced-off pieces have very fine fibers that are not wasted but are used with the galleta grass in the foundation. The remaining thinned yucca splint is divided four or five times, making each splint less than an eighth inch in width. The number of splints a weaver obtains from a yucca leaf depends on the original width of the leaf, the skill of the weaver, and the quality of her coils. Of course, it also depends on what she wants to make with the yucca strips. A miniature plaque requires thinner strips than a large plaque or a large, deep basket. After stripping it away, the upper part of the leaf is split into two parts. These usually do not bleach quite as white as the lower part, so they are either used for the bottom of large baskets, where their off-white or greenish color cannot be seen, or they are dyed red or black.

It takes the basket weaver many hours to prepare the yucca leaves in this way before she can spread them out for bleaching in the sun, for turning yellow in winter rains, or for starting the complicated task of dyeing.

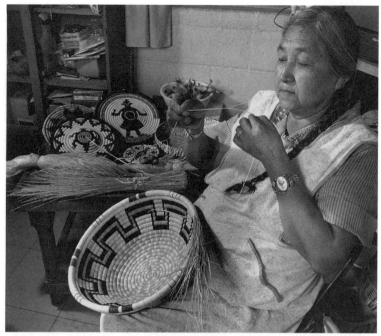

Here, Annabelle Nequatewa is using yucca splints made from the upper part of yucca leaves in the bottom of a large, deep basket. Note the darker shade of coils on the bottom compared to the wall of the basket. Annabelle is thinning the splint she wants to use. (1991; ASM no. 85542)

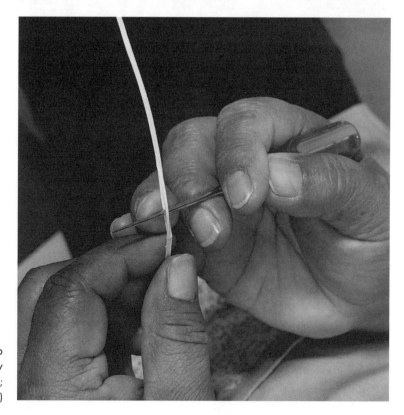

Thinning a yucca splint to paper-thin consistency before dyeing. (1992; ASM no. 87086)

While the splints for the white and green colors can be cleaned again during the coiling process and just before a splint is to be used, the yucca fibers used for the yellow color and the red and black dye have to be carefully cleaned, since nothing can be removed from them after they have assumed their coloring. Whenever family and community obligations allow it, several friends or relatives gather in someone's house to carry out this activity together while chatting, laughing, and exchanging the latest gossip.

Collecting Plants for the Red Dye and the Dyeing Process

The two little plants Hopi basket weavers use to make their red dye grow close to the Second and Third Mesa villages and can be collected easily, providing that enough rain came to stimulate their growth. Both are also used for teas that taste pleasantly refreshing. One is commonly called Navajo tea (*siita*). The other is commonly called Hopi tea (*hohoisi*), and it also grows in South America. Both plants have served Native Americans for centuries as a beverage and as a dye.

Dye use varies with each basket weaver, depending on which plant she prefers. The women of Second Mesa seem to have a slight preference for siita, while those from Third Mesa work with whichever one is more abundant. Some decidedly favor hohoisi.

It was at the end of May 1991 when I enticed Annabelle Nequatewa to go looking for siita. She needed it for her red dye, and it would give me a chance to photograph this gathering activity. She had told me that her son Edward often helped her collect her materials. He and Ruby, his wife and a very good basket weaver in her own right, quickly agreed to come along. We drove to the southern slope of Second Mesa, where in most other years they could find siita plants in abundance. This year, however, there had not been many winter rains, and the plants we found were no higher than two to three inches, though they grow up to six inches tall. Also, Annabelle concluded that other weavers had been there collecting already. The plant is dark green and has very narrow leaves that cling close to the main stem. The whole plant is used, clipping it off at ground level. The ground was hard and dry and held on to the roots, which I thought was good, as it assured renewed growth. After an hour of collecting, we had no more than a pound and a half of siita.

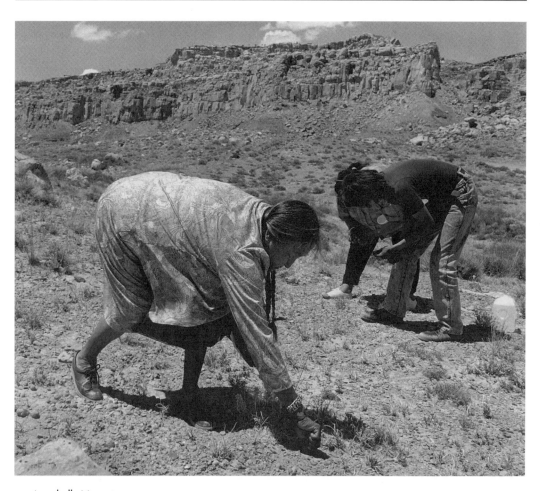

Annabelle Nequatewa, with her son Edward and daughter-in-law Ruby, collect *siita* (*Thelesper-num subnudum*) below Second Mesa. (1991; ASM no. 85560)

This amount is just enough for one dyeing, providing freshly picked siita is used. Of course, siita is dried by spreading it out behind the houses. In its dry stage it can be stored away and will last for years, always ready to be used for tea or for dyeing the red color for basketry. For tea it is only boiled for a short while, whereas in the dyeing process it boils for at least thirty minutes, making a very dark brown liquid. The yucca splints are then put in, and the boiling continues.

Hohoisi is a plant similar to siita, but it grows taller and is collected with its blossoms. According to Mary Russell Ferrell Colton, both plants yield a higher concentration of dye if collected before the summer rains come and before they have reached their full growth.

Treva Burton and her sister Bessie Monongye live on Third Mesa in the old village of Oraibi. They are both excellent wicker basket weavers, and they usually find the hohoisi they need for

their dyeing in Treva's peach orchard. Many of her peach trees had died over the years due to a lack of rain. The peach harvest in 1991 was nil, partly because of continued minimal rainfall and partly because a late frost had killed many of the early blossoms. The sandy soil was favored with a good crop of hohoisi blooms that year, and both sisters took their share home with them. Treva and Bessie took the whole plant, including the small yellow blossoms. The plant provides them with a deep, warm orange-yellow and vermilion red, depending on how long they boil their rabbitbrush in it.

For quite a while Joyce Ann Saufkie had been promising to let me photograph her when she dyed yucca leaves, and we finally arranged to meet on November 17, 1991. I arrived from Tucson to spend a day while she dyed her yucca splints red. I realized that this was a great favor, because it takes so much preparation for a

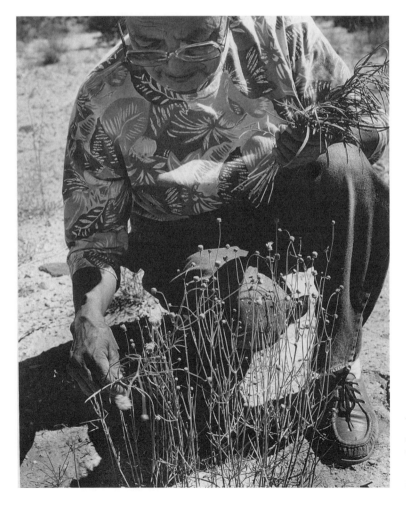

Treva Burton of Oraibi collects *hohoisi* (Hopi tea) for the orange-red color in her wicker basketry. (1991; ASM no. 85875)

weaver to have her yucca finely cleaned and split for this occasion, and she needs to have eight to ten bundles ready to make this laborious task worthwhile. A weaver is anxious to have such a large amount for one dyeing process so that she will have enough of the same color without variation to make a large plaque or a deep basket. She had told me previously that on the days when she does the dyeing she usually does not like to have anyone around her because the work requires her full concentration and she cannot afford to be interrupted or answer questions. There are also many taboos attached to this dyeing method. For example, anyone coming unexpectedly into the house during the dyeing has to stay until the whole process is finished, or the process will result in faded colors. If the weaver is pregnant, she would not consider dyeing material herself but would ask someone else to do it for her. The red will also fail to dye properly if a basket weaver attempts to do her dyeing after a death in the family. When that happens, she cannot do any artistic work, like basketry or pottery, for four days, and she has to wait weeks before she can resume her dyeing. Even then, a special cleansing ritual has to precede the dyeing.

Unfortunately, Joyce received notice of her distant aunt's death in Flagstaff, so she had to cancel our meeting. We tried again in early April 1992. This time she had only one bundle of yucca splints prepared and went through the process only for the photography, which was really a sacrifice of her time. The night before, Joyce had boiled a handful of dried siita in a gallon of water for three and a half hours. She poured this brew through a sieve and put the very dark yellowish-brown liquid back on the stove to heat. While she waited for it to come to a boil, she went outside to make a wood fire. She did not have much wood, and it did not make many coals. From then on she had to do a lot of running between this outside fire and her kitchen. She washed the finely split bundle of yucca leaves in warm water, rinsed them, and laid them on newspaper on the floor. The siita broth was almost boiling when she added a handful of white alum (si'önga). This is native alum, which forms around the damp edges of wet soil below the mesa cliffs and which has long served Hopi basket and textile weavers as a mordant in dyeing. The dye with the mordant added boiled for another fifteen minutes.

Outside she dragged part of a sheepskin to the fire and added more wood. Then she went back to the stove in the kitchen. She held the yucca splints loosely in her hand and dunked them

halfway into the dye. She held them there and turned them, try-ing to avoid burning her hand in the hot steam. Since the pot was not large enough, she had to turn the yucca splints over several times so that both ends were dyed. This procedure took about half an hour. The yucca turned to a golden orange-yellow. Then it was time to tend to the fire outside again. The coals were good now, and Joyce put the sheepskin on them. In a few seconds, clouds of smoke emerged. Over the smoking wool she rigged a stand that supported a heavy metal screen, and she transferred the yucca onto the screen. Some of the dye dripped onto the coals and produced more smoke. She turned the yucca frequently and periodically put it back into the dye and then back onto the screen, reversing the ends of the long splints so that both ends of the yucca were exposed to the smoke. She repeated this proce-dure for more than forty minutes. The smoke was pungent, and Joyce tried hard to keep her face out of it. The fire did not last long enough to turn the yellow-orange into the brilliant rust red color preferred by Joyce and most other weavers. She usually dyes eight to ten bundles at a time, which takes her all day. But then she has much more wood on hand to make a bigger fire and also more wool. The fire is more intense, and with more wool it gen-erates more smoke. Then the color turns more quickly to the deep rust red. She said she would smoke this bundle of yucca leaves again the next time she dyed yucca.

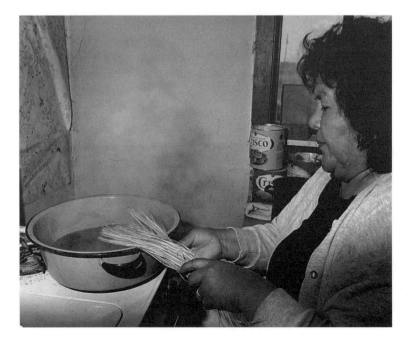

Joyce Ann Saufkie dyeing white yucca splints in boil-ing broth of the *siita* plant. (1992; ASM no. 86710)

Annabelle told me that her mother used an old large sifter basket as a screen. It was always in danger of being consumed by the fire, so her mother kept a bucket of water handy for dowsing the flames. The resulting increased smoke helped to turn the yucca red.

As fascinated as I was by this sequence of chemical reactions, I did not envy Joyce doing this job. Standing all day long in the smoke is no fun and is hard on eyes and lungs, but it is done by most Second Mesa basket weavers because the beautiful and favored color it produces cannot be duplicated by any commercial dye.

Concerning the black dye, Joyce said that Hopi sunflower seeds make a better dye than the commercial black dyes. However, nobody grows the sunflowers anymore. If she had any, she would need four handfuls (about two cups) of seeds to two gallons of

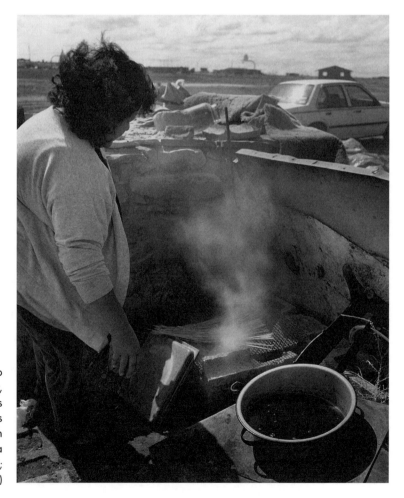

To set the color and to achieve a rust red color, Joyce Ann Saufkie smokes the dyed yucca splints over a fire fueled with sheepskin. The siita broth is in front. (1992; ASM no. 86718)

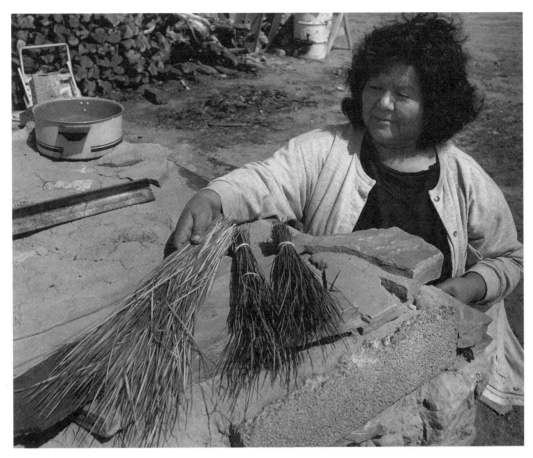

water. She would boil them for an hour and a half, let the water cool, and then immerse the yucca splints in the dye until they turned an even black. They would not need to be smoked afterwards. She would then wash the yucca in cold water, add some ice, and rinse until the water was clear. Like almost all the other weavers, however, she uses the commercial dye now, following the instructions on the box.

THE PLAITING TECHNIQUE

In plaiting, the warp and weft elements are usually of the same plant, and unlike the case of the coiled and wicker techniques, the warp and weft are equally engaged in passing over and under each other. A plaited basket is usually not tightly woven and is therefore flexible or semirigid in construction.

In this technique, the green leaves of the yucca plant are used to make the traditional plaited sifter (or ring) basket. The sifter

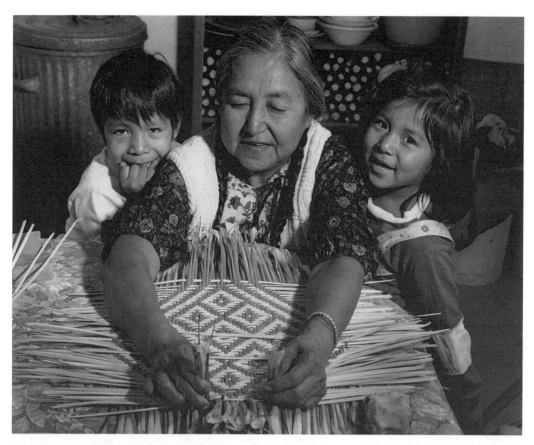

Annabelle Nequatewa finishes the twilled diamond design for a plaited sifter basket. She enjoys the company of two of her grandchildren, Carl and Eddiebelle Nequatewa. (1991; ASM no. 86249)

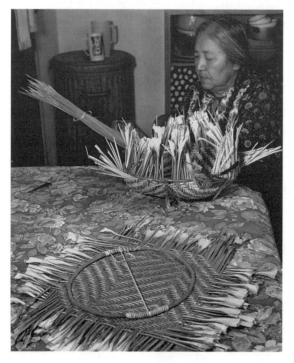

A wooden ring is tied into a circle while the wood is still freshly cut and is allowed to dry. Traditionally, the branches of scrub sumac (*suuvi*) were used for the ring, but today several different materials are used. Freshly cut sumac branches can easily be bent, and when tied together they will dry into a ring form. However, it is hard for many women to climb the cliffs under the mesa tops to gather sumac branches. The intrusive tamarisk bush, which often grows in locations that are easier to reach, provides branches that can be bent equally well into rings for plaited sifter baskets. In addition, hobby shops in Winslow and Flagstaff carry metal rings that are the correct size, and a perfectly round basket can be produced with this modern article.

After the woven mat is large enough to fit its proposed ring, the weaver pulls most of the unwoven yucca blades through the ring. Transforming a square object into a round one is not easy; some blades on the corners of the mat stay outside the ring. They are later fastened to the rim with the bent-over blades and then cut off close to the rim at a forty-five-degree angle. (1991; ASM no. 86258)

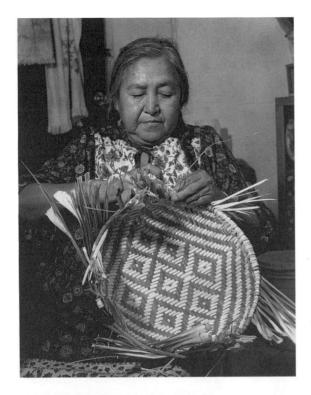

The extending yucca leaves are bent over the ring and secured with a twining "stitch" to the basket. Annabelle is using split yucca leaves as "thread." (1991; ASM no. 86274)

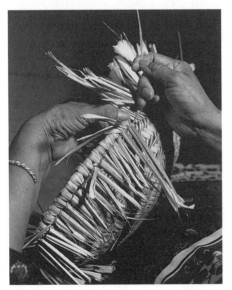

A close-up view shows that Annabelle uses two yucca "threads" in twining the bent-over plaiting elements to the ring, thus creating a so-called 180-degree self-selvage. (1991; ASM no. 86268)

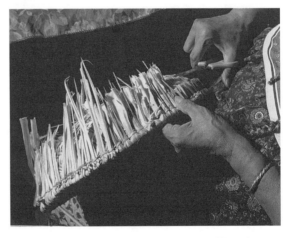

The uneven ends of the self-selvage are cut off less than two inches below the rim. Most plaited sifter baskets are woven solely of green yucca leaves. However, in recent decades Hopi weavers have been using white or dyed yucca blades in addition to the green ones to create geometric or figurative designs. The dyeing is done with commercial dyes. (1991; ASM no. 86286)

basket still serves in most of the daily routines of food prepara-
tion, functioning as a container for many foods and as a sifter, or
winnowing basket, for beans and corn.

When the green yucca leaves are brought home, the basket
weaver pulls off the excess fibers on the sides of the blades, splits
the upper triangle of the leaf off with her awl, and needs to do no
further cleaning before starting to make the plaited sifter basket.
The intricate twilled design the weaver achieves is entirely up to
her imagination. She can use the green side of the yucca leaf
throughout, or she can use the green side in one direction and
the lighter side in the other, placing the leaves in a ninety-degree
angle to each other. If she wants her design, which usually is
a variation on the diamond, to stand out more, she uses white
bleached yucca blades to contrast with the green ones. She weaves
a square, flat mat, its size depending on the length of the leaves
she uses.

THE WICKER TECHNIQUE

The warps for wicker baskets consist of several stems of a differ-
ent plant material from that used for the weft. It is a less flexible
fiber and therefore constitutes the more rigid and less active ele-
ment in this weaving technique. The weft—a single stem of a
more flexible plant material—is the active element that passes
over and under the warp. The wicker technique produces baskets
that are usually of a rigid construction, making them also suitable
as burden baskets.

Hopi wicker basketry is an art in itself, unique in its processes
and its colorful designs. Today it is produced only on Third
Mesa—in considerable quantity in the villages of Oraibi, Ky-
kotsmovi, and Hotevilla, and in smaller amounts in Bacavi, Lower
Moenkopi, and Upper Moenkopi. More than a hundred years
ago, wicker plaques and baskets were most likely produced in the
villages on the other mesas too, because today a number of basket
weavers in those villages employ the wicker technique in the
manufacture of baby cradles, burden baskets, and the rims of
piiki trays. But this wicker technique was not used by the pre-
historic Anasazi, who are in part considered ancestors of the
Hopi people. The Anasazi and Mogollon peoples, as well as the
Great Basin cultures to the north, used the wicker technique to
some extent, but the remaining fragments of their work bear
no resemblance to modern Hopi wicker basketry. I suspect that,

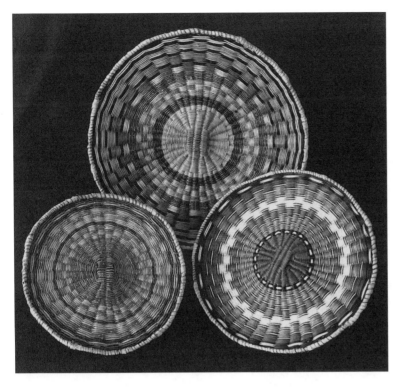

A good example of Hopi wicker plaques from Third Mesa. These three plaques were woven by Bessie Monongye of Oraibi, who used wefts dyed in vegetal dyes, a labor of love undertaken by only a few wicker weavers today. (1991; ASM no. 85460)

like the contemporary Hopi coiled-basket weaving technique, Hopi wicker weaving was introduced by clans migrating from the south.

While experts on basket weaving may define the Hopi wicker technique as either a form of plaiting or as a technique of its own, it is indisputable that Hopi women have developed their wicker technique into an art form.

Collecting Materials for Wicker Plaques and Baskets

In wicker basketry the relatively rigid warp material works with the fairly supple plant used for the weft. The warp is the plant *Parryella filifolia*, which has no common name and is called *siwi* in Hopi. The weft material consists of the stems of rabbitbrush (*Chrysothamnus* spp.; in Hopi, *siváapi*). Using these plants makes the collecting easier because they can be collected at the same time. For certain applications the twigs of scrub sumac and *qahavi* (arroyo willow; *salix lasiolepis*) are used. Like other plant material for basketry, siwi and siváapi traditionally are not collected until four days after Niman, when the Katsinam leave the Hopi villages for the year.

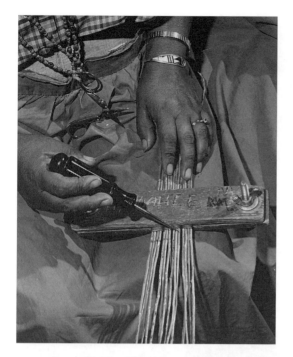

Almarie Masayestewa starts the *yayni* (beginning) of a wicker plaque. A Hopi wicker basket weaver starts her plaque or basket by laying a certain amount of warp sticks parallel to each other. For convenience, the warp sticks, of the bushy plant *siwi* (*Parryella filifolia*), are held between two wooden boards. They are then divided into sections of three or four sticks, each section constituting one warp element. For newborn and baby plaques, only two or three sticks per warp element are used. Each warp element is then held together with a more supple weft element: a single stem of colored *siváapi* (rabbitbrush). (1992; ASM no. 87119)

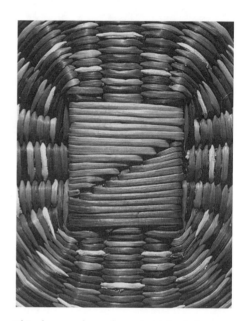

This close-up shows the early method of weaving the yayni. Today only a few wicker weavers know how to make this beginning (see chapter 5). The diagonal, or sometimes stepped, motif of a yayni was common at the beginning of the twentieth century, but its use declined in about 1930, and it is seldom seen today in new wicker plaques. This yayni was made by Abigail Kaursgowva of Hotevilla in 1993.

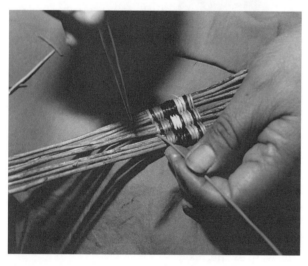

The Hopi wicker weaver either weaves the yayni in one color or incorporates a design by using different colors or a different weaving method. The weft elements have to be kept moist so that they will bend easily around the edges of the warp without breaking. If the wrong kind of siváapi plant is used, it will break. A stem that is too dry will also break when the weaver makes the tight loop around the edges. If a stem breaks while she is making the yayni, the weaver has to start over. (1992; ASM no. 86532)

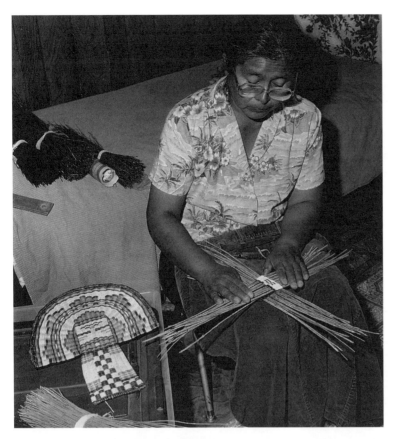

Leora Kayquoptewa of Hotevilla demonstrates that the yayni for a Palhikwmana wicker doll is made in the same fashion as the yayni for a plaque. Katsina figures and Katsina faces are often woven into wicker plaques. To depict the faces correctly, the yayni must be made of more warp elements than are used for animal or geometric designs. (1991; ASM no. 85807)

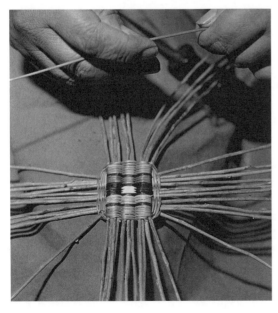

For the center of a wicker plaque or basket, the weaver (here, Almarie Masayestewa) must make two yaynis, crossing them at a ninety-degree angle (this is called a cross-warp start) and holding them together by weaving the wefts in a circular pattern around them. (1992; ASM no. 86543)

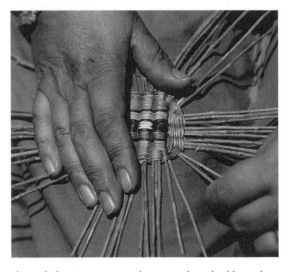

The radial weaving pattern has started, and additional warps are added in the corners to achieve the round structure. As the radius of the plaque or basket grows, warps are added to increase the diameter. (ASM no. 86544)

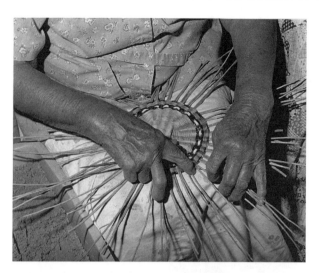

In weaving her wicker plaque or basket, the weaver (here, Eva Hoyungowa) bends the warps to the side so she can lean in closer to the weaving area. The larger the plaque, the more difficult it is for her to reach across it. This necessary bending of the warp stems is the main reason wicker weaving is done more in the winter than during the hot summer months. The summer heat dries the siwi warp too fast, causing it to break when bent. Once a wicker plaque or basket has been started, it must not dry out, or the piece in progress will be rendered worthless. Due to the advanced stage of work, the woven piece cannot be resoaked in water. Therefore, great care is taken to keep the fibers and the started wicker piece damp in moist sand, which the weaver usually keeps right next to her in a shallow box covered with a piece of plastic. The sand, which comes from special locations near the villages of Third Mesa, has a very fine grain structure and a special moisture-retaining capability. To keep mold from getting on the fibers after repeated use, the sand is changed about every three weeks. (1993)

The weft elements are woven over and under the warp elements, then pushed together so tightly with the awl that the underlying warps become invisible. In most medium-sized plaques, a warp element consists of four siwi stems. In order to increase the radius, more siwi stems are added to the warp elements until they number four. At this point the weaver divides each warp element into two, thus having two stems to each element, which is increased to four as the radius of the plaque grows. The last division of the warp elements usually coincides with the black-and-white band toward the center of the plaque. This band symbolizes clouds and is repeated near the rim. A geometric design on a plaque is usually enclosed by two cloud designs. (1993)

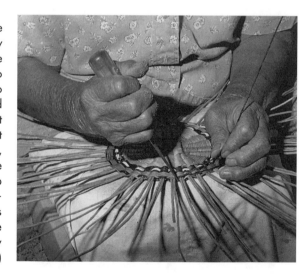

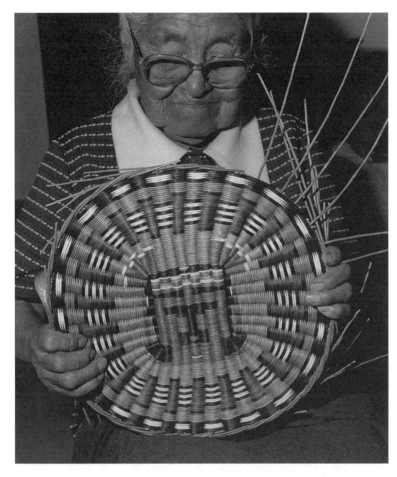

Abigail Kaursgowva holds one of her beautiful plaques with a Katsina face in the center. She is ready to prepare the rim for coiling. From each warp element, only one stem is retained; the others are broken off. The remaining siwi stems are bent to the left and loosely tucked under each other, then coiled and held securely with a yucca splint, which is usually dyed black. (1992; ASM no. 86479)

On August 13, 1991, Bessie Monongye and her sister Treva Burton took me with them on a trip to collect siwi and siváapi. It was a beautiful day, sunny and not too hot, with a light breeze making it comfortable to be outdoors in midday. Both plants grow wild beside roads and in fields. The freshly grown siwi stems are straight and are longer than those of the siváapi. Around August, the bushes start to bloom, opening their small, clustered blossoms of pale yellow. Below the blossom, feathery green leaves grow halfway down the slender stem. The blossoms signal the right time for picking, but as Treva showed me, another sign is that the coloring of the stem has turned from reddish brown to a silvery gray. The color starts at the bottom of the stem, and it has to be at least two-thirds up the stem before it is time to pick the siwi. It takes the experience of the Hopi basket weaver to see this.

Both women were very selective in their search for stems with the right thickness and length. They also have to be very straight.

Siwi is considered a shrub because of its many stems growing from the sandy soil. They grow in clusters, but it is hard to say where one plant ends and the next begins. Siwi can grow five feet tall, and, I was told, the thicker stems were once used as the rings in plaited sifter baskets. Sometimes the wood is burned and the ashes used in dough for blue corn piiki. Bessie and Treva used knives to cut the stems. After collecting several armfuls, they placed them on large sheets, which are then rolled up and carried over the shoulders.

The collecting continued. We walked past cornfields where long lines of large, green, healthy-looking cornstalks receded into the distance. The sun glistened on the long, pointed leaves, which seemed to dance in the breeze. Hopi poetry about the Corn-maidens came to mind, but I had to listen to Bessie and Treva, who were pointing out the siváapi bushes to me. Dyed siváapi is

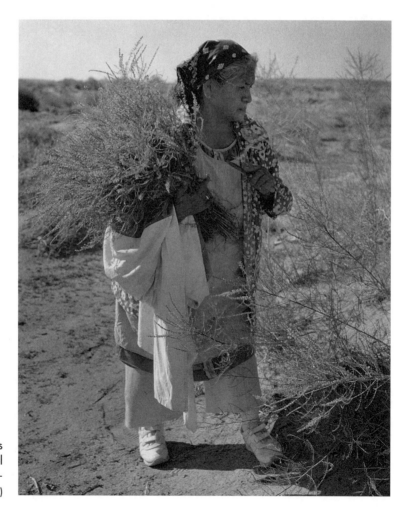

Bessie Monongye collects siwi, the warp material used in Hopi wicker weaving. (1991; ASM no. 85842)

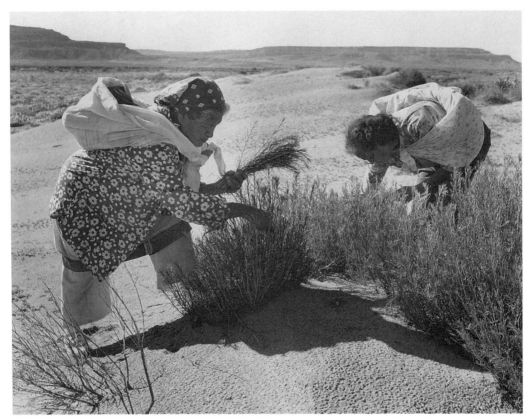

used for the weft material in wicker weaving, passing over and
under the siwi stems to create the beautiful colored designs in
wicker plaques and baskets. Like siwi, siváapi is a shrub, but it is
smaller, with stems and leaves of a silvery green. Both siwi and
siváapi often grow in close proximity to each other. The right
time to collect siváapi is when the stems in the whole plant are
standing straight and the top with the largest amount of leaves
does not sag. This occurs at about the same time that the siwi is
turning silvery gray.

Bessie Monongye and her
sister Treva Burton, both
from Oraibi, collect
siváapi, the weft material
used in Hopi wicker weav-
ing. (1991; ASM no. 85856)

Bessie and Treva used their sharp knives to cut the siváapi stems
that suited them best. I tried to cut some too, bringing my small
bounty to my friends, who, a bit hesitantly at first, told me that I
cut stems that were too thick to be good for making plaques. In
the refined art of Hopi wicker weaving, a weft has to be thinner
than the warp so that the warp will disappear. I learned that the
aesthetic awareness of the Hopi basket weaver starts at the point
of collecting of plant material.

A small number of thicker siváapi stems can be used for certain
items, however, such as deep baskets. Bessie and Treva told me

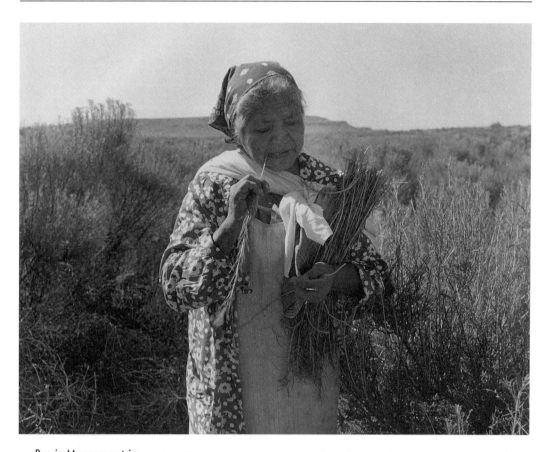

Bessie Monongye strips the leaves off the siváapi, holding the end of the stem with her teeth. (1991; ASM no. 85855)

that from August to early October is the best time to collect siváapi because during this time the outer peel on the stems, together with the leaves, can be stripped off more easily in one swoop. Both of them demonstrated how this is done. They loosened the peel at the bottom of the stem with a fingernail, then, holding this lower part with their teeth, they stripped off the peel and leaves with one quick downward pull. If siváapi is not cleaned right away, or is collected later than October, the outer peel gets too hard and has to be removed with a knife.

On that day we gathered siwi and siváapi for about two hours, and both Bessie and Treva brought large bundles back home. Siwi is collected in great quantity between August and October to be stored for future use. Its leaves have to be stripped off before storing. The stems have a tendency to dry out fast, and if not used right away, will have to be soaked in water for three to four days or buried in wet sand for a week before being used for weaving.

Freshly cut siváapi stems with their skins peeled off are light green. To bleach them lighter, the weavers spread them out under the sun, turning them frequently. Should it threaten to rain,

they bring them inside. When the siváapi stems have turned to a pale beige, they have bleached long enough and are in the best condition to take the dye colors. Most of the wicker weavers today use aniline dyes, which give them saturated colors in great varieties. Only a few in Oraibi and Hotevilla still use vegetal dyes, producing plaques and baskets that have the subdued elegance of pastel colors.

The day I spent with Bessie and Treva reaffirmed my sense of closeness to the Earth because by the end of the day I knew more about the plants around me and could recognize them in their natural surroundings. Later I could admire them in their artistic transformation as a plaque or a basket. The intimate knowledge of the plants Bessie and Treva gathered spoke of the bond with the Earth which is so prevalent and so important among Hopi women.

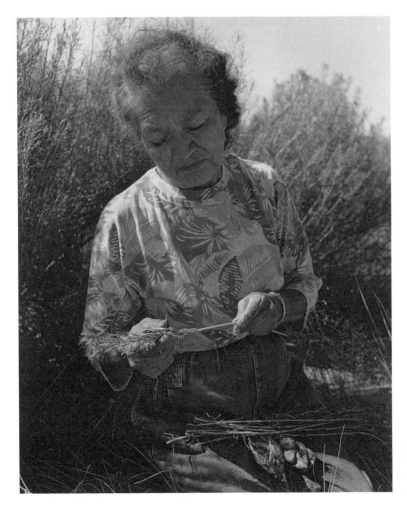

As an alternative, Treva Burton strips the leaves off siváapi stems with a knife. (1991; ASM no. 85869)

Siváapi stems, cleaned of
their leaves, are spread
out in the sun to bleach.
(1991; ASM no. 86025)

Dyeing Siváapi

Siváapi is an interesting plant, for several reasons. First and most
important, the whole plant except the roots can be used in basket
weaving. Second, nature created two varieties of this plant that are
so close to each other in appearance that it is easy to be fooled.
Only one variety is suitable for wicker weaving, but the blossoms
and peels of the other kind can also be used for dyeing the stems
of the proper variety.

Once I fell victim to this "fooling." On my trips to the Hopi
Mesas I usually stay in a little motel in Keams Canyon to make
my travel funds last longer. In July 1993 I ventured into the can-
yon proper to see if any siváapi grew there. I was still trying to
shed light on the obscure history of wicker basketry among the
Hopis, and I reasoned that if siváapi grows around First Mesa, it
must have grown there also a hundred or two hundred years ago.
But as far back as people could remember, wicker plaques had
not been made on First Mesa. I did find siváapi in Keams Can-
yon, growing along the wash in large groups of tall plants. It was
blooming brilliantly in yellow umbels, making a spectacular dis-
play. I made close-up photographs of the blossoms and also pho-
tographed the plants as a whole. I noticed that some clusters
looked a darker green, but I seemed to remember from two years
ago that siváapi plants were light green. I cut two handfuls of

the long stems, leaving the blossoms on them because I knew that the women of Third Mesa use the blossoms for dyeing the yellow color.

An hour later I was back in Hotevilla to continue my visit with Eva Honyungva, a great lady of wisdom and knowledge. Her relative from Oraibi and my friend, Bessie Monongye, was in Eva's house too, visiting for the Home dance. I brought my gift of siváapi to both of them, waiting like a child for their approval that I had brought the right thing. They looked at it and no approval came from their lips. Then Bessie said, "It looks alright, but it blooms too early!" She smelled it. "It does not smell right." There are two kinds of siváapi, she said; one is gray and the other is green. The ladies from Third Mesa collect only the green siváapi because it does not break, and it blooms no earlier than September or October.

Bessie stripped the peel off one stem and bent it around her finger. Sure enough, the stem broke every time she bent it. I think Eva sensed my disappointment at having brought them worthless siváapi. She said she would look at it in the daylight the next morning. Hotevilla has no electricity; the lightbulbs in their houses are powered by solar panels, which provide only a dim light. It was getting to be late afternoon, and we all left for the plaza to attend the last dance of the Home dance and bid farewell to the Katsinam.

The next morning when I came to Eva's home, the freshly stripped off peels and blossoms from the siváapi were laying on the floor, the stems discarded. Eva intended to use the peels and flowers for making her yellow dye at a later date. Meanwhile she would dry them. At least my harvest could be used for something!

Later on, when I talked to Dora Tawahongva, she too mentioned the two kinds of siváapi and said that the gray one is not suitable for weaving. Dora is one of the few wicker basket weavers in Hotevilla who still use vegetal dyes. Her artistry is admired by the other basket weavers and is collected. Her work is recognized as outstanding in execution and in the beauty of its design and form.

There are some variations in how the individual weavers use the plants in their dyeing process. For red, those who use vegetal dyes use siita and smoke it. Others use only hohoisi. They boil it and the siváapi for a very long time and usually do not smoke it, though I know of one who does. For orange, some use the hohoisi plant and blossom, boiled and smoked. For yellow, some use

siváapi blossoms, which are collected in October and November and then boiled and smoked. For green, some use the yellow dye from the siváapi blossoms, to which they add some indigo. Others use only *maa'óvi* (snakeweed). For blue, some weavers use indigo, which they purchase, or a mineral called *sakwa* (azurite).

For white, the color (called *qötstsöqa*) is achieved by soaking the siváapi in kaolin, a white clay that was once used as a base coat on plaques (as described in the appendix) and is now used for kachina dolls as a whitewash (*tuuma*) underneath the other colors. Some basket weavers add white latex paint to the whitewash so that it will not flake off as easily. The white clay is found below the mesas in areas known only to Hopis.

For black, *a'qaw'u* (sunflower seeds) were formerly used, but sunflowers are not grown anymore. All the weavers now use commercial aniline dye for the black color.

Siváapi stems collected during late fall and winter yield the whitest stems, which are favored for the material that will be whitewashed to obtain the white color. If they want to collect the siváapi blossoms for dyeing, Third Mesa women have to watch the weather closely. Frost can come early to the Hopi Mesas, and it will kill the blossoms. In November 1991 I had arranged with Treva Burton to photograph the process she uses to dye materials with vegetal dyes, but because of an early frost she could not collect the siváapi blossoms. Also, even though she had enough ho-

After being soaked in kaolin (white clay) to dye them white, the siváapi are spread out on a sunlit floor to dry. (1992; ASM no. 87115)

hoisi on hand for her orange color, the early winter cold that year prevented us from making a photographic documentation because the time-consuming smoking process has to be done outside.

Considering the rather complex tasks involved in working with natural plant dyes, it is perhaps little wonder that Hopi women have switched to aniline dyes to achieve their colorful palette for wicker weaving. It is, however, regrettable that their knowledge of the rich resources available in their plant world will be lost in the foreseeable future, as only a few women still possess it.

Leora Kayquoptewa of Hotevilla allowed me to photograph her while she was using aniline dyes in her dyeing process. Following the directions on the package, she first dissolved the dye powder in the right amount of water and heated the liquid to boiling on the stove. Then she put a bundle of cleaned and bleached siváapi stems loosely into the solution. She used a scarlet red dye, and her pan was large enough to accommodate the length of the siváapi. Leora held a wooden stick in each hand to keep the siváapi submerged in the boiling dye. It took only a few minutes for the desired shade of color to be reached, and Leora then grabbed all the siváapi with her sticks, let them briefly drip off into the pan, and then laid them on newspaper on her kitchen table for drying. She dyed three bundles this way but probably could have done five if she had had enough siváapi. All this took only about thirty minutes—only a fraction of the time it would have taken to dye with vegetal dyes. Such dyes have to boil for at least an hour to prepare the dye and then another forty minutes (or possibly much longer, depending on the color desired) to dye each bundle. Then additional time and work are required to smoke the siváapi in order to set the desired shade of color.

While siwi and siváapi are used for weaving wicker plaques and occasionally a wicker tray or deep basket, the wicker technique is also used for traditional basketry items, like burden baskets, which are carried on the back; for the border of piiki trays; and for the bed and headband of baby cradles. For these, the branches of scrub sumac are usually still used. Scrub sumac is a bush with small leaves grouped in threes and is therefore called three-leaf sumac. It grows on steep, rocky slopes of the mesas, particularly Second and Third Mesas. It is difficult to obtain because it requires the collector to climb around and over big boulders to get to branches suitable for basket weaving. The best time for cutting it is in October and November. It can be collected after Niman, but in

Leora Kayquoptewa of Hotevilla uses wooden sticks to submerge the siváapi in boiling aniline dye. (1992; ASM no. 87200)

Later she spreads the dyed siváapi onto newspaper to dry. (1992; ASM no. 87197)

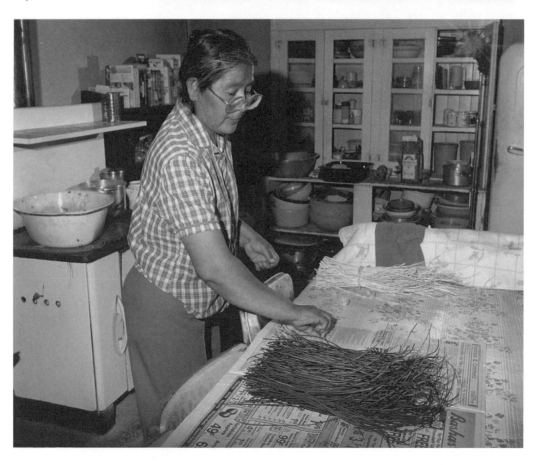

August the new shoots are usually still too short. Only the fresh branches that have grown within the past year are straight enough for basketry material. Once the branches become older, they loose their juices and shrivel, bending and twisting into a state that makes them useless for basketry. One weaver told me that she cuts the branches of the plants she collects right down to the ground, or even burns the bushes, to guarantee a new growth of straight branches the next year.

Until recently one could read that scrub sumac is also used as the warp material in wicker plaques and baskets, but I know that at least today siwi is used instead. Perhaps there was a misunderstanding almost a hundred years ago when researchers tried to write down the Hopi word for sumac. Otis T. Mason, in his re-

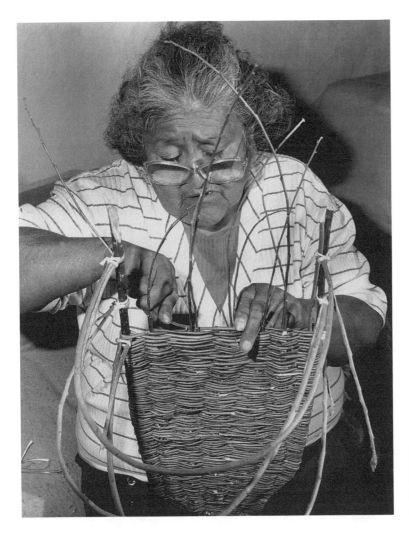

Evelyn Seletstewa of Mishongnovi on Second Mesa uses scrub sumac branches to weave baby cradles. (1993)

port for the U.S. National Museum at the Smithsonian in 1902, gives the Hopi name for *Rhus trilobata* (sumac) as "*Si'ibi.*" He heard the Hopi word correctly, although according to Emory Sekaquaptewa the correct spelling is "siwi." In any case, the plant was misidentified: the Hopi name for scrub sumac is *suuvi*. (To avoid perpetuating the confusion, the English term *sumac* is used throughout the book instead of the Hopi term *suuvi*.) The thin branches of the two plants look very similar, and they both turn from red-brown to gray, which is the proper sign to collect them. Another sign for sumac is the seeds turning red. Then it is the right time to go to the cliffs and cut the branches. In earlier times, sumac berries were also gathered and used as a mordant in dyes.

Only a very few women on Second and Third Mesa still make cradles, burden baskets, and piiki trays. I heard of an occasional piiki tray being made on First Mesa, but none of the other sumac items are made there anymore. It is said that at one time burden

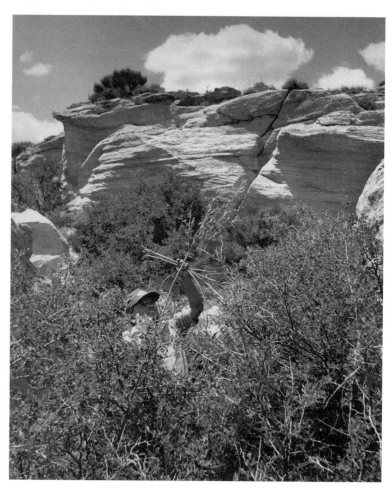

Ivan Seletstewa collects scrub sumac branches for his wife, Evelyn, on the cliffs of Second Mesa. (1993)

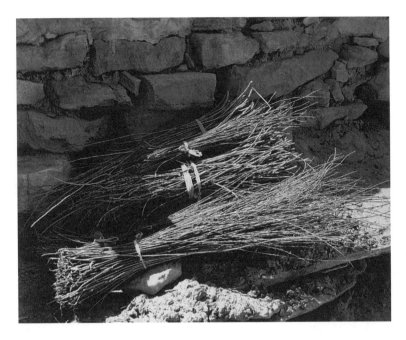

Two bundles of scrub sumac (top) and two bundles of *qahavi* (arroyo willow) outside Evelyn's house in Mishongnovi. (1993)

baskets were made by men. Unfortunately, I have not found a man who makes them, possibly because they are not needed anymore. Of the few ladies who have the skill to make these basketry items, only one or two collect sumac themselves. The others ask their husbands to climb the cliffs and get it for them.

On two occasions I went with Ivan Seletstewa of Mishong-novi, whose wife, Evelyn, makes cradles and burden baskets for initiations. On our first collecting trip, we went to the cliff north-east of Shipaulovi, where I was amazed at how difficult it was to find the right branches. The second time Ivan went to a location with easier access. A few years ago Polacca High School built ter-races to retain the soil on a steep slope between the school build-ing and the lower athletic court. Scrub sumac bushes now grow on the narrow terraced steps. Perhaps the school planted them there, or perhaps nature seeded them, having basket weavers in mind. The branches have so much sap that when we were cutting them my knife became dull in five minutes, and my hands were badly scratched by the gnarled older branches, which seemed to want to protect their younger offspring.

Sumac branches are stripped of their foliage just after they are cut. Further preparation is not needed for basketry. However, once they are dried, the branches have to be soaked in water for three or four days before they can be used for weaving.

The Forms and Functions of Hopi Basketry

Considered to be one of humanity's oldest crafts, basketry pre-dates pottery making in North America. From its beginnings, basketry items served as containers for seeds, leaves, and grasses used as food, for medicinal purposes, or for the manufacture of utensils. Bags made of pliable fibers comprised one of the early forms of basketry. The tray or shallow bowl is a form that reaches back into antiquity.

With the invention of pottery, either pottery bowls and trays were suggested by pre-existing basketry or, conversely, forms of pottery, particularly the jar, influenced basketry. Before the advent of pottery making, tightly coiled basketry trays and shallow bowls were used for cooking food, using hot stones dropped into the cooking water to make it boil. This function continued well into the time of early pottery production.

Like any item produced by humans, basketry forms changed, new forms were added and old ones either fell into disuse or were perpetuated over the centuries, depending on the needs and preferences of their makers and the requirements of the people who used them. Hopi basketry still exists in a symbiosis of function and form, a fact this chapter attempts to explore.

PLAQUES

The flat, perfectly round basket tray, commonly called a plaque because of its almost flat shape (in Hopi it is called a *poota* on Second Mesa and a *yungyapu* on Third Mesa), constitutes the most common form of Hopi basketry. In Second and Third Mesa villages, plaques are now made continuously throughout the year. Many are made for sales purposes, and an astonishing number of them enter the non-Hopi market.

However, an even greater number of plaques never leave the reservation, because within the Hopi social structure plaques serve to reaffirm the links between families and clan members.

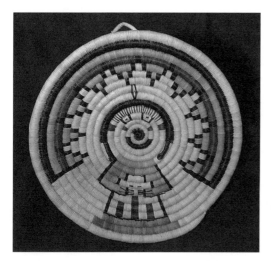 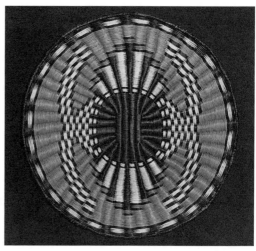

Examples of Hopi plaques. On the left is a coiled plaque with the image of Hahay'i wuuti (Katsina Mother) under a rainbow and rain cloud design. On the right is a large wicker plaque made by Abigail Kaursgowva of Hotevilla in November 1992. Abigail calls the design "Katsina feather shield on their back." (Left: 12.25" in diameter, made by an unknown maker in the early 1990s; photographed at the Hopi Guild on Second Mesa, in 1992; ASM no. 87184. Right: 16" in diameter; photographed in 1992; ASM no. 87111)

Thus, plaques play an important role in "paybacks" for a Hopi bride's wedding robes, and the required number seems to increase every year. Plaques are also given as gifts to repay favors or work performed by the receiver and as prizes to winners of footraces. Finally, they have symbolic meaning for newborn babies, toddlers, and small girls; they are specially made for use in kiva ceremonies and rituals; and, perhaps most of all, plaques are proudly and reverently displayed in basket dances of the women's societies.

The more I learned about Hopi weavers and their work, the more I became aware of the importance of basketry in Hopi life. Far from being a strictly utilitarian object, their function penetrates deeply into the social interactions of clan and tribal members. My observations are only glimpses into the complicated and multilayered social traditions of Hopi society. Many of the detailed facts and meanings of plaques and other forms of Hopi basketry remain unknown to me. My account and my photographs can only report and show what I was told and shown by the Hopi basket weavers whom I interviewed and who befriended me.

Many of the plaques made on Second and Third Mesa are not for sale, as they are made for obligatory paybacks among Hopi families and clan relatives for favors or work done. For instance, the ties between an aunt and her nephew are strong. In times past, and sometimes today, a nephew would bring his aunt meat from a hunt so that she would have food in the house. Today he more commonly brings her meat or groceries from the market. She repays him with a plaque equal in size to the value of the food. The boy, or young man, can do with the plaque as he pleases. He

may keep it and hang it in his home, give it to his mother so that she will have a plaque handy should she need one for a payback, or he might give it to one of his unmarried sisters to use in social dances. She, in turn, might need this plaque to pay back a favor to the boy with whom she has danced in a social dance. The nephew can also use the plaque as a gift to someone else, or he can sell it for money.

The strong relationship between aunt and nephew is particularly expressed at the basket dances of the two women's societies, Lalkont and O'waqölt. At the end of the dance day, when all dances are finished and all the gifts have been showered on the people, many of the women give the plaque they danced with to their nephews. These are their best plaques in terms of weaving technique and design.

The winners of footraces, which are often associated with ceremonies, are the recipients of plaques. These coveted prizes are literally "run after," with the first winner receiving the largest and most beautifully decorated plaque and the next three runners each receiving ever smaller plaques.

Plaques of a special size and decoration are given as gifts to newborn babies by the grandparents of the baby. At Powamuya (Bean dance) and other Katsinam ceremonies, Katsinam also bring small plaques, so-called baby plaques, to infant girls and boys on Second Mesa but only to little girls on Third Mesa. When the children are older than two, only girls receive these small plaques. Plaques given as gifts increase in size as the girl grows, and by the time the girl is old enough to be initiated into the Katsina society between the ages of eight and eleven, the plaque she receives from the Katsina is twelve to fifteen inches in diameter. After initiation she does not receive any more plaques. Plaques also are given as regular gifts at birthdays or to good friends to make them happy. I have received wicker plaques from some of my friends over the years and, of course, treasure them.

By far the most important compensatory giving of plaques is the wedding payback. After the wedding robes for the bride have been delivered to the bride by her in-laws, the bride and her family reciprocate with a substantial payback of plaques and foodstuffs.

When a young Hopi man and woman agree to marry, the groom's family delivers gifts to the bride's family in the form of sacks of flour, meat, groceries, and shawls and blankets. After the wedding ceremony has been performed, the bride lives with her

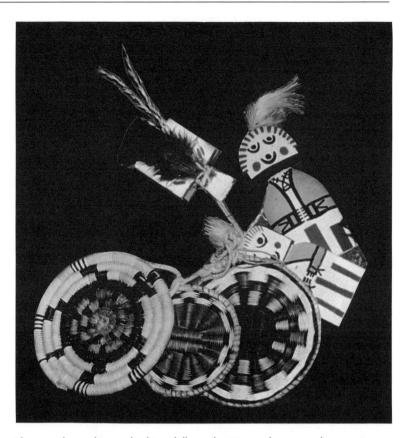

These newborn plaques, kachina dolls, and miniature dance wands were given
to a newborn baby girl by the Katsinam at the Powamuya ceremony on Second
Mesa in February 1994. The newborn wicker plaque (*yungyaphoya*) at right
has the sunflower design, which is the traditional design for the first plaque
given to a newborn girl on Third Mesa. The plaque was made by the girl's pa-
ternal grandmother from Third Mesa. The additional smaller wicker plaque and
the coiled plaque with a turtle design were made by aunts from Third and Sec-
ond Mesa, respectively.

The first plaque for a newborn baby on Second Mesa is a small coiled
plaque (*ngöla*) with simple designs of either clouds, a flower, a turtle, or a deer
woven in the three "natural" colors: white, green, and black. Often the rim coil
of a newborn coiled plaque is not finished. The flat kachina dolls (*putsqatithu*)
represent the earliest stage of fetal development and are traditionally given to
newborn babies. Represented is the Hahay'i wuuti (Katsina Mother). Larger
dance wands are used by women in their society dances.

in-laws. The male relatives of her husband now start to weave her
wedding outfit. The robes are woven of cotton on upright looms.
Since the men also have daily obligations of farming, wood haul-
ing, ranching, and possibly ceremonial preparations, the weaving
can take weeks or even months. The bride has to cook for the
men during all this time. If children are born meanwhile, they

too have special robes woven for them—a white cotton shawl for a girl and a dark brown and white checkered kilt for the boy, plus moccasins for both. The bride receives a large white shawl with large tassels on the corners that have symbolic significance, a smaller white robe that she carries in a specially made case of rolled up reeds, a white wedding sash, and white moccasins. Only when she has received all these robes and items is the wedding completed. Then she is presented by her husband's family in her wedding outfit to the assembled people and Katsinam in the plaza at the next Home dance, the end of the Niman ceremony and the end of the yearly cycle of Katsinam ceremonies.

The wedding payback has to be done as soon as possible after receiving the wedding outfit. Now it is the bride's family's obligation to pay back to the groom's family, and in particular the male members who made the wedding outfit. The time it takes for a bride to pay back her husband's family depends largely on how much help a young woman gets from her sisters and her mother in making the many plaques. I have talked to mothers who have

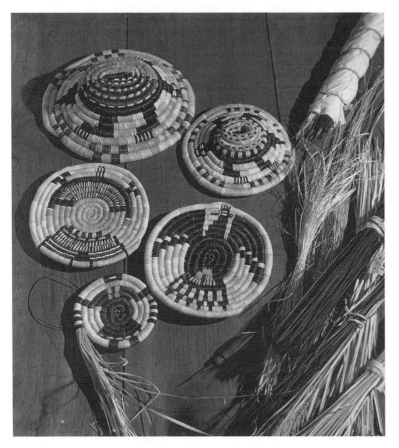

On Second Mesa coiled baby plaques (ngöla), which are from four to five inches in diameter, are given by the Katsinam to babies and toddlers after they receive their newborn plaques. Unlike the newborn plaques, the rim is always finished. Today weavers can create more elaborate designs using more colors than they could in earlier years. All five plaques shown here were made by Martha Leban of Shungopovi in 1992. (ASM no. 86509)

spent years weaving plaques for the various wedding paybacks of their daughters. If she has to do it all by herself, a mother may still be working on her payback when she is middle-aged and her children are all grown. Divorces also can delay a payback because often a plaque earmarked for the payback has to be sold for urgently needed cash. This is the most common reason for prolonging a payback. Thus, often years pass by before this extensive and expensive ritual of compensatory gift giving is fully accomplished.

It is left to the bride's discretion as to how many plaques she makes for the payback. Usually the amount is balanced against the goods she received at her wedding, including her wedding robes. Every Hopi is aware of the approximate value of a plaque compared to a shawl, a blanket, or a certain amount of food. According to many Hopis I spoke with, the amount of goods delivered in a payback has seemed to increase in recent years. Some women said that people appear to be in competition with each other in making the paybacks ever more generous. Frieda Hoyhoeoma of Shipaulovi told me that when she was married about thirty-five years ago, she was given six or eight plaited sifter baskets filled with groceries, fifty sacks of flour, and four fringed shawls. In return, she made twenty-three plaques for her payback. When one of her daughters married six years ago, she received a larger number of gifts from her husband's family and paid back with thirty-five plaques. Frieda said that it is quite common today for a bride to receive hundreds of sacks of flour and up to forty shawls and fifty blankets. The payback has to be correspondingly large.

On Third Mesa I was told that wedding paybacks now include up to a hundred wicker plaques, several new garbage cans filled with blue and white ground cornmeal, fifty to a hundred sacks of wheat flour, and many cakes and pies, as well as large amounts of piiki and numerous pots and pans. I never had the chance to witness the delivery of all the goods to the house of the groom's mother, but years ago while I was visiting the family of a kachina-doll carver in Shungopovi, a delivery of several laundry baskets and tubs heaped high with piiki was made as part of a payback. Because of the large amounts involved in paybacks, the delivery is done in stages. At other times I saw cans of cornmeal and sacks of wheat flour stacked up, ready for delivery. It was an amazing sight. Two years ago I was looking for Frieda's sister Rita in Shipaulovi and was asked to come inside her house. In the kitchen, women were busy preparing stews and other festive

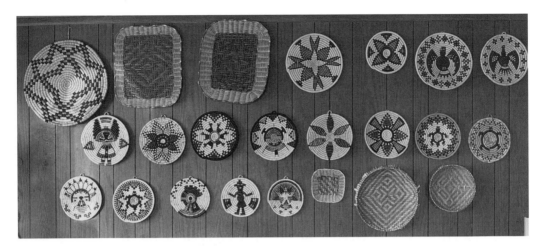

foods to feed the groom's family, who were to arrive shortly. I did not know that Rita was preparing for one of her daughter's paybacks. I found Rita in the adjacent living room, where the longest wall was hung with three long rows of coiled plaques, each more beautiful than the last. It was the first time I had seen such a marvelous display, and I was overwhelmed. There must have been at least eighty coiled plaques on that wall. A long table in front of the wall was set for the meal, and the first guests arrived. It was not the right time for photography, as wonderful as it would have been for my documentation.

A wedding payback display of coiled plaques, piiki trays, and plaited sifter baskets in the house of Pearl Nuvangyaoma of Second Mesa. (1992; ASM no. 86213)

Many months later, Rita's and Frieda's third sister, Pearl Nuvangyaoma, allowed me to photograph the payback plaques displayed on a wall in her house. This was the payback for one of her daughters who had been married for many years, and the payback was a great relief for both mother and daughter. Customarily, plaques for a wedding payback are displayed in the bride's mother's house for the groom's family to admire. The guests are welcomed with a warm meal while they sit under the display of plaques. The next day the payback goods are delivered to the groom's mother, who distributes plaques and food to the male relatives who wove the bride's robes and contributed the gifts for the bride.

Three basketry items in the payback are mandatory. One is the so-called wedding plaque, which is the largest plaque in the group and which belongs to the groom for the rest of his life. This wedding plaque is delivered heaped high with white cornmeal. A somewhat smaller plaque with a similar design is filled with sweet cornmeal and is therefore called a sweet cornmeal plaque. The third item is a piiki tray loaded with piiki. The rest

This beautiful coiled wedding plaque (*qötsa'inpi*) was made by Joyce Ann Saufkie of Shungopovi in April 1992. The star, or flower, design continues into the rim coil, and the colors are restricted to white, green, and black. It is important that the rim coil not be finished, thereby exposing the bundle foundation material, galleta grass, at the end. On this plaque, white cornmeal would be piled high and carried to the groom's mother on payback day. The plaque belongs to the groom, and he keeps it for the rest of his life. (ASM no. 86655)

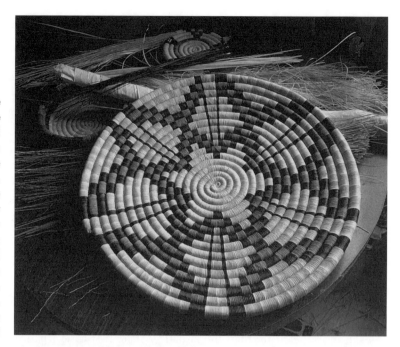

This sweet-corn plaque (*tos'inpi*) was made by Edith Longhoma of Shungopovi. The sweet-corn plaque is another requirement of the wedding payback and is heaped with sweet (yellow) cornmeal on the day of the payback and carried to the groom's mother's house. This plaque, like the wedding plaque, has a flower, or star, design in the restricted colors of white, green, and black. But it is a smaller plaque, its design does not continue into the rim coil, and the rim coil is coiled with yucca splints to its very end. Whoever receives this plaque in the groom's family can do with it as he pleases, including selling it. (Photographed at the Hopi Craftsman's Exhibition, Museum of Northern Arizona, Flagstaff, June 1993)

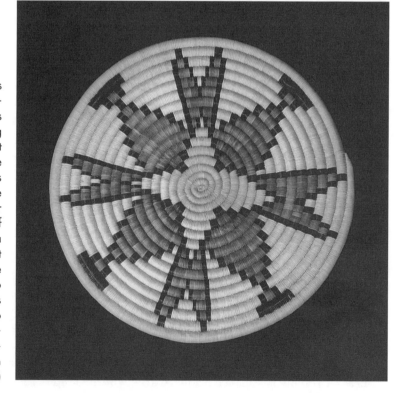

A piiki tray (*pik'inpi*) by an unknown basket weaver. The piiki tray is the third required basketry item in a wedding payback. (Photographed at the Hopi Craftsman's Exhibition in 1993)

of the plaques can be of any number, size, and decoration. Usually a couple of plaited sifter baskets are added and sometimes also a sifter or tray for parched corn.

TRAYS

The flat form of the plaque is at least several hundred years old, based on the archaeological discoveries at Canyon Creek Ruin dating from the early fourteenth century. But the slightly deeper tray form reaches even further into the past. The tray form makes a receptacle that is perfect for holding fruit, gathered foodstuffs, and foods that are ready to eat. The plaited yucca sifter basket is probably one of the oldest basketry forms in the Southwest. Its use stretches back to Basketmaker II times (ca. A.D. 200–500), and over all the centuries it has been made of the same material: yucca leaves. Plaited fragments have been found at numerous archaeological sites where the plaiting technique was used to make mats and baskets. We know that plaited yucca sifter baskets served the Mogollon, the Hohokam, and the Anasazi. Today, Hopi yucca sifter baskets come in all sizes, from a few inches to more than twenty inches in diameter. Most are round, but some are oval or square in shape. Today, in both the coiled and wicker techniques, the tray form is used less than it was years ago. Modern utility wares have taken over many functions of the tray except in its

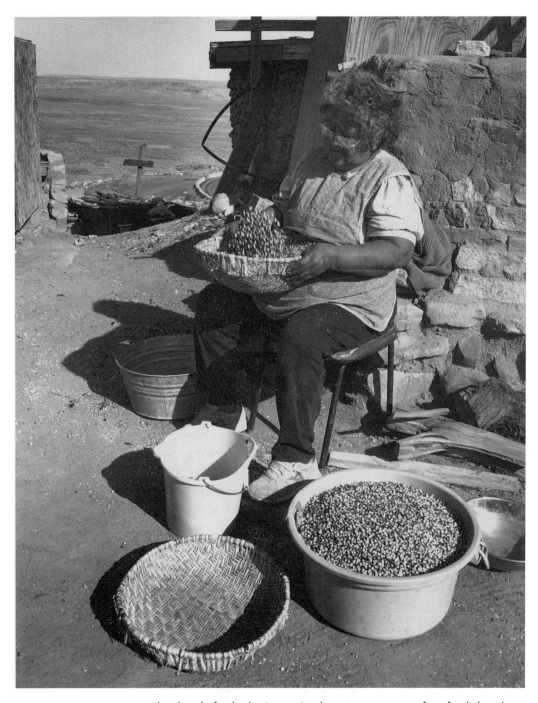

The plaited sifter basket (*tutsaya*) is the most common tray form for daily tasks.
Evelyn Seletstewa of Mishongnovi uses two large sifter baskets to winnow husk
debris from shelled corn. (1994)

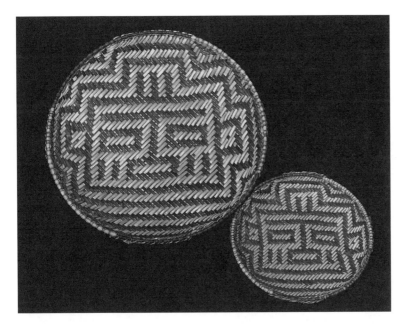

Two sifter baskets with Mudhead Katsina faces, created by Kevin Navasie of First Mesa with red-dyed yucca leaves. (Photographed at McGees Indian Art Gallery, Keams Canyon, 1994)

plaited form. The plaited sifter basket, however, has a perfect tray form, and today it is still the most common utilitarian basket used by the Hopis.

By splitting the yucca leaf, the weaver has two colors to work with—the green outer side of the split leaf and the almost white color of the inside. By using both plaiting elements she can produce a twill, or diagonal, weave. Often weavers use beautiful diamond patterns and variations thereof to create astonishing designs.

Plaited sifter baskets (also called ring baskets) are used every day in Hopi households. They serve to hold all kinds of food: peaches, apples, ears of corn and shelled corn, brown beans, white beans, lima beans, wild spinach, and other wild foods. Sometimes sifters are made in a loose weave to be used according to their name: for winnowing corn and beans and for sifting out dirt or husk debris. All in all, the plaited sifter basket is the workhorse among Hopi baskets.

Some basket weavers create patterns incorporating dyed yucca leaves, and in so doing they achieve stunning geometric designs or very stylistically sophisticated Katsina faces. These colorful plaited sifter baskets are used as gifts, are sometimes submitted to juried shows, or are used in the basket dance by young girls who have not yet mastered the art of making coiled or wicker plaques. Plaited sifter baskets are still made by most women of all three

Hopi Mesas, including the villages of First Mesa. On First Mesa, however, they are only made for wedding paybacks and before special dances, mainly the O'waqölt basket dance.

DEEP BASKET FORMS

The deep-basket form must have been known to the Hopis for a long time. Since a basket is basically a container, mostly for food, it stands to reason that Hopi basket weavers must have made large, deep baskets to hold food for storage during the many months between harvests.

I was told by Jerri Lomakema of Shungopovi that, as a youth, her grandmother saw large, deep coiled baskets used as storage jars in an old house in Mishongnovi. First metal and now plastic containers have long since replaced baskets for the purpose of food storage, however, particularly for beans and seeds.

At one time, coiled basketry was produced on all three mesas, and due to its tight weave compared to wicker, one could assume

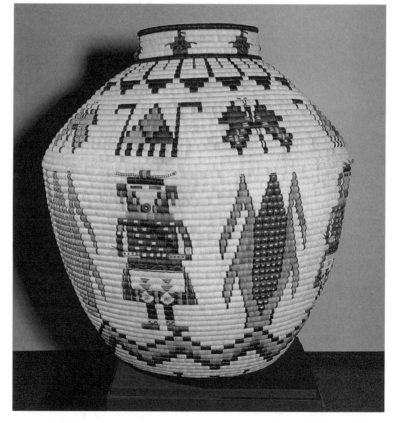

A large, deep coiled basket (*wukopotasivu*) by Joyce Ann Saufkie. It took Joyce two years to weave this beautiful basket, which is decorated with images of four Ka'e Katsinam and four ears of corn, four butterflies, four rain clouds, and on the neck, six Mudhead Katsina faces. Joyce sold the basket to Dan Garland, owner of Garland's Navajo Rugs in Sedona, Arizona, in 1990. Dan entered the basket in the Hopi Craftsman's Exhibition at the Museum of Northern Arizona in Flagstaff the same year, and it won the Best of Show award. (Height: 22$\frac{1}{4}$″, width: 20″; 1990; ASM no. 84215)

that coiled basketry storage jars or deep baskets were used by the Hopis in all villages besides Second Mesa in addition to pottery storage jars. Deep wicker baskets may also have been used for this purpose.

With the introduction of trading posts in northern Arizona, and with the availability of metal, wood, glass, and stoneware jars in addition to boxes, barrels, and tubs that were more impermeable to rodents and insects, storage baskets probably were used less and less. However, the knowledge of making such baskets certainly did not fade. A transition in function occurred during the latter part of the nineteenth century when Hopi basket weavers began to purchase more Anglo kitchenware and started to sell their basketry to the newcomers. In the process, the basket weavers started to make forms that were more familiar to, and that fit the needs of, Anglo society. Soon they were making coiled and wicker baskets in the form of wastebaskets, which collectors and traders readily bought for just that purpose. This is a totally un-Hopi form, but it was produced for decades in an astonishing quantity and with increasingly colorful and complicated designs.

Hopi weavers made medium-sized bowl- and jar-shaped baskets (particularly seed jars) around the turn of the twentieth century, as seen in photographs from that time and baskets in the collection of the Arizona State Museum. They are bulbous, with constriction toward the rim, and some had lids and carrying handles (see Tanner 1983). They are usually coiled, because this produces a tighter weave and is more suitable for carrying seeds to the fields. I have not seen this form being made for several years, and it has probably been replaced by metal and plastic containers. Weavers make similar shapes in coiled baskets, but they have a wider rim and no lid. They are occasionally made for the non-Hopi market.

Most coiled deep baskets made for collectors today are large, with walls curving outward and constricting toward the top. Sometimes they form a neck with a slightly flared rim. They are usually masterpieces of uniformity in weaving technique and overall design. Usually the design has two or three motifs each consisting of two elements opposite each other: two full kachina figures or their faces, cloud or lightning, or ears of corn. These large baskets are made only for the collector market, and they are produced by only a few of the Second Mesa basket weavers.

Even fewer wicker basket weavers still make large, deep bas-

kets. I am told that they are too difficult to make, and no more than seven or eight women still make them. I found five of them, one of whom is the oldest woman in Hotevilla. She is Vera Pooyouma, who is thought to be between 104 and 108 years old. In 1993 I photographed her with a deep wicker basket she was working on. Large wicker bowls are still made by some weavers, including Dora Tawahongva. Her beautifully executed bowls and plaques can be found in stores and galleries. The bowls made today are not as large as those made twenty years ago, however. At that time, Laura Coyouma, who lived below Oraibi, was the last basket weaver capable of making them. I photographed her in the early 1970s making such a large wicker bowl. Her lap was not big enough to hold the enormous shape. In contrast to large coiled baskets, which have figurative designs, large wicker baskets are decorated only with geometric designs. In wicker, Katsina figures and faces are reserved for plaques.

The large, deep form of Hopi coiled and wicker baskets (excluding the wicker burden basket) was produced in the late nineteenth century, more for the benefit of non-Hopi collectors than for utilitarian or ceremonial needs of the Hopis themselves. I have not seen such baskets in old photographs, and there are few references to them in written reports that clearly identify them as having been made by any pueblo peoples (see, for example, Mason 1904; Voth 1901, 1905; Fewkes 1892, 1899; and Stevenson 1884). Stevenson 1884 mentions large water jars that had been covered with pitch to make them watertight and that he had been told were made by Apaches. They do look like Apache artifacts in illustrations. A conversation I had with wicker basket weaver Allie Seletstewa of Hotevilla lends credence to the idea that deep baskets came to be made specifically for the non-Hopi market. Allie told me that in her youth one of the older ladies had made a large, deep wicker basket that she sold for a good price to a collector who came by. Seeing this form of basket as a profitable item that brought in more money than smaller baskets, she encouraged the other weavers to make such large baskets. On Second Mesa, weavers speak openly about the fact that large coiled baskets with Katsina figures and eagles can be sold for more money because they are especially sought by collectors. Large wicker baskets are faster to make than large coiled baskets. Few of the weavers can make more than one of the coiled baskets in a year, and for many weavers it takes more than a year to finish

such an enormous piece of art. Only a few women attempt to make them, and those who do make them for sale to collectors.

MINIATURE FORMS

On the opposite end of the size scale are miniature baskets, more of which are made today in the coiled technique than in wicker. This form presumably existed in prehistoric times, based on some very small wicker plaques excavated in pueblos of Kechipawan and Hawikuh, both in the vicinity of Zuni, New Mexico. In modern times, apparently stimulated by traders in the 1950s and 1960s (see Tanner 1983), basket weavers in Shungopovi tested their skills in finding out how small a coil they could weave and still maintain traditional form and design in a plaque or bowl

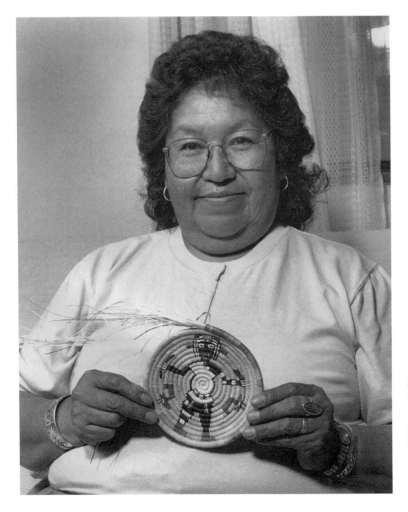

Madeleine Lamson of Shungopovi holds a miniature plaque (*potawya*) that depicts a full-figure Left-Handed Katsina with two deer. The rim coil is not yet finished. (1993; diameter: 5.5″)

shape. They produced precious little things, and this style has since found great favor among collectors.

Weavers of miniature coiled plaques and baskets have refined their technique to ever finer and smaller coils, retaining all the details found in designs of larger pieces. Only a few women make them, but their work is extraordinarily well done. The size of these miniatures ranges from three to four inches in diameter or height. They should not be confused with the small plaques of four to five inches in diameter that are made for newborn babies and toddlers. These usually have thicker coils than miniatures and are restricted in colors and designs. Miniature plaques can have any design, depending on the skill of the weaver.

TRADITIONAL UTILITARIAN FORMS

Foremost among the utilitarian forms is the plaited sifter basket made of yucca, which is described in the section on trays. Other utilitarian basketry forms used by the Hopis are made in the wicker technique or, like the piiki tray (*pik'inpi*), in a combination of plaited and wicker. Next to the sifter basket, the piiki tray is the most used basketry item today and functions to hold freshly made piiki either rolled up or as unrolled sheets used in certain ceremonies, such as initiations. Most piiki trays are about sixteen by twenty inches, which conforms to the size of a piiki sheet. The piiki sheet is itself somewhat smaller than the piiki stone on which cornmeal mush is thinly spread by a fast back-and-forth movement of the hand. The three-inch-thick piiki stone is heated by a piñon fire and becomes very hot. The thinly spread cornmeal dough bakes quickly, and when done the sheet is taken off, folded three times in each direction, and rolled up. Rolled-up piiki is about ten inches long, three inches wide, and an inch and a half high. A piiki tray can hold a pile of three or four dozen piiki rolls. On this tray, piiki is carried to the houses and kivas.

The center section of a piiki tray is plaited in one of several stepped designs. The material for the plaiting was traditionally scrub sumac (*suuvi*), but today it is often replaced by siwi (*Parryella filifolia*). The thinner branches of either material are used, preferably the longest ones, and they are often split down the middle. The outer side of the bark is darker than the inner side. Used alternately, the two colors add to the variation of the plaited design. The border is wound in the wicker technique,

using the plaiting elements as the warp elements in the wicker weave. Formerly, long, thin sumac or siwi twigs were used for the border weft elements. Though most basket weavers still use these twigs, finding the plants can be difficult, so some piiki tray makers now use commercial reed material instead. The material comes from China in large rolls and in a variety of thicknesses. The rim of the piiki tray is finished like all wicker basketry items: excess warp elements are broken off, but one twig is left in each element. It is bent to the left, together with previous ones bent in the same direction, and then coiled with a green yucca strip for the rim.

A parched-corn sifter looks like a wicker plaque that has been woven loosely and crudely and finished with a green yucca coiled rim. The beginning in the center is a loose weave of crossing elements and has no similarity to the neatly woven weft elements of regular wicker plaques. The sifter has no design and no color, because the material for the wefts is not siváapi but scrub sumac or siwi. A sifter is used to dip parched corn from a large pot filled with hot sand in which the corn is parched. The sifter serves as a

A roll of the commercial reed material used in some modern wicker basketry other than plaques. (1994)

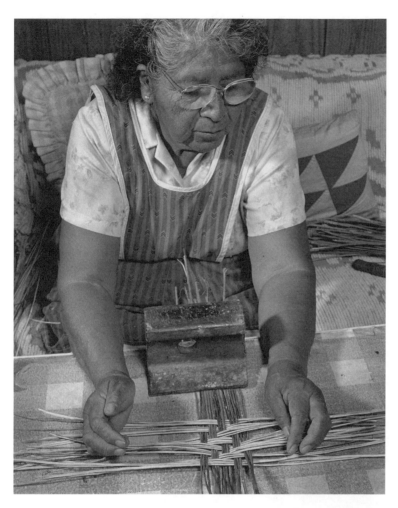

Pearl Nuvangyaoma starts
the plaiting of a piiki tray.
(1991; ASM no. 86108)

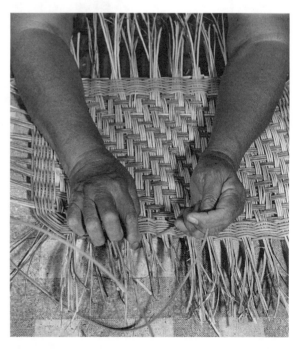

She uses the wicker technique in weaving the
border. (1991; ASM no. 86142)

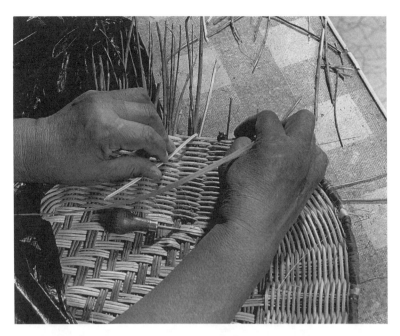

In making the rim of the piiki tray, she breaks off all the stems of the warp element except one, which she bends and incorporates into the coiled rim. (1991; ASM no. 86152)

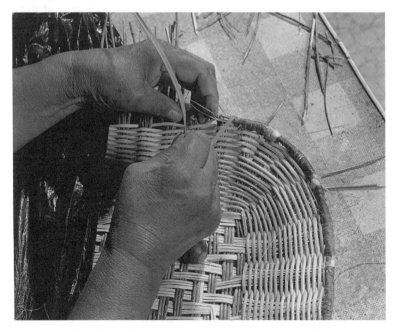

She finishes the piiki tray by coiling the bent-over warp stems with a green yucca splint. (1991; ASM no. 86151)

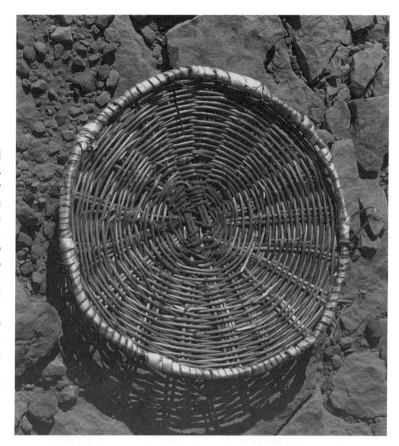

One of the traditional utilitarian basketry items is a parched-corn sifter (*tsayánpi*). Hopi women parch corn in hot sand in a kettle over hot coals. Sifters woven in a loose wicker weave are used to lift the parched corn from the kettle. The hot sand falls through the mesh. This sifter was made by Vera Pooyouma of Hotevilla in 1994. The warp and weft fibers are siwi (*Parryella filifolia*), and the rim is coiled with a green yucca splint. (1994; diameter: 8″)

large dipper and a sieve at the same time, because the sand passes through its loose weave.

BURDEN BASKETS

For many months I tried in vain to photograph someone who was making a burden basket and to gather detailed information on its manufacture. Four women said they still make burden baskets but only infrequently because there is very little demand for them. Another major factor that seems to discourage their production is the scarcity of usable sumac material. Allie Seletstewa told me she cannot find enough straight shoots to make the baskets. She said she wished she knew of an area where the bushes grew and she could reach them easily. Scrub sumac, which is the kind that grows on the Hopi reservation, grows in the mesa cliffs among huge sandstone boulders and is very hard to reach. Allie said that if she had easier access to several bushes, she could burn them after the growing season in the fall to insure a vigorous

growth of straight new branches the next summer. Many years ago, when burden baskets were still used at harvest time and many more were made, people on Third Mesa used this method to encourage the growth of straighter sumac branches. Fall burning also seems to be a custom among the San Juan Southern Paiute, who use sumac for their basketry too. The cultivation of wild plants is in such decline among the people of the Hopi Mesas that it may be forgotten in the next generation if it is not resumed.

Two other weavers who still make burden baskets occasionally, Leonora Quanimptewa and Evelyn Seletstewa, both of Mishongnovi on Second Mesa, repeatedly bemoan the fact that they cannot get enough scrub sumac for their basketry. Both are in their fifties or sixties and occasionally have health problems that prevent them from weaving. They need the help of their husbands to collect the scrub sumac, and even Evelyn's husband tells of how hard it is to collect the branches of this plant.

The decline in the manufacture of burden baskets among the Hopis can be explained by the fact that they are not a utilitarian item anymore. Harvests are brought in by trucks today, and as mentioned earlier, peach and other fruit trees hardly grow below the mesas anymore because young men are not interested in cultivating them. Burden baskets were once also called peach baskets, a name so little used on the mesa today that people sometimes confuse them with a smaller type of carrying basket called a fruit basket and often used as such.

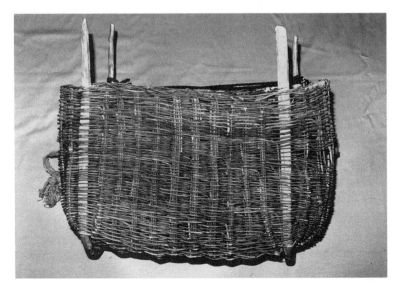

This burden basket (ho'apu) was made in Hotevilla in 1931 by a Hopi man or woman named Sequoptewa. The basket is 27.5 inches long, 16.5 inches high, and 9 inches wide. It is made with scrub sumac warps and wefts, and the heavier, U-shaped branches are oak. (1994; Museum of Northern Arizona collection no. OC 2759)

The larger, older form of burden basket (*ho'apu*) is seldom made today. When one is made, it is used in Katsina ceremonies, particularly for the So'yok Wu'uti Katsinam to carry in the Powamuya ceremony. I am told that the baskets used in ceremonies last a long time and become very old, but they literally have to fall to pieces before they are replaced. Both men and women used to make them, but when I asked on both mesas, nobody could tell me the name of a man who still makes them. Brian Honyouti of Hotevilla said that he has not seen them being made in his lifetime.

Allie Seletstewa knows how to make a burden basket and explained it to me as follows. The two U-shaped frames are of oak, which the men brought from distant forests when they went traveling. The branches are an inch to an inch and a half in diameter and can be bent when still fresh or when they have been soaked in water for two to three weeks. Unsplit sumac branches serve as warps and wefts and are woven in wicker fashion around the oak frame. These baskets stand about eighteen inches high and are more than twenty-seven inches in length. They have an opening on top about nine inches wide. The sides are fairly straight, and when finished the four ends of the frame extend slightly beyond the rim. Bands of heavy cotton cloth or buckskin are attached to the frame so that the basket can be carried on the back.

SMALL BURDEN BASKETS

The *ho'aphoya*, a smaller version of the burden basket, is used ceremonially by male initiates into the Wuwuchim society. They are also carried on the backs of Katsinam in the Powamuya ceremony when the Katsinam come into the village early in the morning. The baskets are filled to overflowing with bean sprouts. The Katsinam bring these portents of a plentiful harvest from the kivas to the houses of the families. Very few basket weavers today know how to make small burden baskets, and these few spend most of their time weaving piiki trays and baby cradles, and occasionally large burden baskets.

Small burden baskets for initiations and ceremonies are ordered to be made. In 1992 Evelyn Seletstewa of Mishongnovi told me that she had made seven such baskets for the newly initiated men into the Wuwuchim society on Second Mesa. She had made them all with scrub sumac, just as they were traditionally made.

The baskets are about fifteen inches high, about fifteen inches

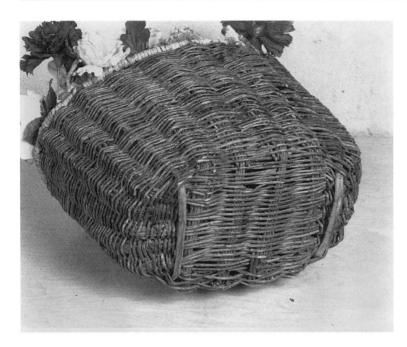

This small burden basket (*ho'aphoya*) like those still used in ceremonies was photographed in a home in Shungopovi in 1994. It shows the same construction as the larger burden basket in the previous figure and is also made of scrub sumac branches. The wood of the thicker U-shaped branches is uncertain.

long, and six to eight inches wide. The construction is the same as that of a large burden basket, with parallel U-shaped sumac branches about a half inch in diameter for overall stability. The bottom is made of thinner, unsplit sumac branches in the wicker technique, in which the warps are worked up into the vertical walls. The walls of the basket continue in the wicker technique using unsplit sumac branches. Finally, the rim is finished like any other wicker basketry piece, by bending one twig of each warp element to the left and breaking off the other twigs. The rim is then overcast with strips of split sumac branches, turning the inner (and lighter) side outward.

After initiation these baskets are kept in the family and may be used to hold food or even plastic flowers. Sometimes they are hung on the wall over the door of the living room. It is this more or less decorative function that has recently stimulated the production of small burden baskets as gifts for a friend's birthday, for example, or an engagement. When made and used for these purposes, they are called fruit baskets, which is a rather new term for a new function in container basketry. Fruit baskets intended for sale are made with siwi, a more readily available material. Tamarisk is often used for the frames.

Sometimes the commercial reed is used for the wefts. This reed is expensive, but it has the advantage of providing very long strips for weaving. In addition, it is easy to dye in pleasing ani-

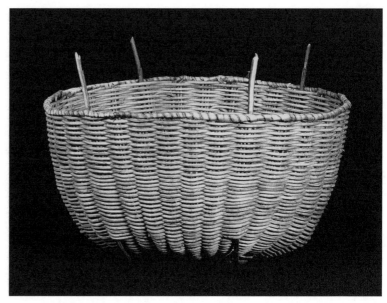

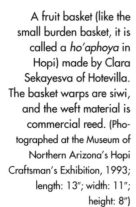

A fruit basket (like the small burden basket, it is called a *ho'aphoya* in Hopi) made by Clara Sekayesva of Hotevilla. The basket warps are siwi, and the weft material is commercial reed. (Photographed at the Museum of Northern Arizona's Hopi Craftsman's Exhibition, 1993; length: 13"; width: 11"; height: 8")

line shades of brown and needs to soak in water for just half an hour before weaving. Since this material is apparently machine-prepared on long rolls, its outside surface is very even. A finished fruit basket made of reed wefts and scrub sumac or siwi warps that was entered in the Hopi Craftsman's Exhibition at the Museum of Northern Arizona in 1993 was beautifully made by Clara Sekayesva and had a very even and smooth appearance.

Evelyn Seletstewa of Mishongnovi was photographed making such a basket with these materials. She started the bottom like the plaited part of a piiki tray, using the split branches of scrub sumac in a straight plaited pattern. If they are available, Evelyn also uses thin branches of arroyo willow (*qahavi*) for the plaited bottom or the wicker walls of her fruit baskets. She continued to use both elements as the warps in the upcurved walls of the basket and used commercial reed as the weft.

CRADLES

This very traditional basketry item is still highly prized among Hopi women. An expectant mother may buy a cradle for her first-born baby, or she may be given a cradle by her mother or grandmother. The basket weavers who still make them are the same people who know how to make the other traditional wicker basketry forms. As mentioned above, not many of them are left, and

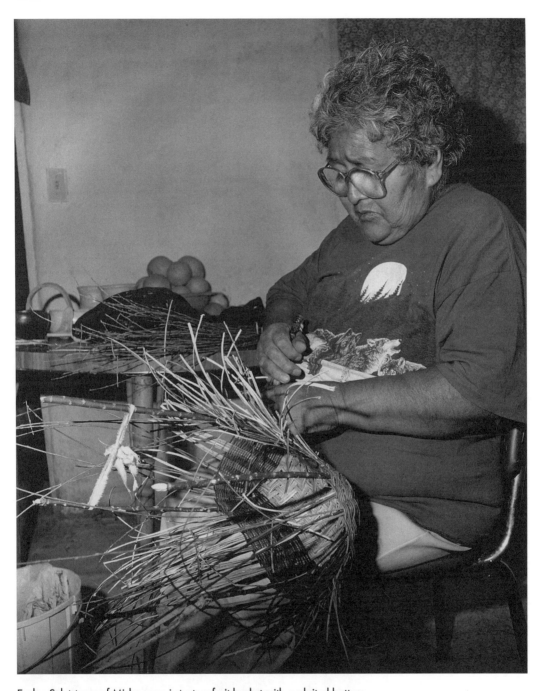

Evelyn Seletstewa of Mishongnovi starts a fruit basket with a plaited bottom of split willow branches, which continue as the warp elements in the basket walls. For the wicker weave Evelyn uses commercial reed dyed brown. (1993; ASM no. 89049)

I have heard of only two young women who are interested in learning how to make the cradles. One of them is Evelyn Seletstewa's youngest daughter, Colleen. She told me she learned from her mother how to weave a real baby cradle. Evelyn and I had tried to get together on several occasions in 1993 so that I could photograph her, but she had fractured her lower arm in a fall earlier in the year, and it was months before she could again weave the difficult sumac used in making these cradles.

All the Indian tribes in the Southwest except the Hopis make cradles with wooden boards. To me, those cradles are truly "boards," whereas the Hopi baby cradle, because it is made in wicker weave is not stiff like a board. I therefore do not like to call the Hopi baby cradle a cradleboard. Most women I talked to also refer to them simply as a cradle, or *taapu*.

The outer frame, of oak, extends the entire length of the cradle

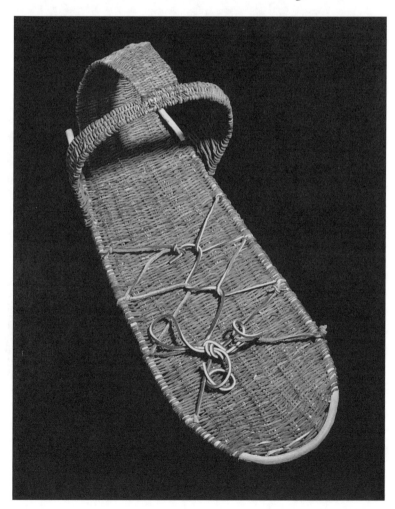

A baby cradle (*taapu*) made of scrub sumac branches by Leonora Quanimptewa of Shipaulovi. (Photographed at the Hopi Craftsman's Exhibition at the Museum of Northern Arizona in 1993; length: 21"; width: 6.75")

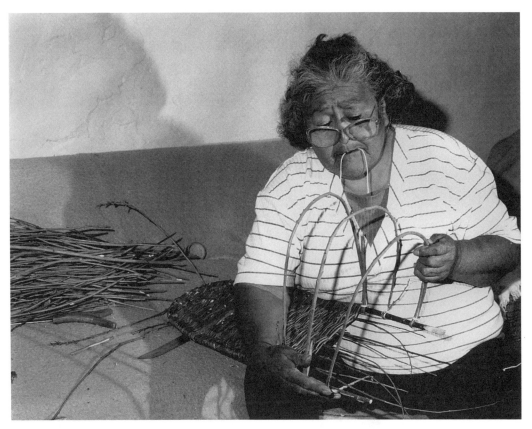

on both sides and is bent into a U shape at the foot and left open at the head. Straight sumac branches that are as long as the weaver can find are used for the warps and wefts. The weaving starts at the bottom, with the warps bent around the frame and securely held in place by the wefts. The weave is made as tight as the weaver can make it, bending the slender but unsplit sumac branches carefully around the frame. I am told that scrub sumac is more flexible than siwi and is thus the preferred material.

Evelyn Seletstewa of Mishongnovi making a baby cradle. She attaches curved sumac branches to form the headpiece. (1993)

After three days of working on the cradle, Evelyn arrived at the point where she started the headpiece and attached thicker sumac branches to the sides of the frame. She made an arch with one branch, temporarily holding the bent end to the frame with a cotton string. Then she continued weaving the cradle's bed for an inch or so before attaching the second arch. This process continued until she had made three arches and continued on the bed a bit more to give the curved branches better support. These three branches formed the framework for the headpiece, which she then started to weave in the same fashion as she had woven the lower part. After completing the first few rows of wicker

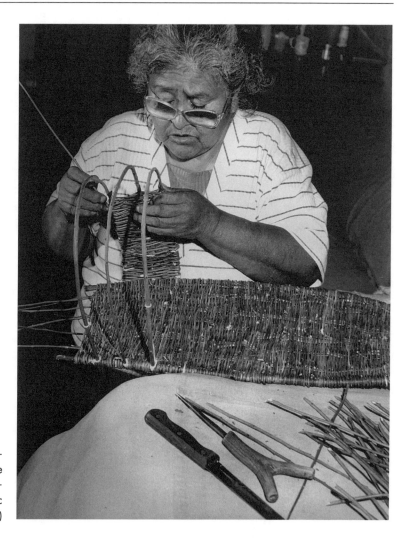

Evelyn weaves the head-
piece, like the rest of the
cradle, in a wicker tech-
nique using scrub sumac
branches. (1993)

weave on the headpiece, she had secured the arch, so she removed
the cotton string. She would do the same on the other side once
she had finished the headpiece. After that, she continued on the
bed for a few more inches, reducing the warps on both sides, and
then continued on the middle. She wove the middle piece long
enough to allow it to curve toward the headpiece and finally to
join it, giving the headpiece its third part in the back. A baby's
head certainly gains more security in this type of weaving.

Both Evelyn and her daughter Colleen have also developed
the cradle-weaving technique in a small form because they found
that this smaller version was of interest to tourist and Hopi alike
as a form of decoration or a toy. Wicker basket weavers in Hote-
villa told me that miniature cradles were traditionally made as

toys for little girls. Mothers made them from scraps left over from weaving plaques and baskets.

Evelyn and Colleen Seletstewa, who, because they live in Mishongnovi, do not have the material for wicker weaving, found the new commercial reed material suitable for making smaller cradles. They dye the reed in aniline dyes and weave bands of vivid colors into their little cradles. Scrub sumac, which is very hard to find these days, is not used for sale items intended mainly for the tourist market. The small frames are of tamarisk, the warps are of unsplit siwi or reed, and the wefts are reed. If they can find it, Evelyn and her daughter also use arroyo willow for their miniature cradles. Evelyn's husband, Ivan, is a good kachina-doll carver and makes flat dolls that fit these cradles; the resulting delightful cradle-and-doll combination makes a very popular sales item. Colleen, in particular, has made them her main basketry work,

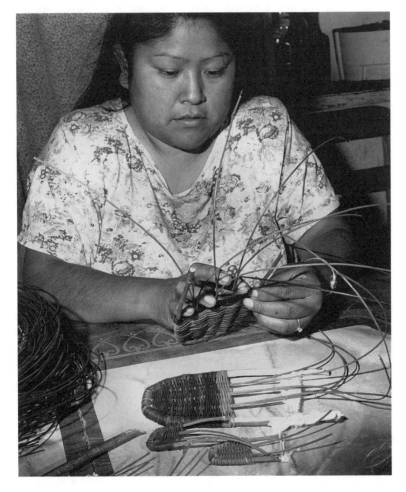

Colleen Seletstewa of Mishongnovi weaves miniature toy cradles using the wicker technique. She uses dyed commercial reed for the weft material. (1992; ASM no. 87160)

and she can hardly keep up with the demand for them. Word that she makes them has spread, and people come directly to her house. Little Hopi girls are so fond of them that people buy them as birthday gifts or, much more important, they are given to them by Katsinam. Upon the urging of Ron McGee of McGees Indian Art Gallery in Keams Canyon, Colleen has started to make cradles that are only one and a half to two inches long. They serve as hanging decorations anywhere, perhaps even on a Christmas tree.

Allie Seletstewa and her daughter Vernita Silas, who live in Hotevilla, also make small cradles beautifully woven with rabbit-brush (*siváapi*), which lends itself so much better than sumac to a tight wicker weave. Rabbitbrush stems are thin, and their surface is so smooth that it appears to be shiny. More important, it is much more pliable than reed and will hardly ever break when bent around the many corners of the cradle's frame. Vernita weaves the cradles so tightly that, as in any well-woven wicker plaque or basket, the warp is invisible; only the elegant smooth surface of the weft material can be seen. The warp material in these cradles is arroyo willow. Vernita uses many colors, spacing

Some small or miniature baby cradles (*tapuwya*) are used as toys, and others are made for sale. These were made by Colleen Seletstewa with commercial reed dyed in aniline dyes. (Photographed in 1992 at McGees Indian Art Gallery in Keams Canyon; ASM no. 87156)

On Third Mesa, Vernita Silas and her mother, Allie Seletstewa, use a different method of making toy baby cradles. As in other Third Mesa weaving, they use siwi as the warp material and rabbitbrush (*siváapi*) as the weft material, which permits a tight weave. Also, the construction of the headpiece differs from those made on Second Mesa. (1993)

them either randomly to create a rainbow of colors or regularly in thin bands of color.

Allie and Vernita use a different technique in making the headcover. At the point where the headpiece starts, Vernita uses a different plant material for the wefts. She switches to long twigs of arroyo willow as wefts in the cradle bed, extending them far enough on both sides so that they can be bent and curved upward to become the warps for the headpiece. This produces a truly plaited pattern created by weaving elements of the same material. Vernita weaves it only as wide as the headcover will be, then she continues with the dyed siváapi, continuing long enough to make the curve for the third headpiece behind the baby's, or doll's, head. Interestingly, Vernita and Allie combine all the willow warps in the center of the headcover right above the doll's head. It seems more complicated to make the headcover in this fashion, but the technique probably makes for more sturdiness on the sides. When I visited her, Vernita was making several of these lovely cradles because Powamuya was only ten days away. Vernita has a full-time job with the Hopi Police, so her time for weaving is very limited, and she probably does not make small cradles for the tourist market.

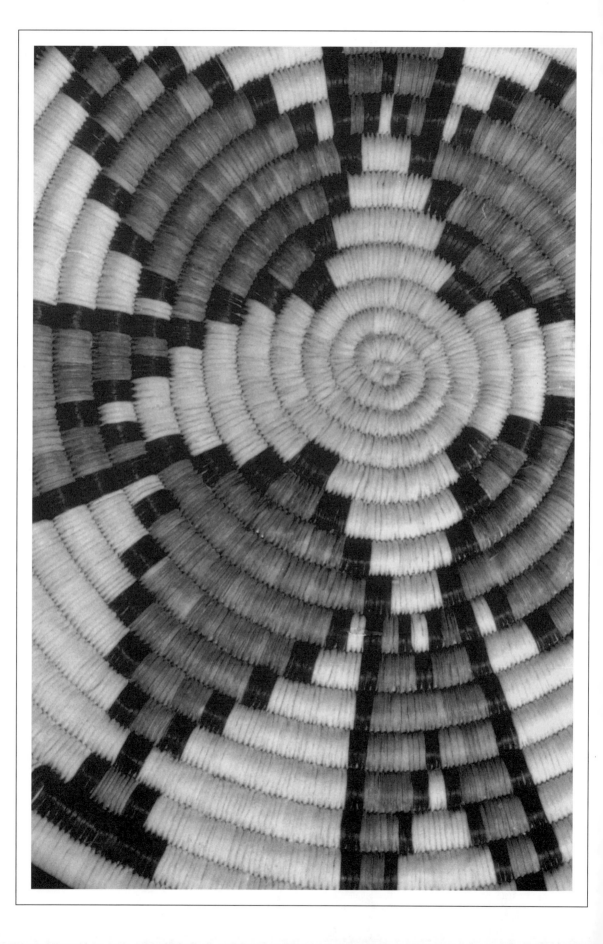

Coiled-Basket Weavers
of Second Mesa

I have known several Hopi basket weavers for about twenty years, and we have established a long-lasting friendship. Their cooperation and kindness have helped me tremendously in correctly portraying the laborious preparations and meticulous execution of their work. But in collecting the documentation for this book, I also made new acquaintances among the weavers. All of the weavers—old friends and new—were my teachers. They were interested in my work and took the time to share their knowledge with me.

On Second Mesa I photographed and interviewed fourteen basket weavers in Shungopovi. All of them weave coiled plaques and baskets, and some also make plaited sifter baskets. In Shipaulovi I became friends with two sisters who make coiled plaques and baskets. One of them also excels in the manufacture of piiki trays, cradles, burden baskets, and sifters for parched corn. In Mishongnovi I became acquainted with a mother and one of her daughters, who weave coiled plaques, baby cradles, miniature cradles, piiki trays, and burden baskets.

EVANGELINE TALAHAFTEWA

Evangeline Talahaftewa was born into the Water/Corn Clan in July 1912 in Shungopovi. July 4 was later established as her birthday. As a little girl she was raised by her grandmother and watched her making baskets and plaques of various sizes. Her mother also wove, but at that time she made only small baskets. It was customary then to sell the basketry at trading posts on the reservation so that the family could buy their groceries. When Evangeline was twelve years of age and was initiated into the Lalkont, her godmother gave her the Hopi name Besokemana (Busy Girl), and her grandmother instructed her in weaving plaques and large baskets and in making piiki. Her grandmother's health had started to

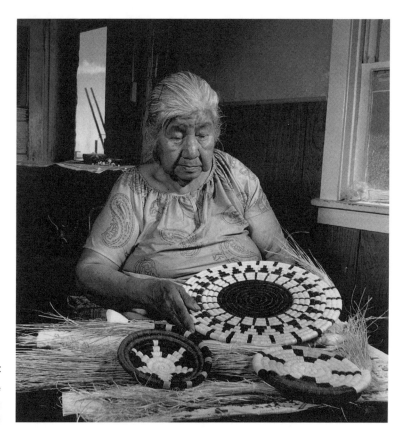

Evangeline Talahaftewa of
Shungopovi works on one
of her feather-design
plaques. (1993)

decline by then, but Evangeline came home from school every
summer to be with her.

Evangeline left school in the seventh grade to take care of her
grandmother and married soon after. Her husband found work as
a carpenter in Winslow, but Evangeline stayed in her mother's
house, raised her children, worked in the fields, and cooked and
prepared food for family and community obligations. Still, she
found time to improve on her basket weaving.

Years ago, she sold most of her basketry to the Hubbell Trad-
ing Post in Kykotsmovi. When that store closed, she sold to the
Polacca store. Eventually she began to sell her basketry to the
Keams Canyon Trading Post before Ferron McGee owned it. For
many years, when she was at the height of her skill and still had
good eyesight, she demonstrated basket weaving in many places.
She and her friend Marcella Kahe, a famous potter from Sicho-
movi on First Mesa, spent many hours side by side, demonstrat-
ing their two crafts. Once, Evangeline was invited to demon-
strate her work at the Smithsonian Institution in Washington,
D.C., and saw a large serpent on display. The serpent looms large

in the migration story of her clan, and she told me that it also loomed large there at the Smithsonian—so large that she only saw its tail. She would like very much to be able to see the rest of that serpent.

Evangeline sent work to the Hopi Craftsman's Exhibition in Flagstaff for many years before she started entering the competition in Santa Fe and now regularly enters work in both shows. In 1979 she made a large, deep basket with the intention of entering it in the Indian Market in Santa Fe. It was her first entry in this coveted show, and it promptly won Best of Show and was sold very early on the morning of the first day to a Ford executive. Nine years later she almost repeated her achievement by winning orange and blue ribbons for another large basket, claiming the Best of Division award and a First Prize in basketry. Over the years she has won many awards in Santa Fe, including five Best of Division awards, five First Prizes, several Second Prizes, and numerous Third Prizes and Honorable Mention ribbons. She usually receives blue and red ribbons from the Hopi Craftsman's Exhibition in Flagstaff. Occasionally she also enters the Indian Fair at the Heard Museum and has received two blue ribbons.

Evangeline, like other weavers of Shungopovi, put special effort into making large, deep baskets either for competitions or for special orders placed by collectors. All the deep baskets are meant for the non-Hopi market, and Evangeline also makes unusually large plaques for this market. When I photographed her, she was working on a large plaque with a remarkable design in black and white. She called it her Feather Design and planned to enter it in the 1993 Hopi Craftsman's Exhibition. The first time she made this particular design, which she created, was in 1969 for the Flagstaff show. It sold very quickly. At that time, as now, she lived in her mother's house next to the large kiva in Shungopovi. From her basketry sales money she bought paneling for the walls of the house and linoleum for the floor. She has also built a new house next door entirely from "basket money." Evangeline has not been a member of the Hopi Arts and Crafts Silvercraft Cooperative Guild (commonly known as the Hopi Guild) for ten years. She left when Fred Kabotie, its founder, retired from his work with the guild. The present manager, Milland Lomakema, is her nephew, the son of her sister. She thinks that the guild is of great help to those Hopi artists who have no other means of income, which are mainly the older artists.

Her daughters, Bertha and Velma Wadsworth, are well-known

basket weavers. Evangeline is also very proud of her granddaughter, who attends the University of Arizona in Tucson. Evangeline's works of art are proof of her words: "You never forget anything you have learned when you are young."

She identifies her work with a Water Clan mark: four raindrops in the form of four black spots, each within a black-outlined square. It can usually be found close to the rim. In 1991 the Arizona Indian Living Treasure Award was bestowed on Evangeline for her achievements in Hopi basket weaving.

BERTHA WADSWORTH

Bertha Wadsworth belongs to the Water/Corn Clan. She was born on April 5, 1937, in Shungopovi. She is a daughter of Evangeline Talahaftewa, and she learned basket weaving from her mother and grandmother. Her mother also showed her how to gather the necessary materials and dye them. By the time she was in her early twenties, she was making large, deep baskets for collectors. She regularly submits her work to the Indian Market in Santa Fe and the Hopi Craftsman's Exhibition in Flagstaff, and she usually enters two pieces, either plaques, sifters (also in colors), deep baskets, or pottery.

Bertha and her husband, Ted Wadsworth, who is a silversmith, have six sons and one daughter. For many years Bertha could not devote as much time to her basketry as she would have liked. She earned money by holding several jobs. She was with an early tribal enterprise for which she sewed pillows, handbags, and dolls, and when this business folded she went to work in 1970 as the head cook for the restaurant at the newly opened Hopi Cultural Center. Georgia and David Mills, the managers at that time, bought many of her plaques and used them to adorn the wooden rafters of the restaurant for the admiration of the customers—including myself, as I recall. Bertha saved the money from selling these plaques to build a new house in Shungopovi. When the Mills left the cultural center in 1975, Bertha also left and became the food service coordinator for the Child Center for Human Services, a state institution. She left in 1983 to devote her energy and creativity to her basket weaving, occasional sewing, and pottery making.

Bertha creates many different designs, drawing her inspiration from traditional motifs, as well as geometric and figurative elements. Her designs stem from her own artistic feelings. She has

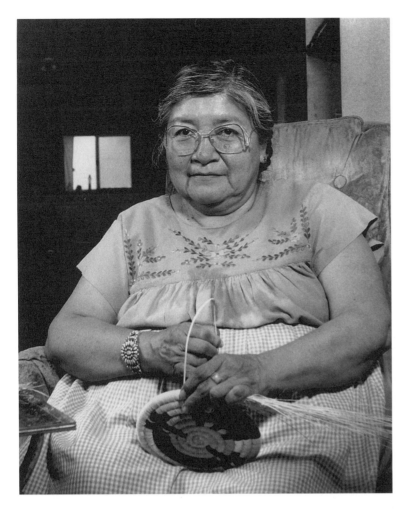

Bertha Wadsworth of
Shungopovi working on a
Katsinmana plaque. (1993)

no time to visit with other weavers and gets little input for her
ideas from the outside.

In 1978 Bertha became the first basket weaver to identify her
work with a hallmark. She uses a corn kernel, symbolizing her
membership in the Corn Clan. She marks an area close to the rim
with four black-outlined squares and sews a corn kernel into each.
One seed is yellow, another is green, the third is red, and the
fourth is black. All four colors are those found in coiled basketry.
She suggested the use of a hallmark to her mother and other rel-
atives, and they liked her idea. Her daughter, Elaine Tewa, uses
two corn kernels, one yellow and the other green. Her niece,
Sheril Talahaftewa, makes a rainbow.

Bertha has refined her basketry technique over the years and
continues to do so. Her refinements include making finer stitches
with thinner yucca splints, reducing the size of her coils, and in-

corporating intricate overstitches for new patterns and textures. Young Hopi girls or women who are initiated into the Lalkont are lucky to have Bertha as their godmother. I could hardly imagine a finer teacher for this artistic skill. One of Joyce Ann Saufkie's daughters is Bertha's goddaughter.

Bertha has won many awards and prizes in a number of shows. In 1988 she won Best of Division and a First Prize at the Indian Market in Santa Fe for her first Sa'lakwmana doll. In 1989 she was given a First Prize in the Intertribal Indian Ceremonial in Gallup for her second Sa'lakwmana doll, and in 1990 another First Prize for her third Sa'lakwmana doll at the Hopi Crafts-man's Exhibition in Flagstaff. In 1990 she entered a large, deep coiled basket in the Indian Market and won another First Prize. Unfortunately, a lack of time prevents her from attempting such complicated pieces more often.

EDITH LONGHOMA

Edith Longhoma is a member of the Bear Clan. She was born on January 27, 1919, in Shungopovi. She watched while her mother and grandmother wove baskets and picked up the skill from them. Her school years were spent mostly in Albuquerque, and when she came back to Shungopovi she was soon married. Her husband served in the army, and they had one son.

In 1945, when Edith was twenty-six, she went to the Grand Canyon, where she found a job. She worked there for thirty-five years but kept up with her basket weaving as best she could. She always collected her own material and spent her days off at Shungopovi collecting *hohoisi* (Hopi tea) below the mesa. She also did her dyeing of the red color in Shungopovi. In 1980 she quit her job at the Grand Canyon, returned to Shungopovi for good, and remarried.

According to Edith, yucca leaves, which are gathered after there have been several frosts in winter, should be spread out and left in the rain so that they will turn yellow. She thinks that the process will be spoiled if the leaves are repeatedly taken out and in. Once they are out, they should be left there until they turn the proper shade of yellow. Her coiled weaving is meticulous and finely executed. She was working on a sweet corn plaque when I photographed her.

Every year, Edith enters her work in the Hopi Craftsman's Exhibition at the Museum of Northern Arizona, and she has won

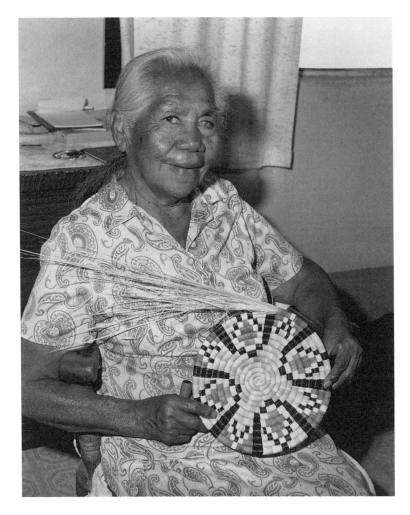

Edith Longhoma of Shun-
gopovi. She is weaving a
sweet-corn plaque. (1993)

"a whole lot of ribbons," including blue ribbons for First Prize. Not long ago she decided to put a Pima basket design of a squash blossom into a wedding plaque because she liked this design very much. In all, she made five plaques with this design, one of which won the Second Prize in the basketry division in the 1993 Hopi Craftsman's Exhibition.

ANNABELLE NEQUATEWA

Annabelle Nequatewa belongs to the Sun/Forehead Clan. She was born on May 10, 1931, in Shungopovi. She has an older brother, Vincent Selina, who is a weaver of wedding robes and ceremonial kilts, and a younger sister, Madeline Lamson, who like Annabelle is an excellent basket weaver. Annabelle learned basket weaving from her aunt, Evangeline Talahaftewa, and she

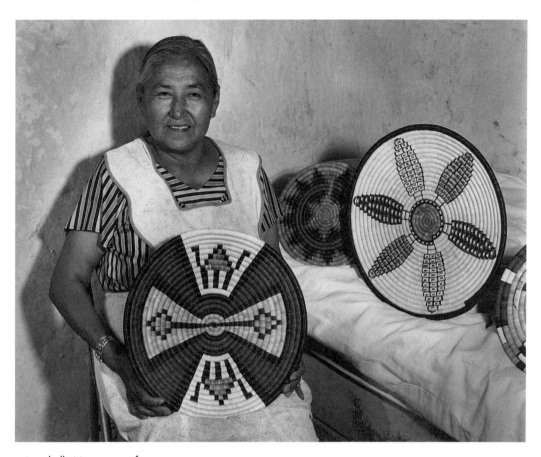

Annabelle Nequatewa of
Shungopovi. (1992;
ASM no. 87217)

has made plaques and deep baskets since she was a teenager. She
was initiated into Lalkont when she was seventeen but is not a
member of Mamrawt, the other women's society in Shungopovi.

Annabelle was married to Edmund Nequatewa, a very fine
kachina-doll carver who died a few years ago. His father, also
named Edmund Nequatewa, worked for the Museum of North-
ern Arizona in the 1930s and wrote the book *Truth of a Hopi*,
which presented stories relating to the origin, myths, and clan
histories of the Hopi. He also worked with Alfred F. Whiting
to write *Born a Chief*, his life story up to his early twenties.
Annabelle and Edmund had three daughters and four sons. Their
twin sons, Merrill and Ferrill, perpetuate their father's craft by
creating large Hopi rattles, which they make primarily for the
collector's market. Jack, the youngest, is a silversmith. Edward,
who often helped Annabelle collect weaving material and who
was the father of four of her grandchildren, died in a tragic car
accident. Now Annabelle, who does not own a car, finds it dif-
ficult to collect yucca, galleta grass, and *siita* (Navajo tea). She

sometimes has to buy the fibers from others. The excellence of her workmanship is proven by the awards she has won, including the 1989 Grand Award and First Prize in the basketry division at the arts and crafts competition of the Scottsdale Native American Indian Cultural Foundation.

Every year Annabelle enters a plaque or deep basket, or at least a plaited sifter basket, in the Hopi Craftsman's Exhibition in Flagstaff. Annabelle is always working on a piece of coiled basketry, but preparing the material and weaving take a long time, and she often has a need for more immediate cash. For this reason, she makes sifter baskets between her coiled basket projects. Sifters can be finished much faster and need far less fiber preparation. Still, hers are superbly made.

Once when I visited her, she was in the process of making a sifter basket, and she consented to let me photograph her while she made it. Edward had collected some sumac branches for her, which she had tied together with a strip of cotton cloth, transforming the straight branch into a nice, round ring. (The scrub sumac has to be bent soon after it is cut.)

Annabelle excels in making coiled plaques and deep baskets. On another occasion I photographed her working on a large basket that, when finished, measured twenty-two inches high and twenty-three inches wide. It had four Katsina faces, with four ears of corn between them.

One particularly large plaque amazed me, and she said that it took her a very long time to make it. Large ears of corn in red, yellow, and blue-black were designed in the form of a star, and each kernel in each ear was overstitched with a contrasting color. It was a beautiful labor of love in basket weaving.

Annabelle sells her sifter baskets either at the Hopi Guild near the Cultural Center or to Ron McGees Indian Art Gallery in Keams Canyon. Her coiled plaques can also be found at the Kópavi International Gallery in Sedona.

MADELINE LAMSON

Annabelle's sister, Madeline Lamson, also belongs to the Sun/Forehead Clan. She is a well-known weaver of coiled baskets and plaques. She was born in 1939 in Shungopovi. She learned basket weaving from her mother and made her first basket when she was twelve years old. She remembers that her mother was always very concerned that Madeline not waste any weaving material because

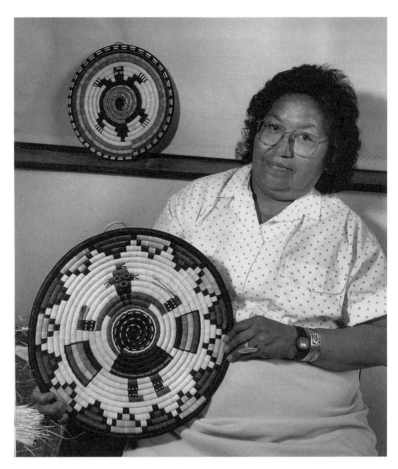

Madeline Lamson of Shungopovi. She is holding the plaque she made that incorporates a full-figure Mudhead Katsina. In the background is a coiled plaque with a turtle design. (1991; ASM no. 85526)

preparing it requires so much work. After 1961 Madeline started to sell some of her baskets and plaques, though most of her work had to be used as payback for her wedding robes.

For a short time in the 1970s the family lived in Phoenix. Now her husband works for the Forest Service in Flagstaff during the week. For three years she worked with school children for nine months every year but continued her weaving at night, though she remembers that it seemed as if she worked on her baskets day and night. Even today Madeline can rarely find the time to sit down with me for just a chat. When I visit she usually grabs one of the pieces of basketry she has started and weaves while we talk. The last time I visited her, she was working on a fine miniature plaque with a full-figure Left-Handed Katsina as its design. The coils were only a quarter-inch wide, and the yucca splints were very fine.

Madeline sells to trading posts in the vicinity and in Keams Canyon, and at the Hopi Guild on Second Mesa, the Heard Mu-

seum, and the Museum of Northern Arizona. She usually sells to Richard Mehagian, who owns the Kópavi International Gallery in Sedona, and to individual collectors. If she could find the time to weave all through the day, it would take her a week to weave a plaque with a fifteen-inch diameter.

Madeline is an accomplished coiled-basket weaver who can make any size plaque or deep basket. She makes very fine miniature plaques, which are sought by collectors, but in fact anything Madeline weaves is highly appreciated by the lucky recipient. When I first met her in her home in Shungopovi, she had finished the bottom of a very large basket and was starting on the lower zig-zag design that marked the rising curve of the walls. I never saw this basket when it was finished, but photographs of the completed work that she has in her home or that can be seen in galleries show the beauty of her work.

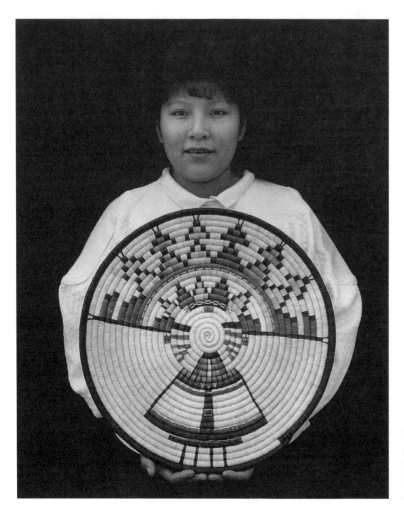

Petra Lamson of Shungopovi with a large plaque depicting the Palhikwmana Katsina. (1992; ASM no. 86573)

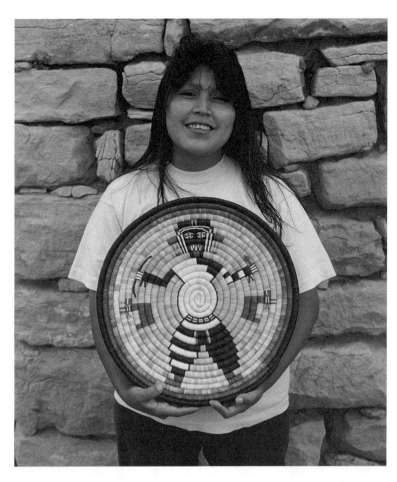

Janet Lamson of Shun-
gopovi with her plaque
depicting a full-figure Left-
Handed Katsina. (1991;
ASM no. 85703)

Madeline has four goddaughters, one of whom, Jerri Loma-
kema, is an outstanding young basket weaver. Madeline taught all
four girls how to weave coiled baskets and plaited sifter baskets for
four days in the kiva after they were initiated into the Lalkont.
All four were very lucky to have her as a godmother for this
instruction.

Madeline is one of the few basket weavers who mark their
work to identify it as their artistry. She finishes her plaques with
a black rim into which she stitches white horizontal marks at
intervals of about an inch. Madeline's two daughters, who are
known for their excellent work, also mark their plaques with the
same design. Madeline and her husband have four daughters and
three sons, and the two basket-weaving daughters are Petra and
Janet. Both live with their respective families near Madeline,
and all three families cook and eat together. Babies are born al-
most every year, which is one reason why the women are always
hurrying to meet the needs of the families. The women become

even busier during ceremonies, when they need to prepare much more food than normally. In spite of this, Madeline manages to continue weaving her basketry and producing remarkable works of art. Needless to say, she has won many awards.

MOLLIE TALAS

Mollie Talas is a member of the Water Clan. She was born on July 28, 1912, in Shungopovi, where she lives today. She learned to make coiled baskets and plaques from her grandmother when she was fifteen.

Mollie is liked by everybody who meets her because of her lovely smile. In her many years of making baskets and plaques, she has often been called upon to demonstrate coiled basket weaving

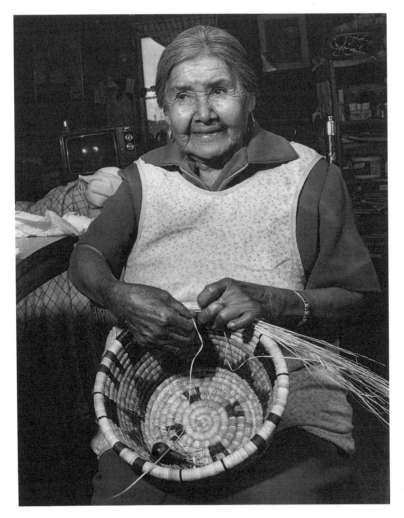

Mollie Talas of Shungopovi.
(1992; ASM no. 86620)

at exhibits like the Hopi Craftsman's Exhibition, the Intertribal Indian Ceremonial in Gallup, exhibitions in San Francisco and elsewhere in California, and twice at the Heard Museum's annual Indian Fair in Phoenix. She has won numerous prizes and awards, but when I asked about them she said that she had them put away and had no time to pull them out for counting.

Today, Mollie still makes her beautiful deep baskets and large plaques with eagles, Katsina figures and faces, and other designs that demand great skill. Over the years she has instructed many of the young women of her family in the basket making art. One woman who benefitted from her knowledge was her niece, Joyce Ann Saufkie, who praises Mollie as her teacher.

My visit with Mollie was short because I came in the middle of bread baking in preparation for an initiation ceremony. That Mollie let me take her photograph at that busy time is a testament to her kindness and generosity.

JOYCE ANN SAUFKIE

Joyce Ann Saufkie is a member of the Water Clan. She was born on May 29, 1939, in Shungopovi and learned to weave from her aunt, Mollie Talas. Her mother is Dorothy Quanimptewa, and both live in Shungopovi.

Joyce was thirteen when she was initiated into the Lalkont, and after that she began learning to weave. When she was nineteen she married Morgan Saufkie, and they have two sons and four daughters. Joyce taught her four daughters how to make coiled baskets. Ruby, the youngest, is perhaps the most accomplished basket weaver of the four. For about eight years in the late 1960s and early 1970s, Joyce was a parent aide in the day school below Second Mesa and had no time to do much basket weaving. In 1980 she enrolled in a three-week seminar in basket weaving that was held in Santa Fe for all American Indian tribes. She received a certificate and gained inspiration to continue weaving. In a sense, her basket weaving took off after that, and she started to make money selling her baskets.

Her first entry in the Hopi Craftsman's Exhibition in Flagstaff in 1982 received a First Prize even though she now thinks that her basket "was not that good." Since then she has regularly been awarded Second and Third Prizes at the Hopi Craftsman's Exhibition. In 1990 she won the Best of Show award with a spec-

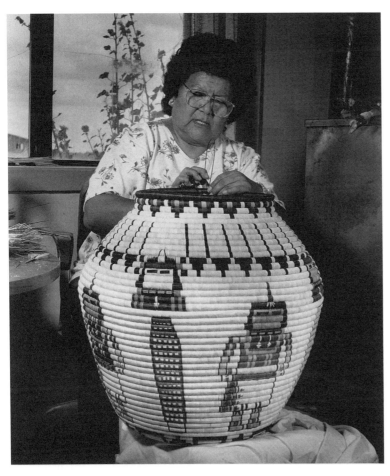

Joyce Ann Saufkie of
Shungopovi. She is work-
ing on a large basket with
four full-figure Longhair
Katsina representations.
(1995)

tacular big basket that had taken her two years to complete. She
usually takes two to three years to make the really large coiled
baskets. She also weaves beautiful plaques and plaited sifter bas-
kets out of yucca. She often makes more plaques than large
baskets because she can complete them faster. Joyce occasionally
marks her work with a trademark to identify it as her creation,
incorporating three stitches of each of the five colors next to each
other into the coil near the rim.

Joyce has about twenty ribbons from juried shows, and quite
often her work is entered either by the Hopi Guild, to whom she
frequently sells, or other traders. Her awards include a First Prize
at the O'odham Tash in Casa Grande, Arizona, in 1989, and a
First Prize in Denver in December 1990. She has won other
prizes at the Intertribal Indian Ceremonial in Gallup and the In-
dian Market in Santa Fe. She says that in Santa Fe the artists must
enter their own work, but traders like Dan Garland or Bruce and

Ron McGee enter her baskets in most other juried shows. In 1993 the very large basket that I photographed her making was entered in the Intertribal Ceremonial and won Best of Show, Best in Class, Best in Category, and the First Prize. It had been entered by the Atkinson Trading Company of Taos, which had purchased the basket upon its completion. Joyce also participates in demonstrations and leads seminars in basket weaving, most recently for Elderhostel at a three-week seminar at Arcosanti, where I photographed her. She has taught at the seminars in Arcosanti every year since 1991. She is a good teacher, and the people love her.

Joyce collects all her own basketry material, including the material for her vegetal dyes, and prepares everything herself. She avoids using aniline dyes, but because nobody grows Hopi sunflowers anymore, her black comes from commercial dyes.

Joyce was always very helpful in contributing to this book. She agreed to several photography sessions, including those on the techniques she uses to make a deep basket, a plaque for a special dance, a wedding plaque, and the wonderful large basket that won Best of Show in Gallup in 1993. She was also willing to be photographed collecting yucca leaves and demonstrating the dyeing process for the red dye in coiled basketry. Without her cooperation, my documentation of contemporary Hopi coiled-basket making would have been very meager indeed. Like many other basket weavers, Joyce recognizes the importance of demonstrating and explaining the difficult tasks and the time-consuming work involved in creating a work of art in basketry.

RUBY SAUFKIE

Ruby Saufkie belongs to the Bear Clan. She was born on April 16, 1915, in Shungopovi. Ruby and her husband have ten children—four sons and six daughters. With the help of two of her granddaughters, who were present, we established that Ruby had, as of February 1994, thirty-nine grandchildren and forty-one great-grandchildren. As people say, "The name Saufkie can be heard often in Shungopovi."

Ruby learned how to make large plaques and deep baskets from her mother between the ages of eight and ten. When she was twenty-one, she was initiated into the Lalkont, after which she progressed in her basket weaving, including the making of

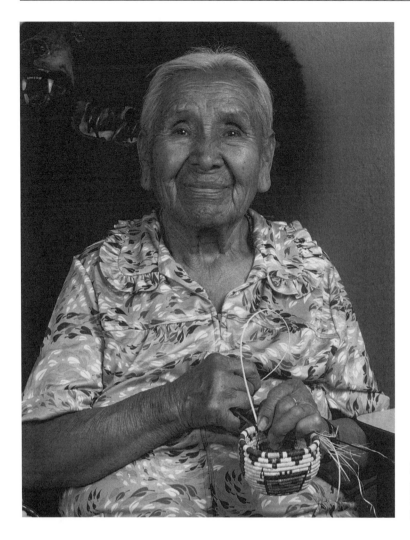

Ruby Saufkie of Shun-gopovi weaving one of her miniature baskets. (1994)

plaited sifter baskets. Later she taught herself the art of making miniature baskets and miniature plaques. Today she still makes all these varied forms. She sells her basketry to individual collectors like Bruce McGee in Holbrook and Ron McGee in Keams Canyon, to the Hopi Guild, and to tourists. Ruby thinks that figurative designs like deer, turtles, and Katsina figures (particularly Mudheads), sell better than geometric designs. Those are the designs she incorporates into the basket pieces she occasionally submits to the Hopi Craftsman's Exhibition at the Museum of Northern Arizona. One very large deep basket that stands thirty-six inches high won the Best of Show award there. She had sold this basket to the Hopi Guild, and the manager, Milland Loma-kema, had entered it in the museum's show.

Ruby, who is the mother of Morgan Saufkie, the husband of Joyce Ann Saufkie, still goes on her own collecting trips to find the yucca and galleta grass she needs for weaving and also the siita and hohoisi for her red dye. She claims that she can achieve as red a color with hohoisi as with siita, a statement I also heard from other older basket weavers.

Ruby freely acknowledges that her basket weaving provides her with the opportunity to have a cash income, and she has been selling her work since she was twenty-one. Nevertheless, her main concern is with the Hopi way of life. "I am happy," she says, "that I taught my daughters and my granddaughters basket weaving. Now they can carry on this tradition."

JERRI LOMAKEMA

Jerri Lomakema belongs to the Bear Clan. She was born in Shungopovi on December 15, 1960. When growing up, she watched her mother, Ramona Lomakema, and her grandmother, Ruby Saufkie, making plaques and coiled baskets and learned the art that way. When she was initiated into the Lalkont at age twenty-two, her new teacher was her godmother, Madeline Lamson, one

Jerri Lomakema of
Shungopovi. (1994)

of the finest coiled-basketry weavers in the village. Jerri's work became better and more refined with every piece she made.

In 1986, at age twenty-six, she won her first award at the Indian Arts and Crafts Fair at the Tlaquepaque shopping area in Sedona. She does not know if it was a plaque or a basket because the piece was entered by a collector who had bought it from her. She first learned of it when the Blue Ribbon, indicating her First Prize, came in the mail. The next year she again won a First Prize, this time at the Intertribal Indian Ceremonial. In 1992 she submitted a plaque for the first time to the Hopi Craftsman's Exhibition in Flagstaff and won a Third Prize. In 1993 she again entered a plaque in the same show and won Best in Division with it.

Jerri likes to make large plaques and baskets, but usually she does not sell her plaques. Instead, she keeps them for her two girls, who often dance in social dances. They then give these plaques as reciprocal gifts. In general, Jerri makes more baskets than plaques and likes to adorn them with Katsina figures because they are favored by the buyers. In regard to her work she remarks: "I like to look at my baskets and see how and where I can improve my weaving. I also hope that my two girls will learn from me and their grandmother so that this art will live on." Jerri belongs to the small group of young coiled-basketry weavers who do excellent work.

MARTHA LEBAN

Martha Leban was born into the Bearstrap/Spider Clan on June 1, 1917, in Shungopovi. Martha learned from her mother how to weave coiled plaques and baskets. Her mother was Kerry Mowa, a basket weaver who knew how to make large, deep baskets, an art Martha never really attempted. Martha recalls that her mother made these large baskets and large plaques until her death and that "she was also a very good cook who loved to bake pies."

Martha lives in the house that her late husband built. He died in 1985 of diabetes, an illness with which Martha also struggles. She tires quickly but manages to keep up with her plaque making. She has four sons and four daughters, who all look after her. Her husband's family also helps her. Her oldest daughter, Remalda Lomayestewa, lives right next door and looks in on her all the time. All her children and relatives bring her food, cook for her, and take care that she has enough coal and wood to keep

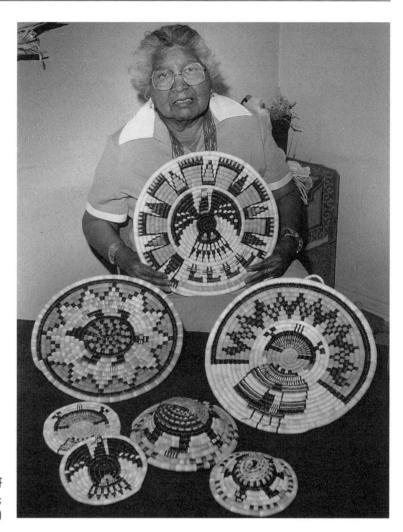

Martha Leban of
Shungopovi. (1992;
ASM no. 86506)

her warm in winter. In 1991 Martha made a medium-sized deep coiled basket with four Katsina heads. It was so well made and so beautiful that she won the Governor's Award for it. The governor invited her to the award dinner in Phoenix, which made her happy and proud.

REMALDA LOMAYESTEWA

Remalda Lomayestewa was born into the Bearstrap/Spider Clan on June 3, 1938, in Shungopovi. She learned her art from her mother, Martha Leban. She is a superb weaver of coiled basketry and makes plaques of all sizes, as well as deep coiled baskets that can be up to thirty inches high. She does not make these very large baskets very often—only one about every ten years—but

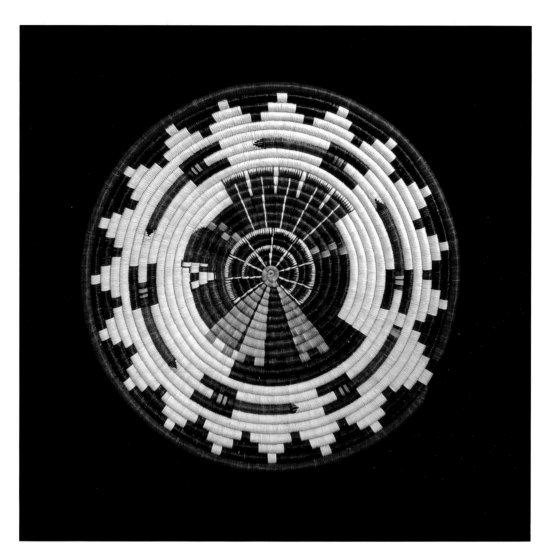

A coiled plaque with a Comanche Katsina head in profile made by Joyce Ann Saufkie in 1992. (Diameter: 22″; photographed at Garland's Navajo Rugs in Sedona in 1993)

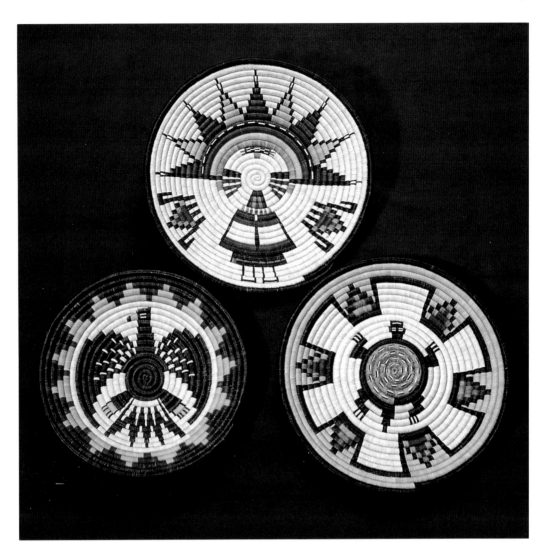

Three coiled plaques Lorraine Sekakuku made with designs of a Palhikwmana (top center), an eagle, and a turtle. They are in the collection of Von and Mae Monongya. (Palhikwmana: made in 1993, diameter: 15.5″, depth: 2.5″; eagle: made in 1993, diameter: 13″; turtle: made in 1994, diameter: 15″)

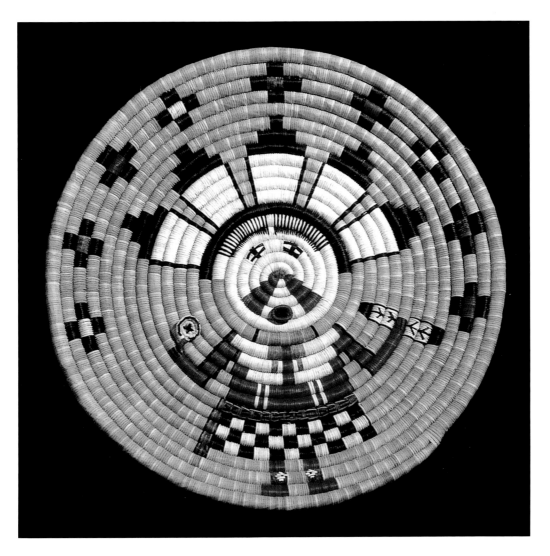

A He-e Katsina coiled plaque made by Jerri Lomakema in 1993. It won the Best of Division award at the Hopi Craftsman's Exhibition at the Museum of Northern Arizona in 1993. (Diameter: 19.5")

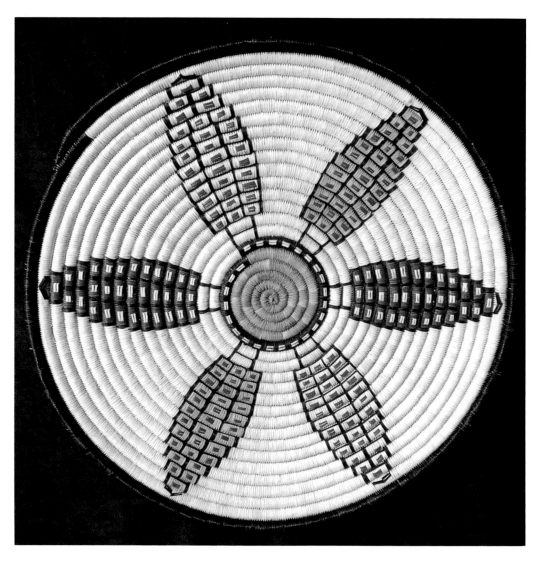

A coiled plaque with six large ears of corn. It was made by Annabelle Nequatewa in 1992. (Diameter: 18″; ASM no. C-28853)

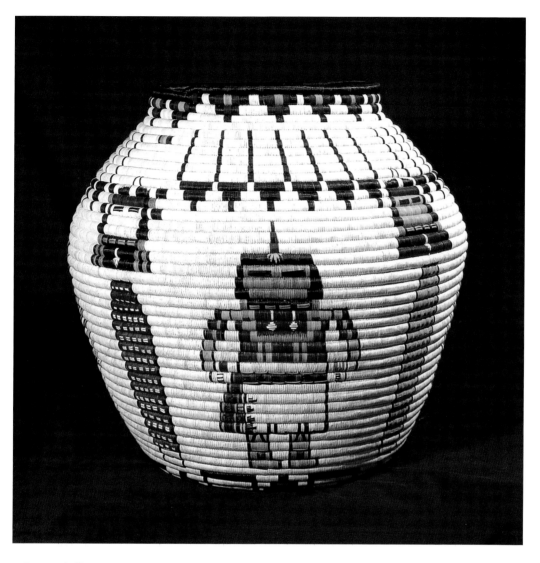

A large coiled basket made by Joyce Ann Saufkie in 1995 depicts four full-figure Angaktsina (Longhair Katsina) in two different colors, four large ears of corn, four Angaktsina faces, and cloud and feather designs. (Height: 21"; width: 21.5")

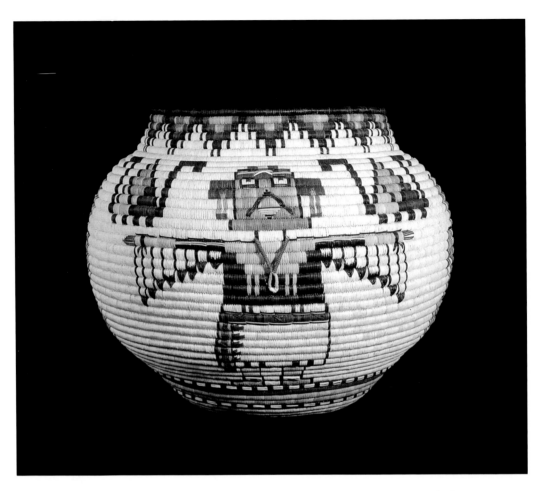

An Eagle Katsina coiled basket made by Madeline Lamson in 1989. The basket represents the first time a weaver used this design in a basket rather than a plaque. It won Best of Show in the Hopi Craftsman's Exhibition at the Museum of Northern Arizona in 1989, and it is now in the collection of Richard A. and Margo Dove Mehagian of Kópavi International Gallery in Sedona, Arizona. (1993; height: 18″, width: 16″)

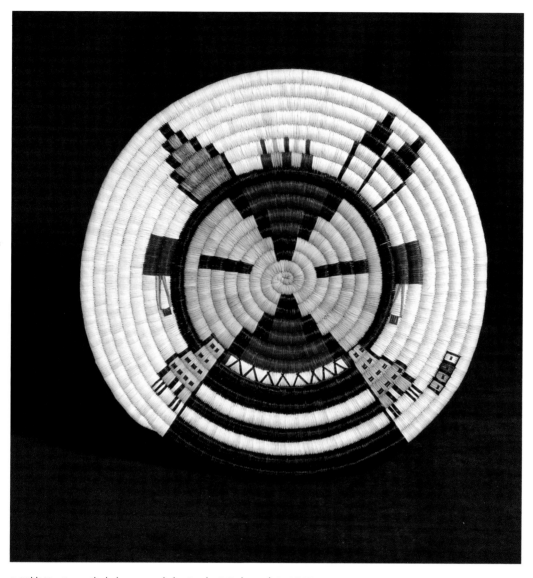

A Hilili Katsina coiled plaque made by Bertha Wadsworth in 1995. (Diameter: 15″)

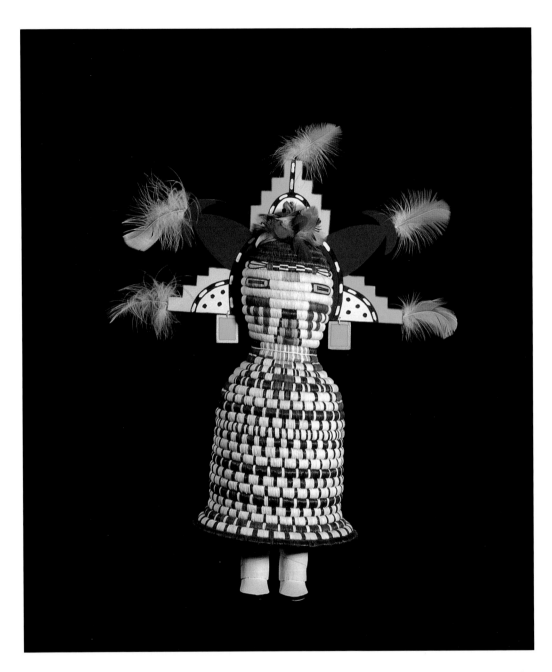

A Sa'lakwmana basket figurine made by Bertha Wadsworth in 1988. It is in the collection of Richard A. and Margo Dove Mehagian of Kópavi International Gallery in Sedona. (1993; height: 22″, including the feather).

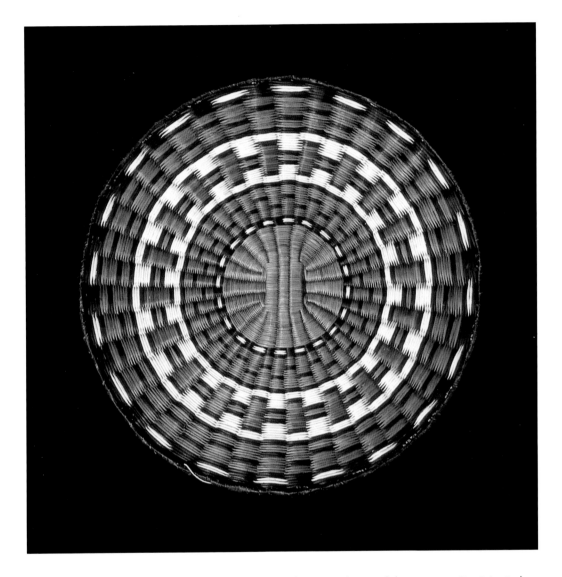

A wicker wedding plaque (*hahawpi*) made by Dora Tawahongva with vegetal dyes. It won a First Prize in the Hopi Craftsman's Exhibition at the Museum of Northern Arizona in 1993. (1993; diameter: 13″)

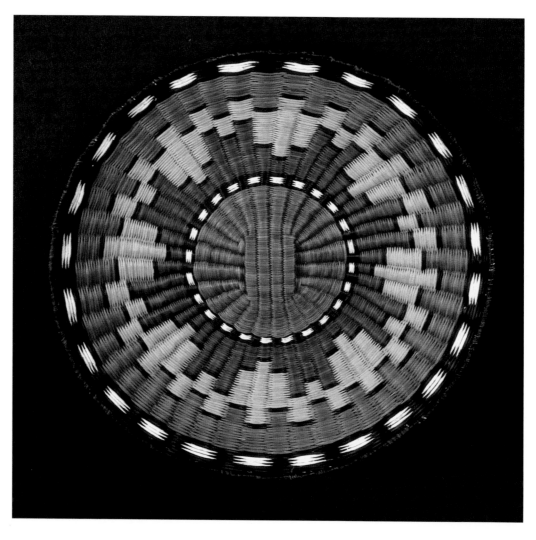

A wicker plaque made by Dora Tawahongva in 1992. It was photographed at McGees Indian Art Gallery in Keams Canyon, Arizona. (1992; diameter: 12"; ASM no. C-28667)

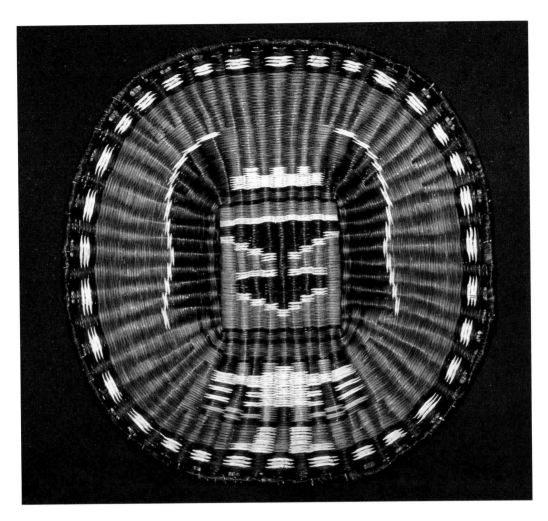

An Angwushahay'i (Crow Mother) Katsina wicker plaque with materials colored with vegetal dyes. Made in 1995, it was the last Katsina plaque that Abigail Kaursgowva made. She said that weaving them has become too hard on her hands. (1995; diameter: 12")

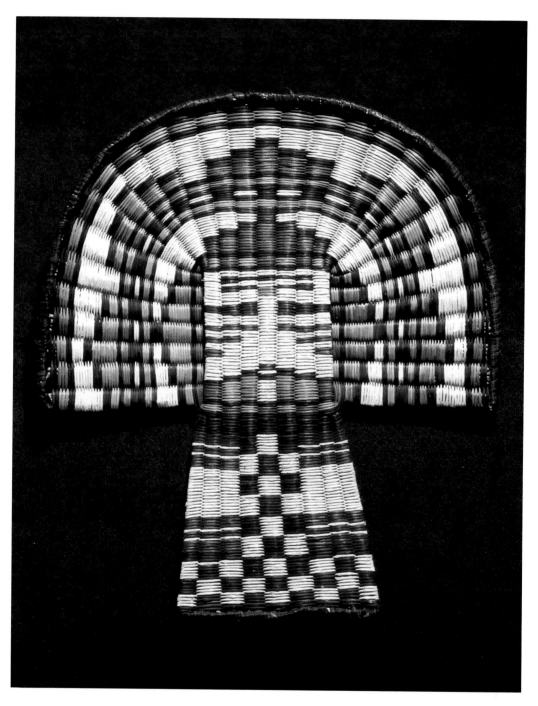

A wicker plaque, or *yungyapu*, in the shape of a putsqatihu (flat kachina doll) depicting a Palhikwmana. It was made by Abigail Kaursgowva in 1993. (1994; length: 12″)

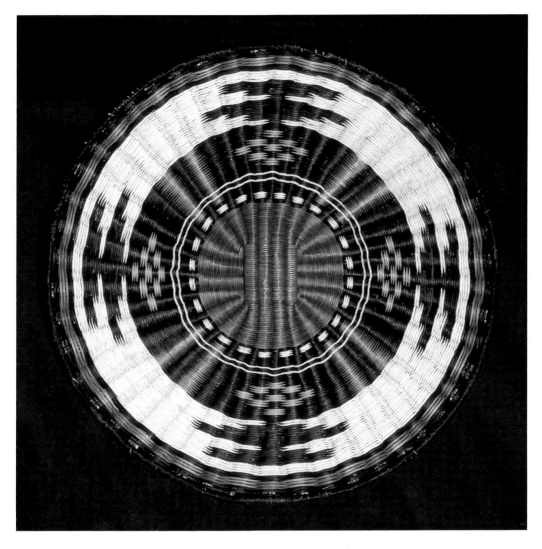

A wicker plaque with an embroidered robe design (*Tuii'yungyapu*) made by Eva Hoyungowa in 1992. (1992; diameter: 15″)

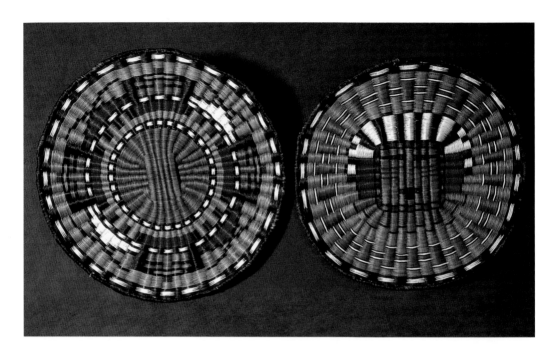

Wicker plaques made by Treva Burton in 1991: four Longhair Katsina faces (left) and a side dancer of the Kooninkatsina (right). The larger plaque is in the Arizona State Museum collection. (1991; diameter: 15″ and 13″; ASM no. C-27026)

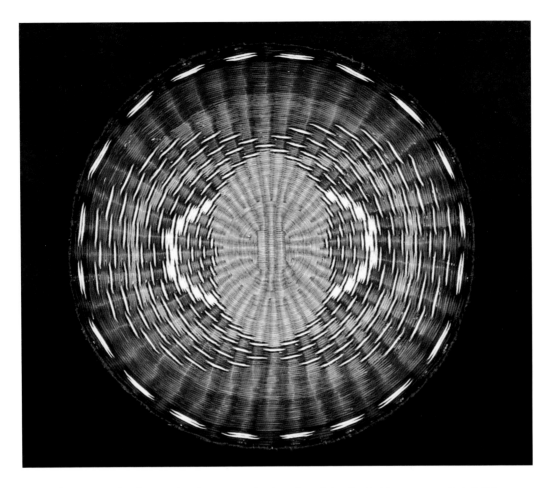

A Ootsokpu (Covered with Particulates) yungyapu (wicker plaque) that Bessie Monongye made in 1995 using vegetal dyes. (1995; diameter: 12.75″)

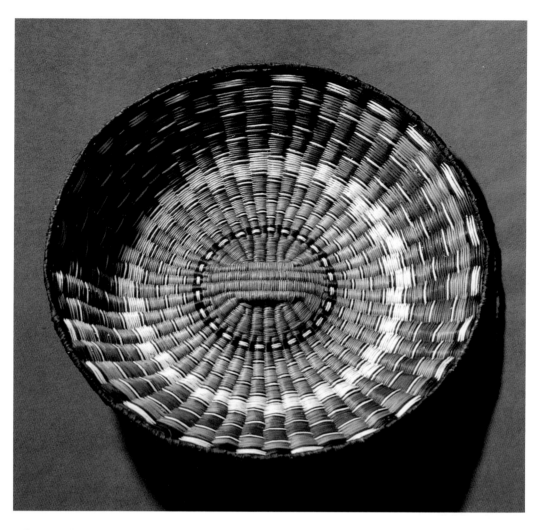

A large, wicker bowl-shaped basket made by Bessie Monongye in 1991 using vegetal dyes. (1991; diameter: 30″, depth: 6″; ASM no. C-27034)

when she makes them they are amazingly beautiful. In 1991 she made an immense and beautiful basket for a collector in Colorado. It took her more than a year to finish because her many family and community obligations sometimes kept her from working on it for months. The design has four full Katsina figures, with two of the same kind opposite each other, slightly offset, and two huge ears of corn providing the fifth element in the circle around the large basket. Stepped zig-zag cloud symbols on the bottom and near the neck of the basket complete the design.

Other basket-weaving duties also prevent her from working on orders for large baskets. Usually she works on plaques for gifts, dances, and paybacks, and as items to sell. During a year she can make ten to twelve plaques and two larger deep baskets with four Katsina heads. These deep baskets are only about half the size of the very large one she was working on in 1991.

When Remalda goes collecting her materials for weaving, she usually enjoys the company of her friends Joyce Ann Saufkie and Madeline Lamson. They take one car and, if possible, collect enough yucca in one trip to last for a whole year. To collect galleta grass, she may have to go several times to different locations, depending on its annual availability. In early summer she collects siita plants for the red color in her designs.

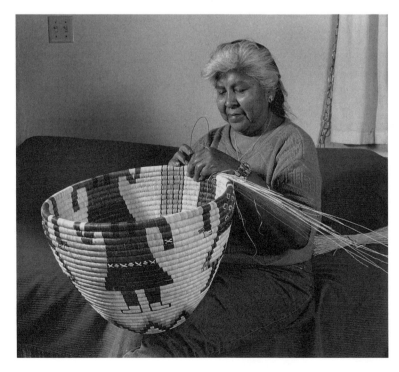

Remalda Lomayestewa of Shungopovi. (1991; ASM no. 86164)

Remalda often demonstrates her weaving at the Hopi Crafts-man's Exhibition in Flagstaff. When I asked her about the awards she has won, she replied that she had won so many that she had lost count.

JOSIE TYMA

Josie Tyma belongs to the Bearstrap/Spider Clan. She is recorded as having been born in Shungopovi on June 1, 1905. The federal government gave her this date of birth when such a date was deemed absolutely necessary for a person's development in life. Her family thinks that the year 1903 is more likely correct. The important fact is that Josie is the oldest woman in Shungopovi and is respected accordingly.

In her youth, when all the women in the village knew how to make coiled plaques and baskets, Josie watched them carefully and eventually taught herself the art. She could make plaques and plaited sifter baskets before she was initiated into the Lalkont. After a short time she also taught herself how to make deep baskets, which sold well.

During her marriage she had four children—three daughters and one son, who is the youngest. Josie now lives with her son, Byron, and his wife, Rachel, who take care of her. Josie taught basket weaving to all three of her daughters. Gladys Kagen-weama, the oldest daughter, became a very good weaver but never showed any interest in making sifter baskets. Josie usually made them for her until 1993, when she made a sifter basket for Gladys to throw to the crowd during the Basket dance. After that, Josie stopped making sifters. In 1990 she made her last coiled plaque. She had to stop because it was too hard on her arms, hands, and eye. Many years ago Josie had lost the sight in her right eye; she cannot remember how or when it happened. Now her left eye needs a cataract operation, which may restore her sight. She does not want to be forced to sit still and do nothing and continues to do housework and cooking. After the operation she will probably begin to weave baskets again.

She remembers that a long time ago she won prizes at the Hopi Craftsman's Exhibition, held every Fourth of July weekend at the Museum of Northern Arizona in Flagstaff. She used to send her baskets and plaques to the museum, where they were sold after the show. She also sold her work through galleries in Sedona and McGees Indian Art Gallery in Keams Canyon. Twice in her

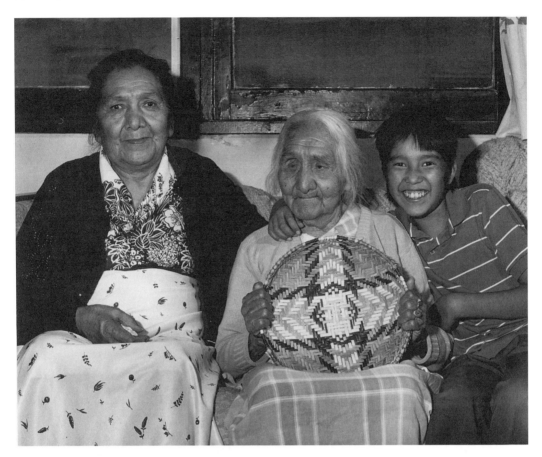

life she traveled to Chicago to demonstrate her art and to bring Hopi coiled basket weaving to that large city.

Josie Tyma of Shungopovi with her daughter Gladys Kagenweama and her ten-year-old great-grandson Benny Naseyowma. (1992; ASM no. 87103)

RETTA LOU ADAMS

Retta Lou Adams belongs to the Bearstrap/Spider Clan. She was born on June 6, 1940, in Shungopovi. When she was fifteen years old, her mother, Gladys Kagenweama, showed her how to make baskets. She, in turn, had learned the art from her mother, Josie Tyma. Retta's family is particularly interesting because in it there are currently four generations of basket weavers.

Retta usually makes one or two large, deep coiled baskets with Katsina figures each year. In 1991 she had made two, finishing the first in July and the second at the end of November. In between, she makes plaques for dances, as paybacks, and for sale. Most of her baskets are purchased by the Richardson Trading Post in Gallup, New Mexico.

Retta taught her only daughter, Alicia, basket weaving when

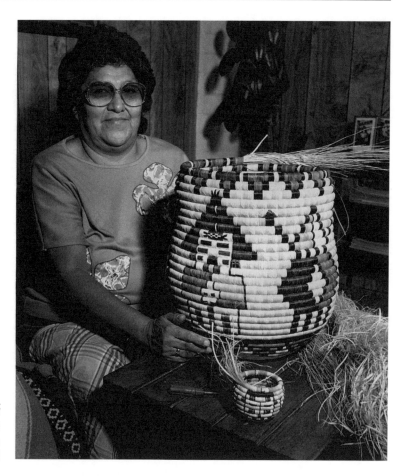

Retta Lou Adams of
Shungopovi weaving a
deep basket. (1991;
ASM no. 86292)

she was fourteen. Alicia is particularly skillful at making miniature
baskets, though she occasionally also makes baskets in a medium
size. Most of her baskets are sold at the Old Oraibi Arts and
Crafts Store in Old Oraibi.

ROBERTA NAMINGHA

Roberta Namingha is a member of the Bearstrap/Spider Clan.
She was born on November 23, 1932, in Shungopovi. Her older
brother is still alive, but another brother and her only sister are
deceased.

From childhood on, she watched her mother make plaques,
but she never attempted to make deep baskets. At age eleven
Roberta was initiated into the Lalkont and started basket weaving
herself. She can still remember her first plaque, which, though
small, had a cloud design composed of all five colors: white, yel-

low, green, red, and black. No wonder she was proud of it and even sold it for twenty cents! At the age of fifteen she also wanted to try to make deep baskets and really put her interest into learning it for herself. She believes that by the time she was twenty she had mastered the craft and was very good at it.

In the early 1960s she won her first prize. She had entered a large plaque with a Crow Mother Katsina design in the Hopi Craftsman's Exhibition. She received a blue ribbon, indicating a First Prize. After that, Roberta entered pieces of basketry in the show every few years, but she entered only those plaques or baskets that she felt right about showing. She excels in making large plaques and baskets, and at the time of my visit she was working on a beautifully executed basket with two large eagle figures opposite each other. She claims that she is not as fast a weaver as her friend Joyce Ann Saufkie. Nevertheless, from time to time she does submit her work to the juried shows at the Intertribal In-

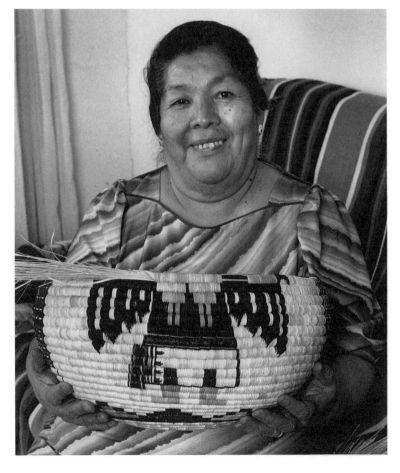

Roberta Namingha of Shungopovi is working on a large basket with two Eagle Katsina figures. (1994)

dian Ceremonial in Gallup and the Indian Arts and Crafts Fair in Sedona, where she has also demonstrated basket weaving. Over the years, Roberta has won six First Prizes and belongs to that small group of weavers who attempt to make really large coiled baskets.

Roberta deals mainly with a dealer in Zuni who buys and sells her basketry. But she also sells to individual collectors who come to her house and to Byron Hunter, who works for the Heard Museum in Phoenix. Occasionally she sells him one of her beautiful pieces of coiled basketry.

At the proper time for collecting the plant materials for basketry, Roberta goes with Joyce Ann Saufkie and Madeline Lamson to share travel expenses and their company. Sometimes they meet to weave together and split their yucca leaves in preparation for bleaching or, once bleached, for dyeing. Sometimes they also weave together, chatting and laughing while they work. They do this mostly when they start on one of their large pieces. The beginning—either the center of a plaque or the bottom of a basket—is the most tedious and uninteresting part, since weaving the intricate design does not begin until later. It is good to share these hours of uninterrupted work and get a good head start.

Roberta is proud of her four daughters and four sons, whom she had to raise by herself. Perhaps, one day, one of her four daughters will continue their mother's art. For now, she can enjoy her eleven grandchildren, who often come to visit her.

PEARL NUVANGYAOMA

Pearl Nuvangyaoma was born into the Sun/Forehead Clan on June 16, 1927, in Shipaulovi on Second Mesa. When Pearl was eight or nine years old, she learned basket weaving from her mother and grandmother. She recalls that there was hardly any time to play when they were children; girls always had to help with the housework. For many years, all four sisters have been exceptional weavers of coiled basketry.

Two of Pearl's sisters—Rita Nuvangyaoma and Frieda Yoyhoeoma—still live in Shipaulovi, while Mary Jane Batala, her other sister, lives in the new housing area below Second Mesa. Pearl also lives below the mesa on land that once surrounded her grandmother's summer house. In Shipaulovi, which is one of the Hopi villages situated high on the precipices of Second Mesa, there is

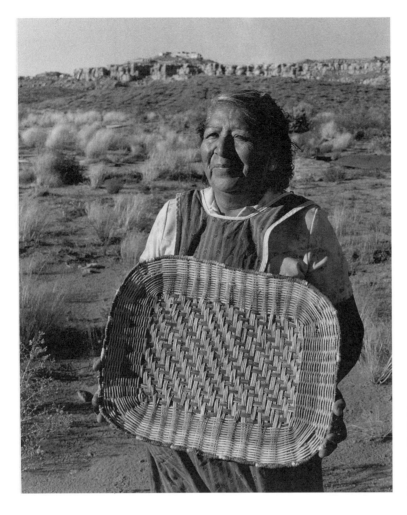

Pearl Nuvangyaoma of
Shipaulovi with the piiki
tray she made for the
Arizona State Museum
in October 1991.
(ASM no. 86180)

not enough room to build more houses, so new families have to
locate below the mesa. When Pearl married, her mother gave her
the old summer home, and Pearl built a frame house nearby in
1945. Since then, Pearl's family has built three houses there, and
she is planning to have a new one built. Her husband used to
work in Phoenix, and she remembers times of loneliness when
he had to be away. She would pack up her children and walk up
to Shipaulovi to see her mother. That was some forty years ago,
when Highway 264 was still a dirt road and she had no neigh-
bors. In 1948 an Exxon station and a post office were built at the
turnoff to Winslow, but the road was not paved until 1957 or
1958. Then a trailer park for the workers on the road was put in
at the crossing, and Pearl did not feel quite so isolated anymore.

Pearl raised eleven children, and she is very proud of them all.

A long row of their portraits hangs over her sofa. It was only re-cently that she and one of her daughters finished all the plaques and piiki trays for this daughter's wedding robes payback. She still has one daughter who has to make her payback. Her children must feel very proud of their mother—and lucky, too, that Pearl can make almost every kind of basketry item. Her coiled plaques are superb, but in addition she can make plaited sifter baskets, piiki trays, small square trays, and burden baskets for ceremonies.

Pearl collects the materials herself, usually below the mesa, where she finds the yucca leaves for her coiled weaving and her sifters. She gathers the whole plant because she uses every leaf of it. Along the road she finds the siwi for her piiki trays, but she can no longer find arroyo willow twigs for the wicker weave of the border of the piiki trays. Instead she uses the commercial reed sold in a Winslow craft store, which gives her long, round strands. She makes sifter baskets in small and large sizes, often incorporat-ing designs with dyed yucca leaves. Furthermore, to supplement her income she embroiders ceremonial kilts. She truly is a woman of many skills, and her work is much appreciated by collectors and tourists.

Pearl has often demonstrated her weaving techniques, mainly for the Hopi Guild. In 1990 the Hopi tribe asked her to represent the Hopis at a demonstration with nine other Hopi artists at the Smithsonian Institution in Washington, D.C. With a smile on her face she said she liked it very much.

From time to time she participates in work parties—those oc-casions when women get together in someone's house to weave for the woman who owns the house, who then, in turn, has to feed all of them. Everyone leaves the pieces they started so that the woman can finish them later. This way she has more plaques for her payback. These get-togethers are very informal on Sec-ond Mesa. They last only one day and are held irregularly.

In 1991 Pearl volunteered to be photographed while making one of her beautifully executed piiki trays. It is now part of the Arizona State Museum collection.

FRIEDA YOYHOEOMA

Frieda Yoyhoeoma, one of Pearl's sisters, was born into the Sun/Forehead Clan on January 18, 1939, in Shipaulovi. Three of the sisters learned the art of basketry from their mother and grand-

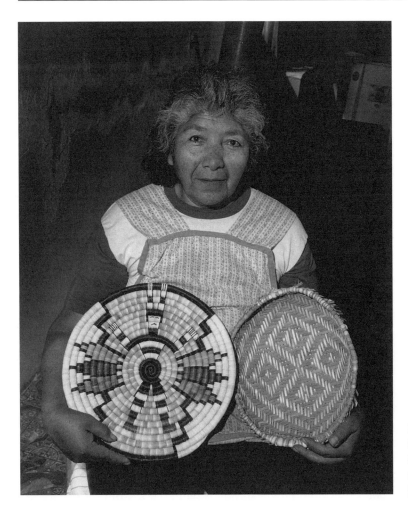

Frieda Yoyhoeoma of
Shipaulovi with her Hano
Clown coiled plaque and
a plaited sifter basket.
(1991; ASM no. 86318)

mother. But Frieda, who is the youngest, was very young when
her grandmother died and instead learned basketry from her
mother when she was sixteen years old. Soon after, she was initi-
ated into the Lalkont.

When I asked Frieda about the role godmothers play in teach-
ing their goddaughters the skill of basket weaving, she said that
many of the young godmothers today do not know basket weav-
ing well enough to teach it, so girls learn more from their moth-
ers. She and her sisters all taught their daughters and made good
basket weavers out of them. Frieda has two daughters and two
sons. Only one of the daughters is married so far, and this daugh-
ter's wedding robes payback was finished six years ago.

Frieda carefully explained to me how she collects and prepares
her plant material. I sensed that she takes great pride in her work

and continually strives to refine her sewing material, her designs, and the selection of the colors she uses. She can achieve a variation in the natural green color of yucca by shortening or lengthening the period of bleaching. This way she obtains any shade of green she desires. She also is very diligent in making the coils in her baskets as evenly round, tight, and compact as she can. To achieve this consistency of evenness in size and compactness, she is very selective in choosing her foundation material. Galleta grass is moderately flexible, but if her coil is getting too stiff, she adds very finely split yucca strips, which are more flexible if taken from the lower part of the leaf. To stiffen the coil, Frieda adds shredded parts of the upper yucca leaves that are too short for the dyeing process. She keeps all these different fiber splints separately rolled in damp cloth so they will be ready when she needs them. She splits the yucca splints for the sewing process as thinly and narrowly as she can in an effort to refine her sewing splints. She saves every scrap that falls to the floor, and the next day she uses them all in her foundations.

Frieda, like other weavers, finds the preparation of yucca splints for the dyeing process the most tedious and time-consuming work in the whole process of basket weaving. The second hardest job for her is the collecting of the material, yucca in particular. She goes collecting with her daughters, and in one trip they try to collect enough for a whole year. Sometimes they have to make another trip when the plants are not quite ready in summer. When the newly sprouted white center of the yucca plant can be removed easily, it is the harvest time for the white leaves. Not every plant will yield to the picking, and often the women have to walk a great distance looking for the right plants or return another time. She and her daughters also share their time in dyeing, another complicated process. She is one of the few lucky women who still have a good supply of sunflower seeds that someone brought her. Frieda makes her black dye last by freezing the solution after each use. She smokes her black yucca to make the color blacker, and uses hohoisi or siita for her red color, which requires smoking.

Her house sits high on the rocky ground of Second Mesa, providing her with a magnificent view in all directions. It is difficult to drive a car to her house and most visitors walk part of the way, but the effort does not deter them from coming to her house, where Frieda warmly welcomes them. She sells to collectors in California, New Jersey, and other places far away. Many write to

her, telling her what they want, and in due time Frieda sends them the finished plaque.

She makes interesting designs, many of which are different from those used by other weavers. She includes bear claws and rattle designs in her plaques and, of course, kachina figures or faces. She gets ideas from books and alters design elements to suit her taste. She says, "I think about what to put in there and then try it. Most designs come out pretty good." Her confidence results in excellent workmanship and artistry.

EVELYN SELETSTEWA

Evelyn Seletstewa was born into the Fire Clan on July 28, 1931, in Mishongnovi. Her husband, Ivan Seletstewa, was born on July 4, 1935, into the Butterfly Clan. They have lived all their

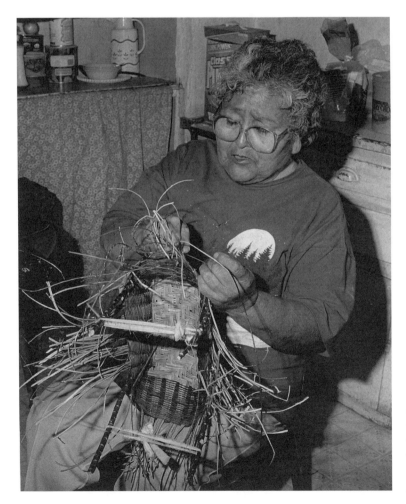

Evelyn Seletstewa of Mishongnovi weaving a fruit basket using split arroyo willow branches for the warp and commercial reed for the weft. (1993; ASM no. 89044)

lives in Mishongnovi. Evelyn grew up in the house next to the Sun kiva, and Ivan's house was opposite the kiva and Evelyn's house. Neither house has water, and Ivan's also has no electricity.

They have four daughters and two sons. Like their mother, all four girls know how to weave coiled plaques, and the youngest, Colleen, also makes the other basketry items her mother makes: piiki trays, cradles, and fruit baskets. Evelyn had to quit school when she was fifteen to help her mother support the family. Ivan quit school for the same reason when he was only thirteen. He carves traditional-style kachina dolls and makes rattles.

Evelyn taught herself how to make basketry when she was fifteen years old and later also taught herself how to make pottery. In the beginning she made only coiled plaques. Now she is one of the very few basket weavers who also make piiki trays, burden baskets, and cradles. Evelyn makes large burden baskets for the So'yok wuuti Katsinam, but it takes her a whole month to weave one basket. She also weaves smaller burden baskets (*ho'aphoya*) for initiations. Cradles are often ordered by young mothers for their first baby, or by collectors. If she can devote her time exclusively to weaving, Evelyn can make a cradle in four days.

The basket she makes most often is the so-called fruit basket. This looks like a small version of the burden basket, but it is woven in a different fashion and with different materials. Colleen drives Evelyn and Ivan to the lake in Keams Canyon, where they collect willow twigs. Unsplit willow twigs are the warps, and the two thicker, U-shaped branches that give the fruit basket its shape are tamarisk branches (formerly scrub sumac branches were used). The bottom of the basket is plaited like the center of a piiki tray, with unsplit willow twigs as warps and split willow twigs woven in twos over and under the warps as the wefts. Evelyn continues the walls in wicker technique, using commercial reed material.

When freshly cut, sumac branches can easily be bent into the desired shape and held with cotton strips until they dry out. Rings for plaited sifter baskets are formed that way, and branches from tamarisk are used for the same purpose. Tamarisk, an introduced plant to Arizona, can be recognized by its reddish brown color, while scrub sumac is more gray-brown.

Evelyn has always been known for making cradles, burden baskets, and coiled plaques. A few years ago she started making smaller cradles out of sumac for sale to tourists. When she dis-

covered the commercial reed material at Casey's, a hobby store in Winslow, she used that for the miniature cradles. She dyed it and found that the colored cradles are most favored by buyers. Her daughter Colleen joined her in making the miniature cradles and now makes them almost exclusively.

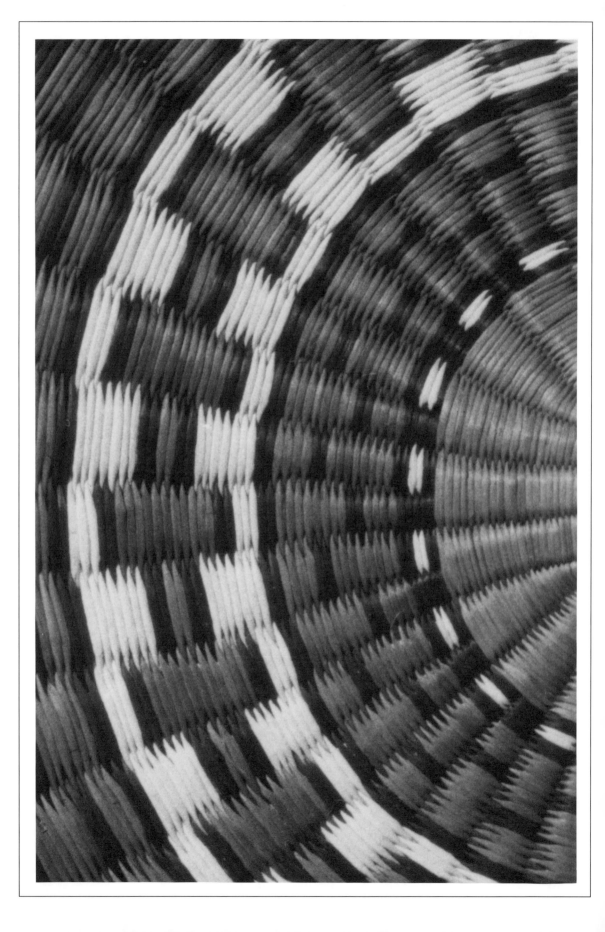

Wicker-Basket Weavers
of Third Mesa

Just as with my contacts on Second Mesa, over the last twenty years I have established friendly connections with Hopi women in Hotevilla and Bacavi on Third Mesa. In 1987, with the encouragement of Von Monongya, one of my friends who is a kachina-doll carver, I approached Oraibi, which for many years had closed its doors to non-Indians. At Oraibi in 1990 I met Von's mother, Bessie Monongye, and his aunt, Treva Burton. Both became invaluable teachers and friends. In Hotevilla I renewed old friendships and made new friends. Altogether, I contacted twelve wicker-basket weavers, ten of whom live in Hotevilla and two in Oraibi. Just as on Second Mesa, the women in the villages of Third Mesa were the advisers for this documentation, and I was their recorder.

VERA POOYOUMA

Vera Pooyouma belongs to the Corn Clan and is the oldest woman in Hotevilla. Her date of birth is not known, but it is believed that she must be at least 104 years old. Her son, the well-known moccasin maker Rex Pooyouma, thinks she is 108. Vera still weaves plaques, deep wicker baskets, plaited sifter baskets, and sifters for parched corn. In 1993 I photographed Vera with a deep wicker basket, which she soon finished and immediately sold. Other women in Hotevilla told me that Vera has more energy than most of them, and still does everything herself, including cooking and keeping her little house in order. Vera is said to work harder than the other basket weavers in work parties, and the younger ones still learn from her. Unfortunately, I could not communicate with Vera directly because she is very hard of hearing and cannot understand my English. Rebecca Hoyungowa kindly translated for me. I wished I could have understood every word this wonderful old lady was saying.

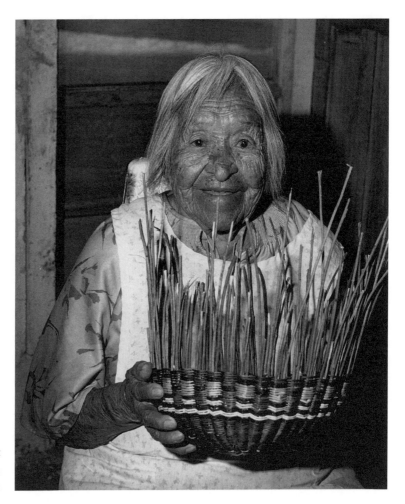

Vera Pooyouma of
Hotevilla working on a
deep wicker basket. (1993)

Vera remembers that she went to school in Kykotsmovi when she and her family still lived in Oraibi before 1906. She thinks she was twelve or fourteen at the time of the Oraibi split in that year. After her family settled in Hotevilla, she was sent with other children to the school in Keams Canyon. She remembers that she went to school in Keams Canyon for three years, and it was during those years that her mother instructed her in wicker basket weaving. Vera was then fifteen years old and was initiated into the Lalkont and O'waqölt societies.

She says that when she started to put color designs into her work she used commercial dyes, which corresponds with the generally accepted observation that aniline dyes were first used from about 1890 to 1910 (see Tanner 1983, for example). For many years after that, Vera used vegetal dyes from plants she collected herself, but now she uses commercial dyes, since their

preparation requires much less time and they are easier for her to use. Years ago, Vera also made baby cradles and piiki trays, which she often sent to the Museum of Northern Arizona for the Hopi Craftsman's Exhibition. For many years she would travel to the museum to give weaving demonstrations at such events, but she cannot see well enough anymore to demonstrate how to make the beginnings of plaques or deep baskets. Nevertheless, her son Rex still enters her pieces every year. Vera says that she never won an award or prize, but she always sells her basketry items.

Two of Vera's sons are still alive, but she says she had many more children who all died in infancy. She cannot remember how many she had. Her memory is clearer when she thinks back to her adolescence, at the time when her father was imprisoned at Keams Canyon for refusing to cooperate with the federal government in sending Hopi children to the government school. He was called Happy by those imprisoned with him because, despite all the anguish and insults they suffered, he kept his cheerful disposition. His photograph—that of a handsome, smiling Hopi man—hangs on the wall of Vera's living room.

When I asked her about the earliest Katsina designs on wicker plaques, Vera replied that early plaques had no woven color designs but were whitewashed with kaolin and then painted by men with blue mineral paint. The only Katsina depicted was the Sa'lakwmana (Shalako Maiden). As I sat next to her, holding her hand and congratulating her on her age, she said: "I don't want to die." I hope that this spirit keeps her alive for many more years. She is truly remarkable.

EVA HOYUNGOWA

Eva Hoyungowa belongs to the Corn Clan. She was born on May 4, 1912, in Hotevilla. Her Hopi name is Polingumka, a Hopi name for a girl that roughly translated means "butterfly emerging." Polingumka has lived all her life in Hotevilla. Having grown up in this village on Third Mesa, she became, by tradition and quite naturally, one of the most superb wicker-basket weavers in Hotevilla. Her daughter, Rebecca Hoyungowa, has the name of Komavenski, which in Hopi expresses the beautiful paint on a Katsina's face. A third generation in the home is Rebecca's son, Thomas Hoyungowa.

Eva remembers that her mother told her she was born in the month of May. Much later, her official date of birth was set as

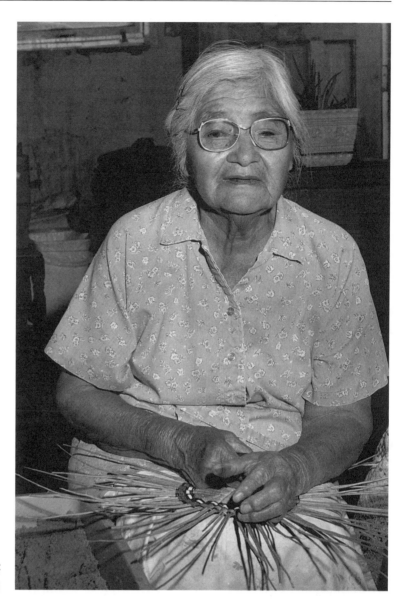

Eva Hoyungowa of
Hotevilla. (1993)

May 4. Eva's father belonged to the Badger Clan, whereas her
husband, who died in 1982, was of the Crow Clan.

Many years ago the Hoyungowa family lived next to the
Sekaquaptewa family in Hotevilla "up on the hill," and Eva has
fond memories of all the children in that family. At the time of
ceremonies, when the men were busy in the kivas and could not
devote their attention to the children, the task of taking them to
the kiva fell to Eva.

When Eva was a little girl, there were no schools on the Hopi
Reservation, and children would start school later than they do

today. Eva was nine years old when she started first grade at the new day school in Hotevilla. Up to then she had spoken only Hopi, but in school she was allowed to speak only English. If children slipped into speaking Hopi, the teachers would strike them with a strap—the girls on their hands, and the boys on their behinds.

Eva stayed in the Hotevilla Day School for a year, and then in 1922 she went to the Sherman School, an Indian boarding school in Riverside, California. She came home to Hotevilla for the summer only once during her nine years at Sherman. During the summer months the older girls were placed as home workers with families. She was allowed to keep half of the little pay she and other girls who did similar housework received, and the other half went to the school. When she returned home in 1933, she was twenty-one and now had the time to devote her attention to learning basket weaving. Though her teacher was her father's sister, Eva had watched her mother making plaques when she was a girl, so now she quickly learned the craft. Her aunt taught her how to weave the designs into wicker plaques and baskets and also showed her how to make deep baskets with lids, which Hopis made mainly for the tourist trade.

Eva also learned from her aunt how to collect the proper plants for the dyes, how to prepare them, and how to dye the *siváapi* (rabbitbrush) using vegetal dyes. Besides the deep lidded baskets, Eva also used to make more shallow baskets, all for sale to non-Hopi collectors and tourists. She would send the deep baskets to the Museum of Northern Arizona for the Hopi Craftsman's Exhibition and often won prizes for them. She also demonstrated her weaving at the exhibition and at the state fair in Phoenix, often with Fred Kabotie. She estimates that she has won at least ten First Prizes and twenty Second Prizes for her plaques and baskets.

For some time she has not been able to make deep and shallow baskets because the work is too hard on her hands and her eye sight is declining. But she still makes beautiful plaques, which she sells to the tourists who come regularly to her house. She never was a member of the Hopi Guild, nor does she sell directly to any trading post or gallery.

Eva often goes by herself to collect material just below the village or around the Hotevilla school. "I like to go collecting," she says. "I like to walk and don't like to sit still." But very often other women quickly collect the material that is close by. Then

women have to drive considerable distances to get enough plant
material to last them several months. Eva used to belong to a
group of Hotevilla women who meet routinely in each other's
homes for several days and keep each other company in their
weaving work. She remembers being admired by the young
women for her knowledge in selecting the right sizes of rabbit-
brush and the right colors to create a particular design, and for
giving them advice in dyeing and weaving techniques. They still
invite her to come, but she declines, saying that she cannot work
as fast anymore.

Eva works on her basketry whenever she finds the time, obvi-
ously enjoying her continuing involvement with the natural fi-
bers. Quite emphatically she remarks: "If I would not be making
a plaque, what would I do? I think it is fun and gives me a good
feeling. I am happy when I am weaving."

ABIGAIL KAURSGOWVA

Abigail Kaursgowva belongs to the Sparrow/Fire Clan. She was
born in Hotevilla on May 16, 1915. As a young girl she was ini-
tiated into the Mamrawt society and is also a member of the
Powamuya society. Hotevilla does not observe the Mamrawt cer-
emony anymore, since their priestess died some years ago.

Like many of the older Hopi women, Abigail started school
when she was about nine or ten. She was sent to the Valentine
School in Truxton Canyon on the Hualapai Reservation and at-
tended that school until she was about sixteen. Like many other
young girls, during the last three summers of those school years
she held a summer housekeeping job with families in California.
Her last year of schooling was at the Sherman School, where,
again, she spent two summers with the same family. She did not
finish school and finally came home after the eighth grade.

Abigail remembers that her father made large burden baskets
and that her mother was a very good basket weaver who also
knew how to make deep wicker baskets. Abigail learned weaving
from her mother but never mastered the art of making deep bas-
kets. Nevertheless, she must have learned weaving very well.

The Arizona State Museum has numerous older plaques in its
collection that have a different type of beginning (*yayni*) than
those made today. I asked several women how old these plaques
were, since none has a more precise date on the catalogue cards
than "collected in the 1920s." No one could tell me. They were

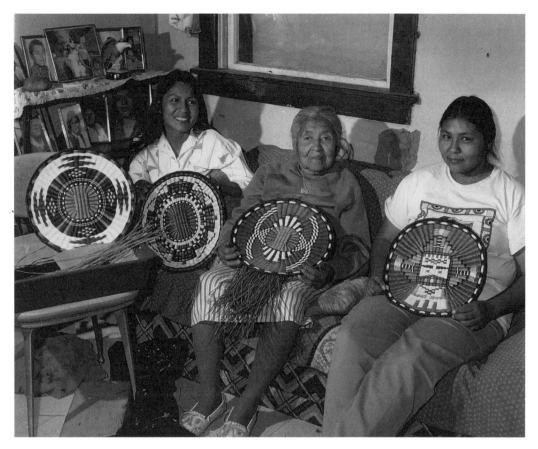

Abigail Kaursgowva of Hotevilla with her granddaughters Jolene Lomayaktewa, at left, and Harriet Lomatska, both of whom are excellent wicker weavers. (1991; ASM no. 86349)

not able to remember ever having seen such a beginning. However, when I showed the photographs to Abigail, she immediately recognized the *yayni* and when asked said she could make this kind of beginning on the spot. About seventy years ago she had learned it that way from her mother, and she remembered that it was believed to be easier for a beginner to start a plaque that way. She also remembered that her mother still used this technique once in a while in her plaques. Abigail said that her mother lived to be very old and showed me a photograph of her taken in 1958. In it her mother, dressed in traditional Hopi dress, appears to be in her eighties. Abigail remembers that her mother would go down to the Hubbell store in Kykotsmovi to sell her baskets and plaques when she needed groceries. That was a time when a sack of flour cost fifty cents and a pound of coffee or sugar twenty-five cents.

Abigail married twice, and her second husband, Nelson, died only a few years ago. She has two sons and three daughters. Only her eldest daughter, Josefine Lomatska, became a basket weaver,

and she is a very fine one. Josefine's daughters, Jolene Lomayaktewa and Harriet Lomatska, visit their grandmother frequently and often share their time weaving plaques. Both young women are excellent basket weavers. Abigail does not waste any of her dyed siváapi strips, inventing and creating her own colorful designs, in which she mixes all her colors. Her weaving creates an impression of kaleidoscopic geometric designs. Her neighbor Allie Seletstewa liked the idea of not wasting any material and also started to incorporate colors at random into her designs.

Abigail uses designs that feature Butterfly Maidens and Katsina figures and faces besides all the other traditional wicker designs. But she also enjoys using old and new motifs to create her own geometric designs, and she works on them constantly, coming up with new ideas all the time. When she was younger, she demonstrated weaving for many years at the Heard Museum, and at the Hopi Guild when Fred Kabotie was still there. She also demonstrated at the Hopi Craftsman's Exhibition in Flagstaff many times. I met her the one time she demonstrated at the Arizona State Museum in the late 1960s, and we have been friends ever since. From the various shows she has won four First Prizes, two Second Prizes, two Third Prizes, and several Honorable Mention awards. She has one Best of Show from the Hopi Guild, which she received at their Fifth Annual Festival on September 5, 1992.

Abigail thinks wicker basketry should earn higher prices, especially considering the creativity that goes into the designs, the color combinations, and the excellence of execution. She believes that as much, if not more, time is spent in preparing the weaving materials as in the actual weaving.

When we talked about the O'waqölt dance—where great quantities of plastic and metal utensils and other modern household items are given away—Abigail spoke her thoughts aloud: "They [the Conservatives in Hotevilla] don't like Hopis to have all that modern stuff, but we have it all anyway. They think we won't be Hopi. . . . But we always will be Hopi. . . . Hmm, yah, Hopi with *pahaana* [white people's] stuff."

JOSEFINE LOMATSKA

Josefine Lomatska belongs to the Sparrow/Fire Clan. She is the third child and eldest daughter of Abigail Kaursgowva, and she learned basket weaving from her mother when she was fifteen. She was born on June 29, 1942, in Hotevilla. Josefine and her

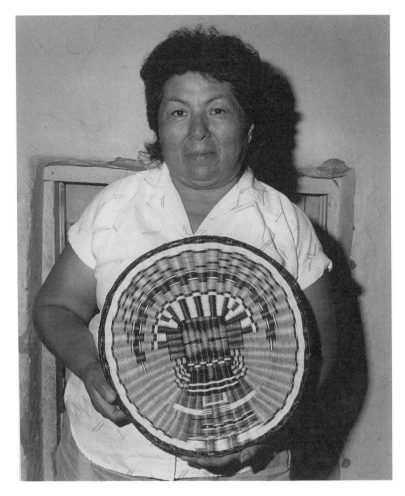

Josefine Lomatska of Hotevilla holding a plaque she made with a Katsinmana design. (1991; ASM no. 85792)

husband have four daughters and two sons. She lives in Hotevilla and works in the kitchen of the Hotevilla School to supplement her family's income. Lately she has had no time for weaving wicker plaques because of her full-time job. But when two of her daughters, Jolene and Harriette, were teenagers, she taught them the art. Jolene, who has a family of her own now, lived with her grandmother Abigail for a while, and both did quite a bit of basket weaving together. Jolene's payback for her wedding robes was in June of 1992, with fifty plaques and plenty of cornmeal and other food. Most of the wicker plaques were made by Josefine, Abigail, and Jolene.

Josefine says that most women in Hotevilla who are more than thirty years of age are still making wicker baskets, mostly plaques. However, the young mothers either have to work for their income or show no interest in the time-consuming art of basket weaving.

ALLIE SELETSTEWA

Allie Seletstewa belongs to the Roadrunner/Greasewood Clan.
She was born on November 25, 1917, in Hotevilla, the second of
five children—three boys and two girls. Even though her mother
wove plaques, she never really saw her weave; her mother was
too busy with household chores and other obligations.

Most of the time Allie stayed with her grandmother, an active
basket weaver who joined other women in weaving parties. That
way Allie could watch all these women make their baskets and
plaques, and she learned a lot. She started to weave her first
plaque with discarded pieces of siwi and siváapi and quickly mas-
tered the craft. She remembers that after an old woman made a
large, deep basket and sold it for a good profit to a white couple,
the woman urged the others to make deep baskets, and Allie
taught herself how to weave them.

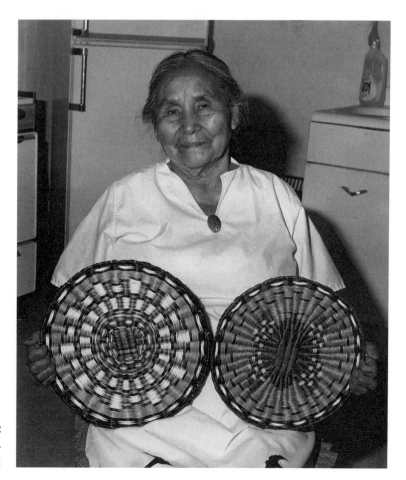

Allie Seletstewa of
Hotevilla with two of her
wicker plaques. (1993)

Allie attended high school in Phoenix but had to leave in the ninth grade to take care of her brothers after her mother died. Her father lived a long life as a sheepherder and was almost ninety when he died at his ranch. Allie married Enos Seletstewa in 1937 when she was twenty years old. They had four girls and five boys but lost two of the boys in their adult years. Allie could devote more time to her basket weaving after her children had grown up a bit. She quickly learned how to keep the little children occupied so they would not interfere with her weaving: she made them little plaques to play with. Once they had their toys, they did not get into her materials anymore, and she could concentrate on her design.

She taught only one of her daughters, Vernita, how to make plaques and baskets, but Vernita pursues the art avidly. Asked why so few women make deep baskets today, Allie acknowledges that they are difficult to make. Once the bottom is woven, it is hard to make the transition to the upright section without breaking the already completed part. She taught herself how to make them by experimenting with wet sand, water, and steam. She was never able to hold a job because she had to take care of first her brothers, then her own children, and now her grandchildren. There was never time to think of herself or to earn money for herself. Today, all of her extra money comes from the basketry items she sells.

Allie is one of the few weavers in Hotevilla who can make a multitude of basketry pieces. She makes plaques, deep baskets, and miniature cradles out of colored siváapi, using scrub sumac as the frame and warps. She also weaves baby cradles for orders, fruit baskets, burden baskets for Powamuya out of scrub sumac, and piiki trays. While cradleboards, fruit and burden baskets, and piiki trays require great skill in weaving, the plaques and deep baskets, with their colorful designs, demand additional artistic creativity from the basket weaver. When I asked Allie about her weaving, she replied: "I picture the design of a plaque in my mind, see the colors. Then I think about how to make it. Once I start it, I look at it and decide where I could make it maybe better." She also said, "Younger women have to earn money by holding a job. They cannot weave. Those that are not working are experts in basket weaving."

What she makes most often are plaques, because they are faster to complete and she can sell them more quickly than deep baskets. Allie's plaques and baskets are eagerly purchased by

Von Monongya in Oraibi and Ron McGee in Keams Canyon. Collectors and buyers also come directly to her door, asking for finished plaques. She submits regularly to the Hopi Craftsman's Exhibition, where she has won two Second Prizes and Honorable Mention awards.

VERNITA SILAS

Vernita Silas, like her mother, Allie Seletstewa, belongs to the Roadrunner/Greasewood Clan. She is Allie's youngest daughter and was born in Hotevilla on October 18, 1958. Vernita learned the art from her mother when she was twenty-five, after the birth of her second child. She remembers that in the beginning it was hard on her fingers, arm muscles, and back, commenting: "When

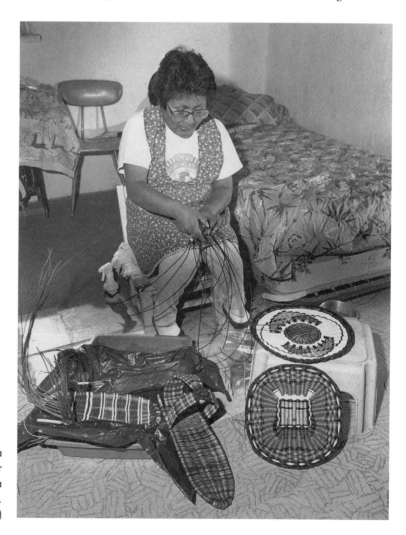

Vernita Silas of Hotevilla with examples of her work. She is weaving a toy cradle for Powamuya. (1994)

you start, you feel like quitting, but when you know how to do it, you just keep going."

Vernita has full-time employment with the tribal police and commutes between Hotevilla and Polacca every day. She can do her basket weaving only on weekends. When I met her she was working on her second small cradle, which she needed to finish for Powamuya as a gift for her goddaughter. The frames were made of small sumac branches, but the warps were of sumac and reed. Neither she nor Allie can find enough sumac anymore for the warps. Traditionally on Third Mesa, scrub sumac was used for all basketry types except plaques. According to Allie, the warps in plaques have always been siwi (*Parryella filifolia*). In small and miniature cradles for toys, Hotevilla basket weavers always used siváapi for the wefts. Vernita used dyed siváapi stems to weave colorful bands into the cradle. It was obvious that siváapi makes a much finer weave than the commercial reed. Siváapi bends smoothly around the corners without breaking and lends itself to a very tight weave around the warps, making them as invisible as in plaque weaving.

Vernita also weaves plaques but has not mastered the art of making deep baskets like her mother. Remarking on the fact that some weavers work into the night to gain extra income, Vernita rejects the idea, saying it is too hard on the eyes. Hotevilla has no electricity, and the dim kerosene or solar-powered lamps make it too difficult to spot errors or breaking points in the siváapi.

DORA TAWAHONGVA

Dora Tawahongva belongs to the Rabbit/Tobacco Clan. She was born in Hotevilla on March 12, 1930, and learned wicker basketry weaving from her mother when she was a teenager. Dora's mother was one of the best basket weavers in the village, especially when it came to the larger and deeper baskets. Dora learned well from her, and she continues her mother's reputation of being one of the best weavers today.

Every time I asked a weaver if she made deep baskets, I was told either "No, but" or "Yes, but," with the weaver going on to say that Dora could make them much better and "really knows how to make them." When I go into arts-and-crafts stores on and off the Hopi Reservation, I often see Dora's basketry as the only wicker items for sale. She produces beautifully executed plaques and smaller deep baskets. In fact, the two or three deep

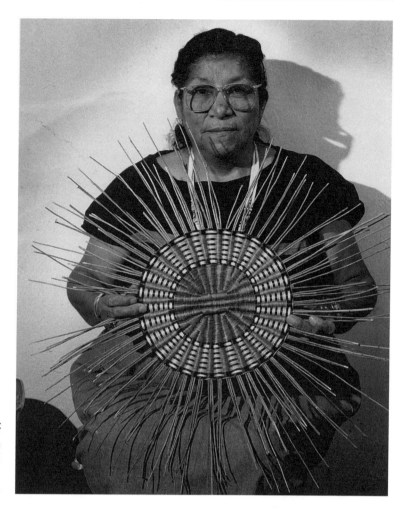

Dora Tawahongva of
Hotevilla. She is holding a
plaque on which she still
has to finish the rim.
(1991; ASM no. 86338)

baskets I have seen for sale over the years were made by Dora.
She has won so many prizes and ribbons that she could not tell
me how many, though she has never submitted to the Indian
Market in Santa Fe.

Dora is very concerned about the future of Hopi wicker bas-
ket weaving. She is fully aware that Third Mesa women have a
special gift for making this basketry, which is justifiably praised
by connoisseurs as the most creative wicker work in design, form,
and craftmanship. Dora has always strived to refine her art and
will continue to do so. She has made herself into the fine artist
she is today.

Dora went to school at the Hotevilla School and spent most
of her life in her village. She is married to Carroll Tawahongva of
the Greasewood/Roadrunner/Reed Clan. Carroll is one of Hote-
villa's textile weavers. They have one daughter and three sons.

Two of their sons are silversmiths, and the youngest carves kachina dolls. Dora and her husband also knit the black stockings that are worn with some traditional clothes. She usually goes by herself to collect siwi and siváapi, which she finds along the roads to Winslow and Leupp. She dyes the siváapi using commercial and vegetal dyes. Dora is one of the very few weavers in Hotevilla who still occasionally uses plants and blossoms for her dyes. She uses *hohoisi* (Hopi tea) for her red color and smokes the dyed material. For the yellow color, she uses siváapi blossoms and also smokes the material after dyeing it. She also uses snakeweed and azurite for the blue color, as well as white clay (*tuuma*) to achieve the white color (*qötstsöqa*). For black she, like everybody else, uses a commercial dye.

Women in Hotevilla have formed work parties, and Dora belongs to one of them. She invites the women in her party into her home for several days on a rotating basis. She supplies them with the necessary basketry materials (siwi and siváapi), and they all make plaques, which the hostess can keep. In return, she feeds them on the work days. The next week she will go to the house of another woman in the work party and weaves for that woman. This system is very helpful before the Powamuya ceremony and the Niman dance, and for paybacks and other occasions when weavers need a lot of plaques all at once.

Because she is one of the few weavers in Hotevilla who can make piiki trays, cradles, fruit baskets, and burden baskets, Dora makes these for special occasions and on request. For all these items she uses scrub sumac, which grows nearby in the cliffs. As busy as Dora is, she allowed me to photograph her on one visit. Since Hotevilla has no electricity, inside photographs are not always totally satisfying. I only hope to have done justice to this wonderful artist.

ALMARIE MASAYESTEWA

Almarie Masayestewa belongs to the Roadrunner/Reed Clan. I learned something of her history after I was unable to photograph a women's work party in Hotevilla on February 2, 1992. I set out to find Almarie, who, I was told, was making piiki. I drove through very muddy streets to Dora Tawahongva's house to find out where Almarie might be, but Dora was not at home. Her husband told me that Almarie was at her brother's house and gave me directions. This house was actually directly opposite

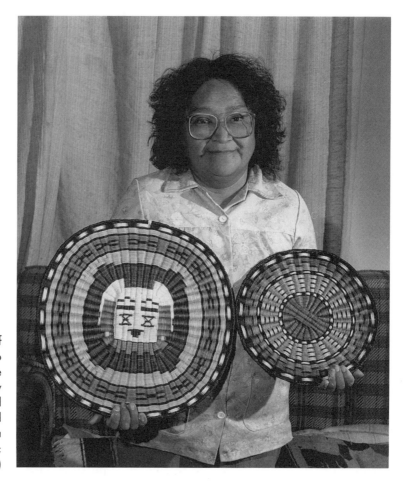

Almarie Masayestewa of
Hotevilla holding two
wicker plaques: a large
plaque with a Snow
Maiden Katsina face and
a Hopi belt design, and
a smaller plaque with a
geometric design. (1991;
ASM no. 86319)

Leora's house, where I had been for the work party sometime
earlier. When I knocked at the door, it was opened by Almarie
herself. After so much disappointment that morning, I felt quite
lucky to find her. Almarie was baby-sitting for her sister, who
had gone to the store. The weather was cold, with rain or snow
threatening.

While we waited for her sister to return, I learned that Almarie
was born on April 25, 1946, and grew up in Hotevilla in the very
house where I met her. She went to Oraibi Day School in Ky-
kotsmovi and then on to the Phoenix Indian High School. She
lived for five years in Phoenix and graduated in 1966 when she
was twenty years old.

Almarie had learned basket weaving during the summer of
1965 from her mother, Lena Naseyowma. During her Christmas
vacation, Almarie went with Lena to a work party. The women
encouraged her and also showed her many details of the wicker

weaving technique. Her mother knew well how to weave the deep baskets with indented bottoms that are so difficult to make.

Almarie wanted to go to college in Oklahoma after graduation and was waiting for her application to be accepted when her husband, Herbert Masayestewa, proposed to her. She was married on October 21, 1966, and never went to college. Instead, she has been weaving plaques and baskets ever since. She says that her plaques are all over the world now. She won a First Prize at the Intertribal Indian Ceremonial in Gallup in 1989 and has won other awards with her plaques. She admits that her deep baskets do not come out perfectly because she has trouble making the indented bottoms. She credits Dora Tawahongva with making baskets very well. Almarie says that baskets are difficult to make and that hardly anyone makes them, certainly not big ones.

Almarie uses aniline dyes for dyeing her siváapi, and she can make any design a collector wants. The designs that sell the best are the eagle, turtle, Katsinmana, Crow Mother, Mudhead, and Tawa Katsina.

Almarie and Herbert have one son, who was sixteen in 1992 and the oldest of the four children they are raising. She and Herbert are also raising a son of one of her sisters, who is deceased, and a son and daughter of her brother.

Almarie makes many plaques for sale to supplement her income, and her work is excellent. She is teaching weaving to her niece, Aurora, whom she has raised, and the young teenager already makes beautiful plaques. Most of the wicker weaving is done during the winter months, when the siwi does not dry out as quickly as in summer. Siwi breaks easily when it dries out. But Almarie attempts to continue weaving throughout the year and spends many hours and days during the summer in her old house in the middle of Hotevilla. This house is much cooler than most because it is sunk into the ground and has thick stone walls. It was here that I found Almarie the first time we met. She was there with Aurora and her aunt, Amy Masayestewa, who is also an excellent basket weaver.

LEORA KAYQUOPTEWA

Leora Kayquoptewa belongs to the Rabbit Clan. She says that her clan came from a different area than the Rabbit/Tobacco Clan. Leora was born on April 20, 1943, in Hotevilla. She is another excellent wicker weaver in Hotevilla, winning a First and Second

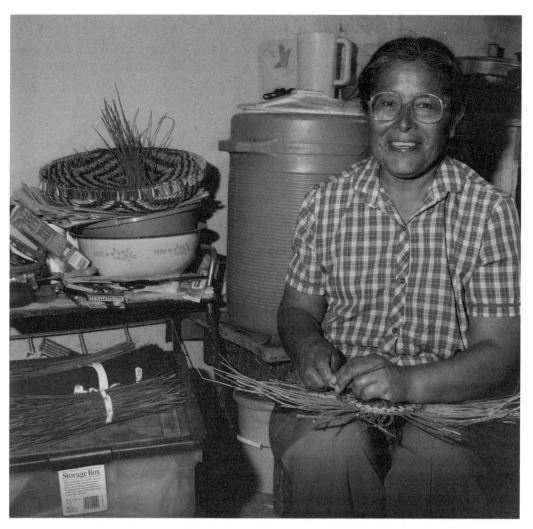

Leora Kayquoptewa of Hotevilla. (1992; ASM no. 87207)

Prize at the Annual Hopi Artist Exhibition at the Museum of Northern Arizona in 1991. She belongs to the same work party as Dora Tawahongva and Almarie Masayestewa and tries to achieve ever-increasing quality in her weaving. To help herself to improve, she sometimes takes the work of better weavers as a guide. Leora learned to weave from her mother and has in turn taught her daughter Roberta how to make wicker plaques and plaited sifter baskets. Leora's beautiful smile brightened the delightful hours I shared with her.

After several unsuccessful attempts to photograph a work party, Leora agreed to let me try again when she had a work party at her home. Unfortunately, Dora and Almarie had to make piiki that day and were not present. At least ten women were assembled in Leora's back room for the work party, but without Dora's and

Almarie's support, Leora's effort was not enough to persuade three of the older women to be photographed. I could sense that the younger women had no objections but did not want to go against the wishes of their elders. Nevertheless, I will be thankful to Leora forever for her goodwill.

Some months later, Leora let me photograph her in her kitchen when she dyed some of her siváapi in commercial dyes. The photographs are given in chapter 2.

BESSIE MONONGYE

Bessie Monongye is a member of the Corn Clan. She was born on August 1, 1927, in Oraibi, the third child of her parents. When she was a little girl, her grandmother, Dalashongsie, taught her how to make pottery, an art she has pursued ever since

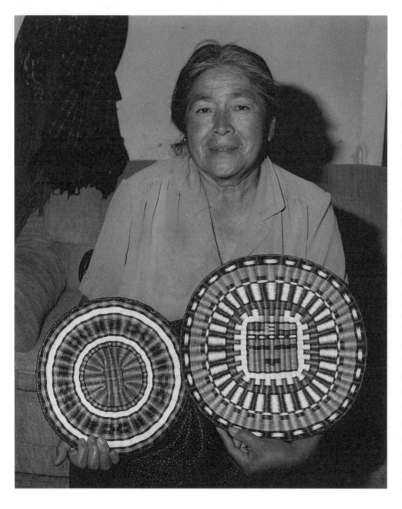

Mildred Albert of Hotevilla is another of the many wicker basket weavers in that village who creates beautiful plaques. In her right hand she holds a plaque with the circular design of a woven Hopi belt. In her left hand is a larger, beautifully exe-cuted Tawa Katsina (Sun Katsina) plaque. This plaque shows the conven-tional rim design of the white cloud motif in a black band, which is used when the background of the preceding design is in color. If the background is in white, as it is in the plaque with the belt de-sign, the encircling cloud design is woven in alter-nating green and red, bordered by a narrow black band. (1993)

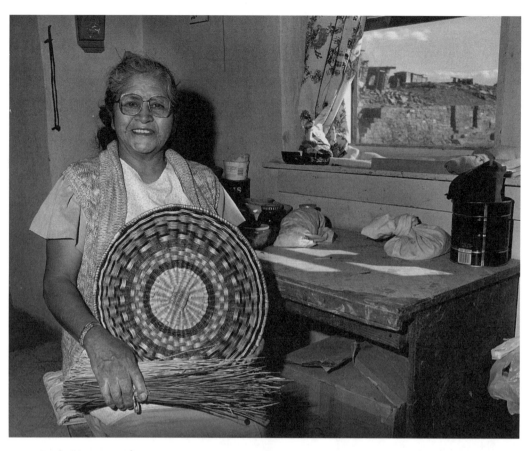

Bessie Monongye of Oraibi holding a large wicker plaque with a design made entirely with vegetal dye colors. (1991; ASM no. 85463)

she came back from schools in Flagstaff and Phoenix in 1946. When she returned to Oraibi she also started to make wicker plaques and baskets, the other important art she had learned from her grandmother. She wove wicker basketry only occasionally until 1969. That year she made many plaques for the O'waqölt basket dance and decided after that to weave regularly.

Bessie makes beautiful plaques and large baskets, bowl-shaped baskets with a wide diameter, and deep baskets with gracefully curved walls that curve slightly inward at the rim. She is a true master of a basket form that few weavers these days even attempt to make. What makes her works so much more valuable is the fact that Bessie uses vegetal dyes. Plant dyes produce hues of subdued intensity that are equal to and reminiscent of pastel colors. To me, wicker plaques and baskets dyed with plant colors are immensely intriguing, softer and more pleasing than those dyed with commercial dyes. Of course, they are much more time-consuming to make because they require so much more preparation of the siváapi: picking the blossoms and plants at the right

time of the season, collecting the alum, and for certain colors, gathering the right mineral; boiling the plant material for hours to make the dye and then boiling the siváapi in it for hours; and finally smoking the red-dyed siváapi and perhaps the yellow and black as well. For all that effort, basket weavers who use vegetal dyes should be compensated much more than they are.

Bessie is a very humble person, however, and I got the feeling that she does not make her baskets for the money alone. The most beautiful work of hers I saw were the baskets for the pay-back of her niece's wedding robes. In many respects, Bessie still lives very much the traditional Hopi way of life. Her son's Von Monongya Gallery on Highway 264 gives the Oraibi artists an outlet for their works. I have observed, however, that when I visit the gallery I seldom see a piece of basketry for sale, and I never see Bessie's work there. The reason may be that my visits are too seldom or that Bessie's basketry pieces are quickly sold. I believe, however, that most of her work does not enter the marketplace outside the Hopi villages.

TREVA E. BURTON

Treva Burton is a member of the Corn Clan. She was born in Oraibi on April 8, 1929, as the fourth child of seven. Her younger sister, Mary Alice, lives next to her, and her older sister, Bessie Monongye, lives in their grandmother's house down in the village next to the plaza. Her youngest sibling and only brother is the famous kachina-doll carver Alvin James Makya.

Treva was taught basket weaving by her mother when she was twenty-two years old and had married. The young family moved to Tuba City for employment, and Treva worked at Tuba City High School for fourteen years. In all those years she had no time for the basket weaving and pottery making she had learned as a child from her grandmother. In 1966 her family returned to Oraibi and built a new house closer to the highway. Ever since her return, Treva has immersed herself in her art and has pro-duced baskets and pottery in great numbers.

Treva does much of her work with her sister Bessie, who is two years older. They almost always go together to collect the materials, and they also keep each other company while weaving baskets. They make plaques that look very much alike, while their pottery styles differ substantially. Treva also makes plaited sifter baskets out of yucca, which can be used as a material dur-

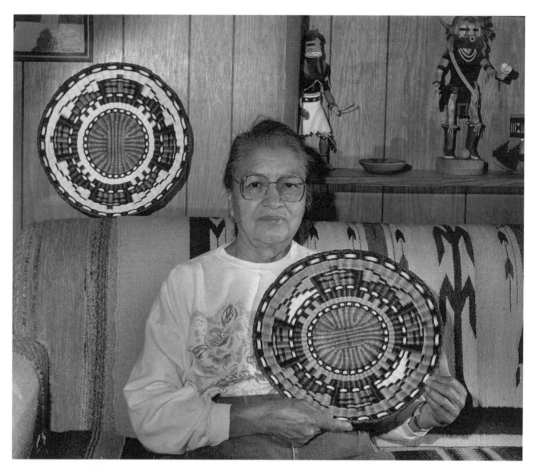

Treva Burton of Oraibi with two large wicker plaques, each with four Longhair Katsina faces and a rain cloud design. She made the plaque she is holding for the Arizona State Museum collection. (1992; ASM no. 86670)

ing the whole year. On August 12, 1991, Treva and Bessie invited me to go with them to collect the two basic materials for wicker basketry: siwi and siváapi (see chapter 2).

Both Treva and Bessie are very good teachers and have shown me much about how to recognize and collect the plants that are necessary for wicker production. In addition, they let me take many valuable photographs that added significantly to my written descriptions. Without their help, my documentation would have been meager and much less informative. However, sometimes Treva's best intentions could not be realized because of uncooperative weather. In November 1991, for example, as I mentioned in chapter 2, she wanted to show me her process of dyeing siváapi with vegetal dyes, but by the time I arrived Jack Frost had overtaken me and prevented Treva from collecting the necessary siváapi blossoms that she needed to make her yellow color. Further, even though she had enough hohoisi on hand to make her orange and red colors, the weather had turned too cold for the

long smoking process after boiling the siváapi in the dye. The rather unpleasant smoking over sheepskin has to be done outdoors. We decided to wait for warmer weather, but Treva's dyeing plans and my travel plans never again coincided.

On another visit to Treva's house to photograph wicker plaques, I found her occupied with her pottery, for which she is also well known. As it happened, it was a good time to visit because Treva mentioned that Bessie and she had worked hard on the payback gifts for Treva's daughter and granddaughter. Both of them had made more than twenty-five absolutely outstanding wicker plaques, and Bessie had also made a large wicker basket. In addition, Treva had also collected six coiled plaques from her relatives. They were in a basketry design commonly called a "Navajo wedding basket," but Hopis call them Havasupai plaques. Besides the basketry, Bessie and she had made sixteen piiki, stew, and serving bowls of traditional Hopi pottery. She had also made twelve modern ceramic bowls painted with Hopi designs and glazed. Finally, great quantities of store-bought metal pots, pans, and dishes had been delivered. Altogether, close to five hundred pounds of blue cornmeal, white cornmeal, parched white cornmeal, baked sweet corn, and white flour still needed to be delivered with the basketry—all of this for a wedding that had been held two and a half years before. Treva felt greatly relieved that she had fulfilled her payback obligation, and I had not only been able to photograph many of the baskets but had also learned a lot that day. When I visit with Treva, she always shares her knowledge and wisdom with me.

Tradition, Ritual, and Continuity

Societies that respect, observe, and perpetuate their traditional activities and rituals usually improve their chance of survival. This is not to say that discoveries, adaptations, and new or alternative technologies should be rejected but rather that a disregard for its fundamental traditions undermines a culture's basic values and contributes to its dissolution sooner than would otherwise be the case. The Hopis' long survival in the harsh, dry environment of the Colorado Plateau serves as an example of this observation.

But what does all this have to do with the basketry that Hopi women make? Essentially, basketry serves as a medium for preserving Hopi culture. Hopi women, in making certain basketry items, establish and perpetuate critical links among family members, clan members, and members of the community at large. In particular, reciprocal gift giving in the form of the presentation of food and basketry reinforces strong social and ritual bonds.

Of special significance is the plaque, which Hopis value highly. The plaque is regarded as a symbol of a woman's role in Hopi society. It is the woman who nurtures her children and her family and prepares the food that feeds them. Much of this food is presented on a plaque. Most of it is in the form of corn flour, but fruit and ears of corn are also carried on plaques or shallow trays. The piiki tray, which is a rectangular plaque, holds the ever-important piiki, whether prepared as long rolls heaped high on the tray or as flat sheets the size of the tray and stacked ten inches high when they are taken to the kiva at initiation.

It is the plaque form that accompanies a Hopi from birth to death. Newborn babies receive one or more small plaques at their first Katsinam dance. These plaques are made by the paternal grandmother or paternal aunt and are given by the Katsinam to the infant. They are meant for the baby to play with and to keep for the rest of his or her life. At the Powamuya (Bean dance), I witnessed Katsinam presenting young mothers of newborn babies with small plaques with freshly cut bean sprouts attached to

them. The poignancy of this scene filled the cold February morning with hope for renewed life and its continuation. On Second Mesa, both boys and girls receive these "newborn" plaques, whereas on Third Mesa only newborn girls are the recipients. There the baby girl's first plaque always has a traditional sunflower design, which is the same design she will use later when she makes her first plaque.

All plaques for newborn babies are between four and five inches in diameter and have rims that differ from other plaques. The wicker newborn plaques from Third Mesa have green yucca rims that by tradition are painted rust red with Havasupai hematite. The powdered red mineral (*kóoninsuta*) is mixed with water, and it can be combined with white clay to achieve shades from pink to brown-red. For centuries the Hopis have obtained this mineral from the Havasupais in Grand Canyon and have used the pigment for body paint. It is highly valued and is rather costly. I was shown a small plastic bag filled with a few tablespoons of hematite and was told it had cost five dollars. When the baby plays with its first plaque and puts it into her mouth, the red color eventually rubs off, causing no harm. Children keep this first plaque for the rest of their lives.

On Second Mesa the newborn plaques are coiled and have a simple geometric design or a turtle, deer, star, or flower design. The design usually continues into the rim coil, something seldom found recently in other plaques, except for a man's wedding plaque. Of great importance for a newborn plaque are the un-

A coiled newborn plaque with fresh bean sprouts from the kiva attached to it. This photograph was taken at noon on the last day of Powamuya on Second Mesa in 1994.

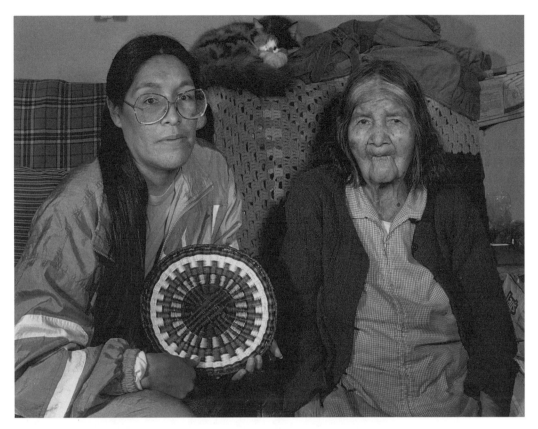

finished rim, as in the coiled wedding plaque, and the restricted colors of its design. No dyed colors can be used, and among natural colors only white, green, and black may be used—the colors, the Hopis say, of "freshly grown plants." Plaques with these colors are fundamental to Hopi rituals—rituals that had their origins in times long past.

The similarity between a newborn plaque and a man's wedding plaque in coiled basketry is remarkable. In both plaques the design continues into the rim coil and the colors are limited to white, green, and black. In most other coiled plaques of recent times, the design ends below the rim coil and the plaque is finished with either a solid white or black rim coil. The sizes of the two plaques are very different, of course; one is the smallest and the other the largest plaque made by Hopi weavers. The outstanding feature of the wedding plaque is its unfinished rim. The last inch or two of the rim coil is not wrapped with yucca, and the galleta grass is left uncovered. Sometimes one sees a wedding plaque with a finished rim, but this plaque is meant to be sold to a non-Hopi, as it cannot be used in a wedding payback.

Debbie Allison of Bacavi holds a wicker plaque with the sunflower design, which is the design a girl or young woman from Third Mesa weaves in her first plaque. Debbie is seen with her great-grandmother, Frieda Quavehoeama of Bacavi, who taught her wicker weaving. (1992; ASM no. 86663)

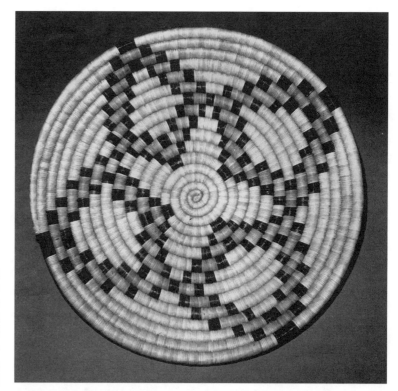

A groom's coiled wedding plaque (*qötsa'inpi*) from Second Mesa. This plaque was made before 1936 and is in the Museum of Northern Arizona collection. (1994; diameter: 20.5″; MNA no. E 171)

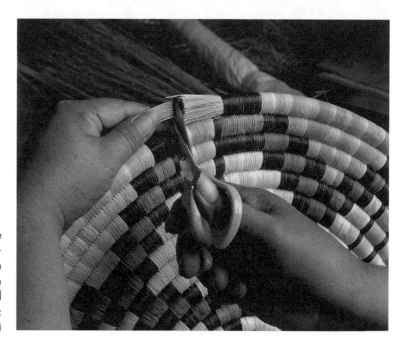

Cutting off the bundle foundation material, galleta grass (*söhö*), which will be left exposed on the rim coil of this coiled wedding plaque. (1992; ASM no. 86672)

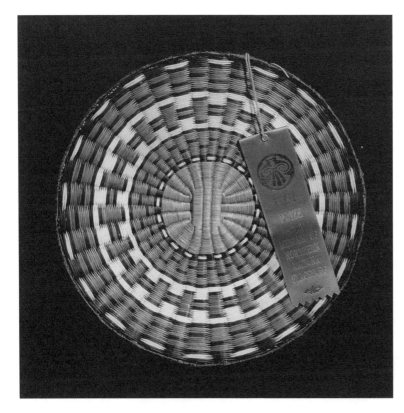

A groom's wedding plaque (*hahawpi*) in a wicker weave from Third Mesa. This beautiful plaque was made by Dora Tawahongva of Hotevilla. It won a First Prize in basket weaving at the Hopi Craftsman's Exhibition at the Museum of Northern Arizona in Flagstaff in July 1993.

A true wedding plaque should never be sold because it belongs to the bridegroom and is of great importance to him. He receives his wedding plaque when the payback for his wife's wedding robes has been made, and their wedding is thus considered completed. The wedding plaque is usually made by his wife. Great symbolism is attached to this plaque, for after the husband's death it will speed his journey to his ancestors. Without it, his soul will take a long time to reach its destination. The plaque is kept for him by his mother, or his sister in the event of his mother's death. The design and colors are reminiscent of the little plaque the husband received when he was a newborn baby. Thus his life starts and ends with two plaques similar in color and design.

On Third Mesa the wicker wedding plaque has the same importance even though this plaque is not as large in diameter as the coiled wedding plaque and has a different design in a wider range of more subdued colors. The concentric center design is called "holding together" because a connecting line holds the other design elements together.

The Hopi name for the wicker wedding plaque is *hahawpi*, or

"something to descend upon." In the literature of about a hundred years ago, Hopi plaques are referred to as sacred trays or sacred plaques. Several of the oldest basket weavers from both mesas say that at one time plaques were used only for ceremonies or paybacks. Apparently the traditional use of plaques in a ceremonial context has not changed, and their use in paybacks has increased. What has changed very much is the production of plaques in great numbers for sale, particularly on Third Mesa. Coiled plaques and baskets are also made for sale, but it takes much longer to make them, so fewer are sold.

Plaques are used in kiva ceremonies as they have been for centuries. I do not know how many plaques are made today for that purpose, but plaques in kiva ceremonies are used to hold sacred cornmeal and *pahos* (prayer sticks with feathers, or feathers with cotton strings), which are deposited during ceremonies in shrines, springs, and fields. These plaques are between eight and ten inches in diameter and have fewer colors and simpler designs than plaques for other purposes. They resemble older plaques from around 1900, when all plaques had less elaborate color designs than today. Some may be heirlooms from those years.

Perhaps because of their tightly coiled weave, coiled plaques are preferred for holding cornmeal used in ceremonies and at Katsina dances, and are still used for these purposes even on Third Mesa. I was present at the Niman (Home) dance in Hotevilla in 1993. After the last dance late in the afternoon, thirty women in traditional dress and bare feet entered the plaza in single file. Each held a medium-sized plaque or very shallow tray filled with corn flour, with a prayer feather on top. In their left hand, which carried the plaque, the women also held a twig or two of fir, which symbolizes water. Twenty-two of the plaques were coiled; only eight were of wicker weave. Interestingly, two of the twenty-two coiled plaques or baskets were shallow Tohono O'odham baskets. The Longhair Katsinam stood in a semicircle and the women passed by, blessing each one of them and leaving their prayers with them by sprinkling them with corn flour. When every woman had spent the flour in her basket, she covered it with the fir twigs.

At the Powamuya ceremony at Shungopovi in 1994, the Angwushahay'i (Crow Mother) Katsina, carrying a large coiled plaque with a Sa'lakwmana (Shalako Maiden) design, led at least fifty Katsinam from the kiva to the plaza. The plaque was filled with a colorful array of Hopi corn kernels, squash seeds, and beans. Here and there a woman would step forward and take a handful

of seeds from the basket to plant later in her field. The maker of this beautiful plaque was, I later discovered, Elizabeth Poneoma, daughter of Velma Wadsworth and granddaughter of Evangeline Talahaftewa.

During the procession of the Katsinam that day, plaques and toys were given to children by the Katsinam. One large plaque measuring thirteen to fifteen inches across and with the figure of the Hahay'i wuuti (Katsina Mother) in its design was given to a five-year-old girl. A twelve-inch wicker plaque with a sunflower design in white, yellow, and black was given to another girl, and several smaller coiled plaques also found their recipients. The large number of colorful miniature cradles given by the Katsinam proved how popular this type of basketry had become. Boys were handed lightning rods, rattles, miniature moccasins, and bows and arrows. In contrast to the early morning, when all the gifts were adorned with bean sprouts, the gifts now had fir twigs attached to them, symbolizing the portent of rain. Most of the gifts were apples, oranges, and ceremonial cookies.

Katsinam not only distribute plaques as gifts to girls but small and medium-sized plaques may also be part of their costume. On one of my visits to Shungopovi, I chatted with Tirzah Kalectaca while she made a Kóonin (Havasupai) plaque for a Havasupai dance to be held in a few days. A few minutes later when I visited with Evangeline Talahaftewa, I found her working on a Havasupai plaque for the same dance. She told me that the Kóonin-katsina carries this particular plaque on his left side, attached to his belt. Very small plaques resembling miniature plaques are used by Longhair Katsinam (Angaktsinam) on the back of their hair to act as a counterweight to hold upright the long eagle feather that crowns their head. At the Niman dance in Hotevilla in 1993, which was performed by Longhair Katsinam, twenty-one of the sixty-three Katsinam had wicker plaques four or five inches in diameter hanging down their black hair. Most of these had a sunflower design. Some small plaited sifter baskets also served as weights. Other items used as weights included miniature pottery ladles, ears of corn, shells, and even a house key.

Plaques are also important in initiation ceremonies, and this use probably reaches back into antiquity. Small coiled plaques— no larger than four inches across and woven only of green yucca with no design whatsoever—are given to the children when they are initiated into the Katsina society at Powamuya. These plaques serve as "plates" from which they eat their ceremonial corn pud-

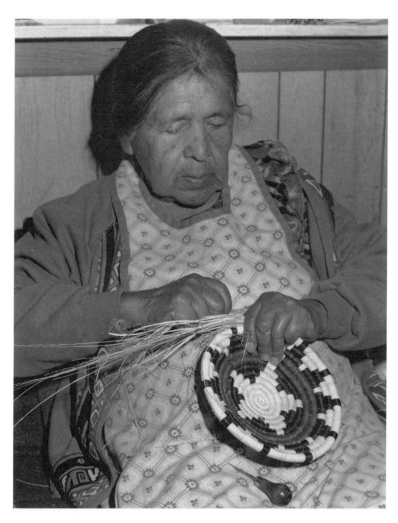

Tirzah Kalectaca of Shungopovi weaves a Havasupai plaque for the upcoming dance of the Kóonin (Havasupai) Katsinam. (1993)

ding. Similar small plaques, also only four inches in diameter, are made by the mothers of boys who are to be initiated into a religious society. These plaques have simple designs of white, green, and black yucca coils and serve to hold the pahos the initiates make for the first time. The initiates also carry sumac burden baskets ceremonially in the early morning hours on the last day of Powamuya, taking the bean sprouts from the kiva to the houses in the village. For another initiation, small plaques are woven on Second Mesa using a very specific method. Only every fourth stitch is secured to the lower coil; the other three stitches are only wrapped around the foundation. These plaques are very similar to fourteenth-century paho baskets found in Blue Creek Cave in southeastern Arizona (see the appendix).

The perpetuation of traditional rituals also manifests itself in Hopi footraces, in which basketry plaques are coveted prizes. The

anthropologists Walter Fewkes and Alexander M. Stephen both noted that races in 1891 and 1892 were connected with the Flute and Antelope ceremonies and also with the Snake dance. I do not know if that is still the case, but on First and Third Mesas foot-races are still held with the O'waqölt ceremony and with social dances like the Butterfly dance. I witnessed one such race in 1992 on First Mesa that was held in conjunction with the O'waqölt basket dance. During the fourth dance, shortly before noon, the first runner entered the plaza and was greeted by the onlookers with great applause. He was quickly followed by ten other young men. The twelfth runner was the first woman and received a new round of applause. The women in the circle kept dancing throughout. After the fifth dance, while the women rested in the kiva, men from the village arranged two rows of goods in the plaza, a longer one for the men, who received Hopi pottery (the major craft on First Mesa), beautiful plaques, blankets, commercial bowls, coolers, food, and many other household items. Though every runner received a prize, the decorated pottery vessels and basketry plaques certainly were the best prizes and were given to the first four runners who had entered the plaza. The row for the women runners was shorter and contained no basketry. To the first woman runner went the First Prize, a beautiful orange piiki bowl. The next three women who had entered the plaza had each received a fringed commercial shawl, while blankets and plastic goods were give to the rest of the women runners.

It seems that the arrangement of prizes can vary according

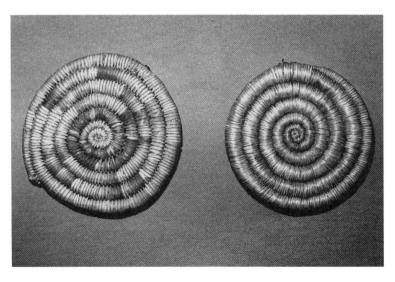

Two small (about 4.5-inch diameter) coiled cornmeal plaques used in the initiation into the Katsina society. They are from a set of four plaques collected by the Museum of Northern Arizona in the 1960s. (1994; MNA no., left: E 4207A, right: E 4207C)

to race and mesa. In comparing modern races with Alexander M. Stephen's account from 1892, it is apparent that changes have been made, the most significant being that in 1892 no goods other than four plaques were given to the four fastest male runners. Interestingly, Burel Naha, the brother of Rainy Naha, who herself regularly participates in footraces on First Mesa, reports that basketry plaques are still the four major prizes. According to Burel, the races start four to five miles below the mesa. One mile into the race, four plaques are placed on the ground. The largest is about fifteen inches in diameter, and the others are progressively smaller. The fastest runner picks up the largest plaque, and the next three runners pick up the others. Each runner with a plaque tucks it tightly under his or her shirt (according to Stephen, the plaque could be grabbed by another runner) and continues up the mesa. On entering the plaza, the first four runners receive another plaque, each plaque diminishing in size with the arrival sequence of the runners.

Plaques are also highly valued as gifts in social dances like the Butterfly dance. Unmarried girls and young women dance in social dances and reward their dance partners afterward with one or more plaques.

A Hopi girl grows up with plaques given to her by the Katsinam. Every year at Katsina ceremonies, particularly the Powamuya and Niman dances, she receives one or more plaques from the Katsinam. These plaques have special meaning for her because they are given with the blessings of the spirits. Just like the kachina dolls given to her by the Katsinam, the plaques increase in size as the girl grows until they reach the maximum size of fifteen inches in diameter. From an early age she is expected to give the plaque heaped high with corn flour to her paternal aunt who, without the girl's knowledge, made the plaque. Her aunt accepts the corn flour and hands the plaque back to the girl. The little girl, in the belief that the Katsinam made her plaque, fulfills a symbolic gesture by bringing her aunt the flour. Her gift to her aunt brings the assurance that she soon will be the nurturer of her family, that she will be able to carry on the tradition of grinding corn and providing food for her children. After her initiation into the Katsina society, sometime when she is between ages ten and twelve, she no longer receives plaques from the Katsinam.

When the girl reaches age fourteen, her godmother can agree to her initiation into one of the three women's societies, of which

the Lalkont and O'waqölt have ceremonies ending with public basket dances. All women's society ceremonies are held from September to early November of each year. They are not held regularly in all of the villages, however.

The procurement of food and the hope for rain and fertility have always been the forces behind the traditions in Hopi society. It is customary that parents look for godparents for their children. For a girl, they ask a woman who is particularly proficient in the traditional observances and activities to be the ceremonial godmother. Finding a good basket weaver is very desirable, as she can teach and guide their daughter in learning this craft. The newly initiated girls remain in the kiva for four days, during which their godmothers instruct them in the art of basket weaving and other functions Hopi women have to know. On Second Mesa the girls learn how to weave a coiled plaque or basket and a plaited sifter basket. The girls may have watched the women in their household before initiation and may thus have familiarized themselves with the necessary materials and technique, but according to the rules of the Lalkont, they are not allowed actually to weave a plaque before initiation. After the four-day instruction by their godmother, they are "on their own," in Madeline Lamson's words, who has instructed all four of her goddaughters. The girls then can learn further from any woman they prefer, which most often is the godmother. Many continue to teach themselves weaving, however.

On the fifth day of the nine-day Lalkont ceremony, an all-night kiva ritual is held, during which, among many other things, the initiates have their hair washed by their godmothers, who give each girl her ceremonial name (Fewkes and Owens 1892). Initiations into the Lalkont occur every four years, but the nine-day ceremony is held every year and ends with a basket dance. Often more novices are initiated than can participate in the basket dance that year; thus they may dance in one of the following three years.

Not long ago, the Lalkont existed on all three mesas, but today this society is alive only in the three villages of Second Mesa, and initiations are held only in Shungopovi. The Water (Patki) clan is in charge of the Lalkont ceremony. Four priestesses officiate at the ceremonial rituals, duties that are inherited from mother to daughter through the generations. Unfortunately, on First and Third Mesas the last priestesses had no daughters, and since their deaths about twenty years ago, I was told, no Lalkont ceremonies

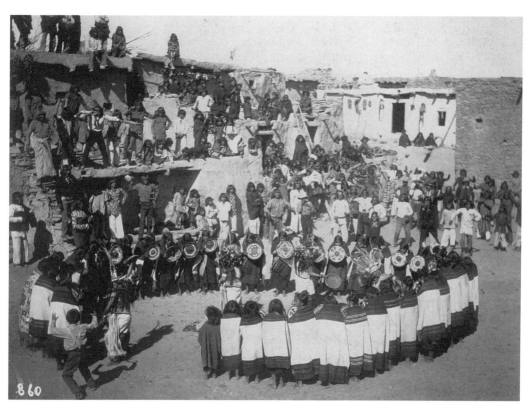

A Lalkont basket dance on Third Mesa, possibly at Oraibi, around 1900. Here four initiated girls throw baskets from inside the circle of dancing women. Photograph by George Wharton James. (Courtesy of the Southwest Museum, Los Angeles; neg. no. 20350)

have been held. In Hotevilla the O'waqölt ceremony and its basket dance are the only ceremonies still performed by a women's society. It is held only when someone is willing to sponsor it. Young girls are initiated on those occasions. Uninitiated girls can dance in the circle with the other women, but they cannot throw any goods to the crowd, which is made up almost entirely of men. This symbolic action of distributing products of the Earth can only be undertaken by newly initiated O'waqölt members and their godmothers.

The situation is similar on First Mesa, where, according to all accounts, coiled-basket weaving had ceased by 1880, though Fewkes and Stephen observed the Lalkont ceremony and its basket dance on First Mesa in 1891. Many women and new initiates participated. In 1993, Marcella Kahe, an excellent potter from Sitsom'ovi (Sichomovi) on First Mesa, advised me that the Lalkont ceremony was held in her village until the late 1960s, when it ceased with the death of the last woman in charge of it. The O'waqölt is still observed, but the ceremony and basket dance are only performed when someone is willing to sponsor them.

One dance was sponsored on November 7, 1992, in Sit-som'ovi, and Marcella belonged to the group of women who were in charge of this ceremony. On that occasion many young girls were initiated and, with the help of their godmothers, after entering the circle of dancing women they threw an immense amount of lightweight household goods, plaited sifter baskets, and even some pottery to the crowd. My heart stopped in ago-nized amazement every time one of the small pottery jars, bowls, or ladles that flew through the air was not caught by a man but landed on the ground between their feet, broken and crushed to pieces. The fourth and fifth dances that day had six and five ini-tiated girls with their godmothers, indicating that many young girls wanted to belong to this society.

Resemblances to the Lalkont basket dance are numerous. To the uninitiated, the most obvious difference is that the girls and godmothers throw their goods from the outside of the circle of dancing women. They have to break the circle every time they need to fetch more of the goods gathered in the center. Also, though the faces of the initiates were painted yellow, they lacked the black lines at the corners of their eyes and mouths that the Lalkont initiates so strikingly display.

In Stephen's time, only baskets were thrown to the men in the audience on the last day. However, one year they had dances on two consecutive days, and on the first day fruits and loaves of bread (Stephen calls them scones) were thrown. This contrasts with items distributed today, which include enormous amounts of plastic and aluminum kitchen items, rolls of paper towels and toilet paper, boxes of Cracker Jack, and plastic clothes baskets, to mention only a few of the goods showered on the crowd. Plaques are only a diminutive part of the array, although they are the ones most desired, and thus most fought over, by the men. On First Mesa the plaques thrown are mostly plaited sifter bas-kets, which are not really plaques in form but are a highly appre-ciated utilitarian basketry item nevertheless. The reason for what might be called "plaque substitutes" is the fact that the women on First Mesa make sifter baskets only for the basket dance and for wedding paybacks. No other plaques or baskets are made on First Mesa. Here the sifter baskets are never sold.

The women at the O'waqölt dance on First Mesa danced with beautiful plaques. Interestingly, some of them held excellent dec-orated pots behind their plaques. I counted seventy-three women,

of whom all but sixteen danced with coiled plaques. The sixteen had equally beautiful wicker plaques, all of them about fifteen inches in diameter. A few of the little girls at the end of the open circle held plaited sifter baskets in their hands. I asked where the coiled and wicker plaques had come from, since the women did not make them, and I was told that the women or somebody else in the family had purchased them from weavers on the other mesas or in some cases had received them as reciprocal gifts. Even on First Mesa, most Hopi women have at least one plaque in their home that they keep for dances. Some of these plaques may be heirlooms. During and after the dance, before more goods are thrown to the onlookers, a grandmother among the O'waqölt members will search out a grandson in the crowd, and after he has politely asked her for it, will give him a special plaque. Quite often this is the plaque that she had danced with. The young man has to reciprocate the favor with groceries.

I do not know the meaning behind the Lalkont or O'waqölt basket dance because my friends could not tell me. This is privileged knowledge for initiated members only. Yet the two Lalkont dances that Joyce and Morgan Saufkie of Shungopovi invited me to attend in 1992 and 1993 amazed and moved me. Standing among several of the dancers outside the kiva between dances and looking into their faces covered with corn flour, I sensed they were tired yet happy, chatting and laughing. In their long hair, bare feet, and pretty traditional dresses they all looked beautiful and almost made me wish I were one of them. When they filed into a long line to walk back into the plaza, their demeanor changed to solemn quietude until they had formed their circle and had begun to sing again. The circle was left open toward the east, the direction of the kiva from which the Lakontaqa came, leading the next two initiates into the circle. The Lakontaqa is the only male figure who officiates in this religious ritual. He and the initiates made two stops before they entered the circle and two stops inside the circle. At each stop the Lakontaqa made two vertical lines with cornmeal, and through them one horizontal line. Near where the lines crossed, the girls threw ears of corn and then progressed to the next stop. The Lakontaqa carried the cornmeal in a medium-sized coiled basket, which, after the eighth and last dance of the day, he threw up to the crowd on a rooftop. A wild fight broke out over the plaque, but the young man who caught it defended it fiercely. After bringing the girls into the circle of singing women, the Lakontaqa returned to the kiva.

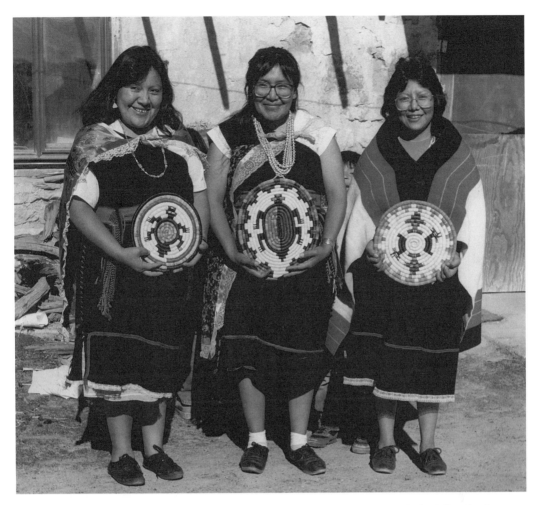

At the Lalkont basket dance in Shungopovi in October 1993, three of the four daughters of the Saufkie family participated. They include, from left, Mary Lou Washington, Juanita James, and Wilhelmina Saufkie. (1993)

Next there was some ritual changing of sides, after which the girls were joined by their respective godmothers, who helped them throw the goods from the center to the crowd. Once they were in the Lalkont dance, they never left the circle. The girls had brought plaques wrapped in sheets thrown over their shoulders into the circle and now threw the plaques to the mainly male audience, who fought tumultuously over every one. Some of the plaques sailed far beyond the plaza and rooftops, landing in the street, where a lucky passerby could pick them up without a fight.

The preferential distribution of the plaques to members of the male audience strengthens the bonds between aunt and nephew, grandmother and grandson, thus reinforcing the intricate relationships among the Hopi clans and families. Most of the goods were contributed by the families of the godmothers. The goods thrown were the same kind as in the O'waqölt basket dance. The

proceedings of the dance and the elaborate dress and headdress of the initiates and godmothers evoked great antiquity. The only significant difference from the ceremony described by Fewkes and Stephen a hundred years ago is the overwhelming volume of goods distributed.

The energetic activity inside the circle and the loud and wild yet cheerful fighting outside the circle contrasted sharply with the behavior of the circle of singing women between the two groups. The women were totally unfazed by the tumult around them, absorbed in their soft singing, rhythmically stepping sideways and back again, moving their plaques from side to side and up and down. I could not help but feel a solemn reverence emanating from this circle of women, a reverence for the Earth that they expressed with every slight bow of their heads and plaques. The unison of their singing and movements obliterated any individuality. They seemed to create their own spiritual world, embracing within their circle the newly initiated girls and their godmothers.

Many of the plaques the women held were the largest I had seen and had the most beautiful Katsina figures on them. Many women dance with their best plaques or borrow one for that special event. Ramona Lomakema, who excels in making miniature plaques and baskets, danced with a plaque that her daughter Jerri had made and that had won the Best of Division prize at the Hopi Craftsman's Exhibition in Flagstaff only four months earlier. Leonora Quanimptewa of Mishongnovi told me that the more beautiful the design on the plaque, the greater is the hope for the spirits' blessing for health and bountiful crops in the year ahead.

After the last dance, the women climbed to the roof of the kiva, took off their mantas, and stood for a short while among more mountains of plastic, paper, and aluminum household goods. Then the full moon rose behind the kiva, and the women, elevated as they were, were bathed in the last rays of the setting sun while we below them were already obscured in shade. It was a spectacular sight. Visual imprints of moments like this stay with us for the rest of our lives. To me it was a spiritual moment that passed all too quickly when the women began to distribute the items and all the hands around me flew up into the air to catch the renewed shower of goodies. With so many women now all throwing at once, it was like the grand finale in a fireworks display, with all the goods raining down on us. I did not see any

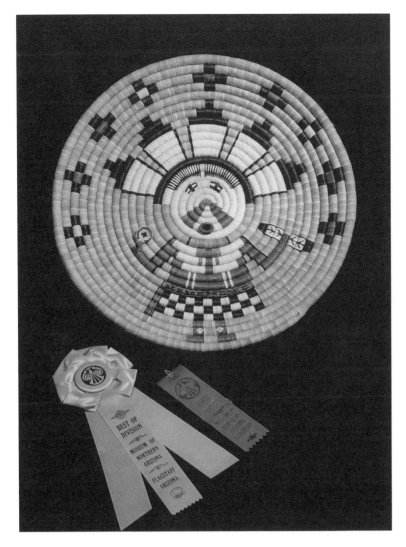

A large coiled plaque with a full figure He-e Katsina made by Jerri Lomakema. It won the Best of Division award for basketry and a First Prize in the Hopi Craftsman's Exhibition at the Museum of Northern Arizona in 1993.

coiled plaques being given away, but since I was surrounded by so many people I may simply have missed them.

What is the meaning of this day? The dances are held at harvest time, and the men who have tended the fields all summer long will soon bring the crops to the villages, leaving them in the care of the women. It makes good sense to me to celebrate the Earth at this time of the year, showing respect and reverence. Earth shares its products with people not only in the form of food but also in the form of plant fibers from which basketry items can be made for daily use. Making a beautiful plaque for a ritual observance to thank and honor the Earth must be one of the meanings of the basket dance. The initiation of new mem-

bers into a religious society committed to this closeness to the Earth affirms the perpetuation of this commitment. I am convinced that the basket dance ceremonies have even deeper meanings unknown to me. Hopi women are very secretive about their rituals, which is for the best, for their esoteric traditions have assured the survival of the Hopi people.

One aspect of the antiquity of Hopi basket weaving embraces the mystique of taboos. Probably there are more taboos that I was not told about because of their esoteric nature. The most important pertaining to basket weaving that I am aware of is that a girl or woman who has not been initiated into either the Lalkont or the O'waqölt is not allowed to make a plaque or basket. If someone breaks the taboo, she is subjected to a disease, usually a skin disease. This taboo is often disregarded today, but it is still rather strictly observed on Second Mesa. Similar diseases will strike a basket weaver if she attempts to make a plaque or basket in the technique of another mesa. This taboo must be a rather recent restriction because both coiled and wicker techniques were used on all mesas until several decades ago. On First Mesa, as mentioned before, coiled and wicker techniques ceased around 1880, though in Oraibi on Third Mesa coiled baskets in the form of shallow trays were made, at least for utilitarian purposes, until the 1920s. Treva Burton, who is now in her early sixties, saw her grandmother make coiled baskets.

Brian Honyouti, a well-known kachina-doll carver and former teacher and principal at the Hotevilla Day School, shared his thoughts with me. He suggested that the division of the crafts may have been facilitated by the Hopis' retreat to the mesa tops around A.D. 1700 to escape Spanish pressure. The increased distances between the villages would have reduced the frequency of contacts between them and may have led to the localization of Hopi basket weaving techniques. Whatever the cause, very few if any weavers on Second or Third Mesa can still make a product in both techniques. Pearl Nuvangyaoma from Shipaulovi on Second Mesa—who is skilled in making coiled plaques as well as wicker burden baskets, cradles, piiki trays, and plaited yucca sifter baskets—told me that she could easily make wicker plaques but does not. She observes the traditional taboo.

Another very important taboo concerns weaving plaques or baskets by pregnant women. A pregnant weaver will not finish the last coil, fearing that if she did, her birth would be a very

difficult one, "restricting the baby." Instead, her mother, sister, or other female relative will finish her basket for her.

A taboo that is strictly observed on both mesas concerns the dyeing process. As I learned when my appointment with Joyce Ann Saufkie had to be canceled, if a death has occurred in the family, even that of a distant family member, no dyeing of any colors is attempted. Any dyeing, particularly in the brilliant rust reds and oranges achieved from dyeing with the vegetal dyes, will produce faded colors. The process has to be delayed for several weeks, and the basket weaver has to purify herself by burning piñon pitch and by bathing in water with cedar bark for a week. The unexpected appearance of a pregnant woman during the dyeing process will also result in faded colors.

Without doubt, basketry is more important and alive in Hopi tradition and ritual than any of the other craft arts, like pottery making, textile weaving, kachina-doll carving, and silverwork. However, Hopi basketry has changed in the twentieth century as a result of its increased commercial value. Before a monetary system was introduced into their society, the Hopis exchanged basketry items among themselves in a barter system, and of course basketry in the form of plaques and piiki trays had its very important function within the reciprocal gift exchange system. With a gradual transition to the monetary system early in this century, Hopi basket weavers traded their basketry for food or household goods with white traders at trading posts. Because they were increasingly dependent on currency and lacked wage-earning jobs, Hopi basket weavers saw the need to supplement their family income by selling their baskets. As the number of tourists visiting the Hopi mesas has increased and more collectors have become aware of Hopi plaques and baskets, the commercial value of these items has grown.

The influence of tourists and collectors has left a mark on the development of Hopi basketry. The traditional form of the deep basket had an incurving opening to give more protection to foods stored in it. It was an impractical form for the American public, however, and did not sell well. Hopi basket weavers adjusted, making their large, deep baskets with straight sides and a wide opening so that they could be used as wastebaskets, which often had lids.

In addition, for a short time around 1900 coiled-basketry weavers embraced the use of aniline dyes, though the use of veg-

etal dye from sunflower seeds to achieve the black color was never abandoned. Since old photographs are not in color, it is impossible to discern what colors besides white, green, yellow, and black were used in Hopi coiled basketry prior to 1900. Colors in very old baskets in museum collections have faded to the point that, if any design can be seen at all, it is in lighter or darker shades of beige or dark brown. It is impossible to say how far back in time the vegetal dyes of siita and hohoisi were used for the red color in Hopi basketry weaving, but shades of red and orange were probably used to a greater extent in the early decades of the twentieth century, when Hopi basket weavers started to incorporate more figurative elements and motifs into their designs. Certainly since the beginning of the practice of weaving Katsina faces and full figures of Katsinam into their plaques and deep coiled baskets (Katsina representations were never woven into deep wicker baskets), their palette included shades of red.

While a few weavers on Second Mesa may have continued to use aniline dyes throughout the decades, the majority of coiled-basket weavers have stayed with the natural colors of white, green, and yellow, and have dyed their reds (and until recently their blacks) with vegetal dyes. The adherence to the traditional custom of using plants that can be collected from nature, and the preference for vegetal dyes among collectors and traders, may well have been the reason why aniline dyes have not been used to a great extent in coiled basketry. I was told that some collectors smell the plaque or basket they intend to buy to be assured by its smoky scent that vegetal dyes have been used and that the color is smoke-set. Thus weavers of coiled basketry found that they increased the monetary value of their work by using vegetal dyes.

Bertha Wadsworth of Shungopovi remembers as a child seeing one old plaque with the representation of a Sa'lakwmana, which was the first Katsina represented on coiled basketry. This plaque had been made by a man (at that time men on Second Mesa also made coiled baskets and plaques). The first use of Katsina representations on basketry apparently involved the weaving of wicker plaques on Third Mesa. As I mentioned earlier, Vera Pooyouma of Hotevilla told me that men painted the image of the Sa'lakwmana in on whitewashed backgrounds on wicker plaques. Memories of this practice go back to around 1900, and it apparently persisted into the 1960s. If Frederic Douglas, the curator of the Denver Art Museum, was correct in concluding that aniline dyes

Three wicker plaques with the figure of Sa'lakwmana or Palhikwmana woven into them date anywhere from 1900 to 1915 and are in the collection of the Arizona State Museum. (1992; from left: no. 12358, diameter: 23.5 cm; no. 12365, diameter: 21.6 cm; no. 12403, diameter: 14.7 cm)

were used at Oraibi as early as the 1880s, then the practice of painting with azurite or indigo must reach even further back. Historical records indicate that indigo dye was given to the Navajos by the Spaniards as early as the 1600s. Navajos and Hopis traded with each other, and it can be assumed that Hopi basket and textile weavers had access to indigo in the eighteenth century, if not already in the seventeenth (personal communication, Dr. Joe Ben Wheat, 1995).

It would be interesting to discover why the image of Sa'lakwmana was used as the first Katsina representation on plaques. Her name is interchangeable with Palhikwmana (which means Moisture Drinking Girl). In both versions this Katsina is associated with clans coming from the Rio Grande area in New Mexico. The first Katsina representation was probably made on a wicker plaque in Oraibi, and it seems to have been the image of Sa'lakwmana.

As noted above, Frederic Douglas traced the use of aniline dyes in wicker basketry to as early as 1880. However, with the founding of Hotevilla the use of vegetal dyes was reintroduced between 1906 and 1908. The reason may have been that weavers in Hotevilla found it difficult to get to trading posts to buy aniline dyes, or it may have represented a rejection of "white man's dyes." However, by the 1930s the use of aniline dyes had become popular on Third Mesa, and by the 1960s they were used by most wicker basket weavers (Mark Bahti, personal communication). In

1940 Douglas acclaimed Hopi wicker work as the "highest developed wicker basketry among Indians," adding that this technique "is not common in America." Today vegetal dyes are used by only a few wicker weavers. Instead, most take advantage of the multitude of bright colors that can be obtained from aniline dyes to produce the great variety of intricate geometric designs now found in wicker plaques.

Buyers, collectors, traders, and tourists are often reluctant to pay what a plaque or basket is really worth. Considering the enormous amount of time and effort involved in producing a Hopi basketry item, this handcrafted art deserves greater recognition and compensation. Hopi basket weavers have an astonishing ambition and drive to refine their craftsmanship by creating the most intricate and complicated designs and inventing new color combinations in wicker work. Their inborn artistic skill and taste are astonishing and manifest in their art. Part of the incentive for this constant refinement comes from juried Indian art shows that award prizes. I have repeatedly heard that women who had won a prize immediately started on a new piece to be entered in another juried show a few months later, challenging themselves to repeat, or possibly even improve on, the excellence of their art. When listening to the words of many women, especially younger women, it becomes clear that they admire those who do the finest work, and as a result they strive to produce the finest coiled and wicker basketry possible.

In the summer of 1994, when the Museum of Northern Arizona broke with its long tradition of judging the pieces entered in the Hopi Craftsman's Exhibition and did not award any prizes, I heard some concern expressed and sensed other silent disappointment. Yet I also heard in Flagstaff that in recent years the best basketry pieces had not been entered because they had been purchased by collectors immediately after they were completed. It is true that I was hardly ever able to photograph a finished piece of basketry in its maker's home.

For the sake of their craft, the best basket weavers should enter their work in juried shows before they sell them, but the badly needed money is always the decisive factor. To benefit all Hopi basket weavers and to make the public aware of their artistry in natural fibers, their art has to be entered in more shows and displayed in Indian art stores and galleries, where it can be seen and appreciated by a much larger segment of the non-Hopi popula-

tion. To heighten the appreciation of this remarkable art, non-Hopis, in turn, must become acquainted with it and learn about the weaving process. Then they will understand the value of Hopi basketry—its traditional intrinsic value in Hopi society and the monetary value of the work that goes into it—and will appreciate it as an art form.

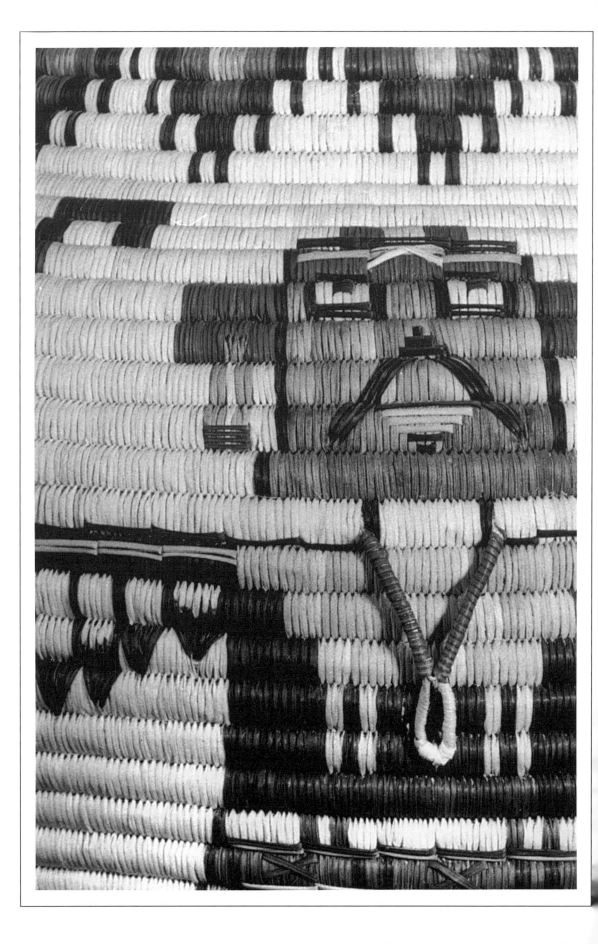

Art Form as Social Bond

Hopi wicker and close-coiled basketry is unique among all Native American arts, and Hopi basket weavers have elevated their work to a level unparalleled in Native American basketry. A basket is, of course, fundamentally a container, and several forms of Hopi basketry serve precisely this function. But even these mainly utilitarian forms—the plaited sifter basket in particular—are lovingly embellished with geometric designs or a Katsina face, evidence of the Hopi impulse toward artistic expression. However, Hopi basket weavers are part of a social structure that imposes regulations and obligations that limit artistic freedom but that also stimulates the continued and constant production of basketry items. While the close-knit Hopi social structure downplays individualism and promotes traditional uses of form and color in certain basketry items, and thus restricts creative inventiveness, it provides Hopi women with the security of clan and family bonds that provide a buffer against poverty and loneliness.

Traditionally, two of the three Hopi women's societies (the Lalkont and O'waqölt) are responsible for transmitting the basket weaving skills from generation to generation by initiating young girls into their esoteric rites, including the teaching of basket weaving. To a certain degree this tradition has broken down on First and Third Mesas, where the hereditary line of officiating women has died out. On First Mesa, where basket weaving was already in decline prior to 1880, coiled baskets and most of the utilitarian wicker wares were not produced much later than the end of the nineteenth century. Pottery became the primary type of container, although plaited sifter baskets are still made for the occasional O'waqölt basket dance and for wedding paybacks. Even piiki trays are still made sporadically by a few women.

On Third Mesa, the only location today where women make wicker plaques and baskets, the instruction of young girls in basket weaving has shifted in the majority of cases from a girl's ceremonial godmother to her mother or grandmother. The reason

for this is the same as on First Mesa: the demise of ritual. The only existing women's society on Third Mesa is the O'waqölt, but its basket dance is now held only when a sponsor is willing to arrange it. The diminished ritualism of women's societies on Third Mesa has had little effect, however, on the production of wicker plaques. The art of wicker basketry weaving is particularly unparalleled in quantity and quality in the village of Hotevilla, where it provides the women with a most important source of cash income. The village of Bacavi, too, is in the process of reintroducing wicker weaving skills to its young girls, who are being taught by several of the older expert basket weavers. Finally, some of the best wicker basketry weavers are found among the small number of inhabitants in the village of Oraibi. Several of them produce extraordinarily beautiful works of art that still employ vegetal dyes. Sadly, however, the expertise in weaving deep wicker baskets has declined in all the Third Mesa villages.

Second Mesa, the center of close-coiled Hopi basketry weaving, is a flourishing center of activity in regard to this art. Here, in September and October, the Mamrawt and Lalkont women's societies observe their esoteric rituals, including the initiation of young girls. I am told that practically all the women living in Shungopovi, which is the largest village on Second Mesa, are members of both societies. They could also belong to the O'waqölt, but its ceremony and basket dance are rarely held and, again, only if a sponsor can be found. At their initiation into the Lalkont, young girls are instructed in, among other things, basket weaving skills taught by their ceremonial godmothers. They are allowed to weave a plaque or basket only when they have been initiated, after which many of the girls continue to practice the art under the tutelage of their mother or grandmother or on their own.

On the two mesas where basket weaving is still practiced, the weavers constantly seek to refine their technique and workmanship. Friends and relatives are quietly admired for their excellent work, and attempts are often made, without envy, to emulate their precision. Thus, a subtle but steady motivation is stimulated among the basket weavers, resulting in a continuously improved quality of workmanship. While this motivation is not readily noticeable on Second Mesa, it does come to the fore when the women talk about each other's work. When I spoke with and observed the basket weavers of Third Mesa, it was easier to see how their social network facilitated this encouragement. In Hotevilla,

for instance, work parties meet on a regular basis. Here, young basket weavers work side by side with older, more experienced women and learn by observation how to improve their weaving. In addition, middle-aged women, after having their basket weaving interrupted for years while they raised their children, may find new stimulation in the art by joining or rejoining such a work party. This system of working in a group not only assures the basket weavers a sufficient supply of plaques for certain events but also eases the tedious and laborious hours of work by mixing it with laughter and gossip with friends.

The basketry items used for utilitarian purposes—such as plaited sifter baskets, piiki trays, baby cradles, burden baskets, and parched-corn sifters—are still being made but less often. The plaited sifter basket is an exception, as it is still used throughout all the Hopi villages in normal daily activities and is made on all three mesas. Piiki trays are often replaced by other flat trays of wood or metal, but many women still use them when making their piiki, and they remain one of the mandatory basketry items in a wedding payback. Parched-corn sifters are not essential for a payback but are occasionally included and are a welcome gift. Very few basket weavers know how to weave a baby cradle even though this traditional item has recently found favor again with young mothers who like their newborn babies to be embraced in Hopi tradition.

Even fewer weavers make burden baskets. Harvested crops from the fields are now transported in cars, so the need for burden baskets has practically vanished. Occasional ceremonial needs for this basketry item are met by using heirlooms or asking one of the few women who still make them to weave a new basket. A smaller version is made for initiations by the few weavers who still know how to weave a burden basket with sumac branches. The smaller version has also become a sales item, in which case it is usually called a fruit basket and is often made of different plant material than sumac.

Hopi basketry production has always depended on the seasons. Age-old knowledge about the seasonal growing cycles of the plants needed for their basketry has always told Hopi women when to collect the plant fibers. Equally ancient is their respect for the Earth and for the products it shares with us human beings. Guided by old traditions, Hopi women observe the right times to collect the plants and when to leave them alone "so that the earth can rest." Collecting and weaving are seldom carried out

when food crops have been harvested and need to be stored for the coming months, but they are more actively pursued again in December and January in preparation for Powamuya. Plaques for kiva ceremonies and initiations are made whenever needed. Such basketry items are held in high regard and are often kept as heirlooms, thereby serving for many years.

Over the last hundred years, Hopi basketry has changed naturally within a body of unchanging techniques and usages. Because it is rooted in well-guarded traditions, major change would not be expected, but any living artform will change in distinctive directions. In the case of Hopi basket weaving, there has been a marked trend toward more complicated and intricate designs in plaques and deep baskets. Indian art shows, other juried shows, and the wishes and interests of collectors and traders have been partially responsible for this trend.

In coiled basketry the very large coils that were common at the turn of the century long ago gave way to smaller coils sewn with precise, evenly smooth, and tight stitches. The splints have become as narrow and thin as the weaver can possibly make them. Except for black, the color in most of the coiled basketry has reverted back to the vegetal dyes used decades ago, and miniature plaques and baskets are now very desired collector's items. Deep coiled baskets, made by several expert weavers, have reached unparalleled refinement, including detailed full figures of Katsinam.

Wicker plaques can be made faster than coiled plaques and are produced in a profusion of complicated color and design combinations. Since the 1930s the colors used have been produced mainly with aniline dyes.

While colors and figurative designs were used sparingly on Hopi basketry eighty to ninety years ago, weavers today challenge their creativity by producing many Katsinam representations, as well as animal and bird motifs that are often very stylized. This development alone should be proof that Hopi basket weaving has been elevated to the level of an art. The necessity for cash income was certainly a major stimulus for this heightened creativity, but I was repeatedly assured that during basket dances the power of prayer increases with the complexity of the design on the plaque a woman dances with. A Katsina representation brings a stronger response from the spirits than does a simple geometric design.

Of all the Hopi arts, basketry is the one that has always created the strongest bond in the social structure. Moreover, it is preem-

inent in all ceremonial observances. Plaques, for example, serve for the presentation of food in numerous circumstances, representing, in their sacred and secular functions, nourishment now and in the future. As gifts, plaques symbolize the role of the woman as the nurturer of her children. The wedding plaque is indispensable for a man's afterlife. The Katsinam give Hopi girls plaques at birth and again repeatedly until they are initiated into the Katsina society. Perhaps the most meaningful transfiguration of the basketry plaque reveals itself in the women's basket dance, in which plaques function as symbols to commemorate and honor the Earth and thus the perpetuation of life.

It seems to me that the basket dance ceremony brings this meaning to its logical conclusion. In a matrilineal society, women, the bearers of life, honor the Earth, the source of all life, with a product of its making: plant fibers that have been woven by the women into beautiful pieces of art. In Hopi society the basketry plaque symbolizes nourishment and womanhood and is accordingly valued and cherished. This spiritual component, combined with superb craftsmanship and beauty, should enter the collector's market at its true worth, as well as being respected as a work of art. Indeed, the entire spectrum of Hopi basketry deserves a new and heightened appreciation.

Afterword

On my last trip to the Hopi Mesas in July 1995 to complete this documentation, I became aware of the constant change inherent in a living art form. In the case of Hopi basket weaving, change has come in the state of the weavers' health and in the availability of the natural fibers used in basketry.

The effects of changes in the weavers' health were made apparent in my visits with two of the weavers represented in this documentation, Edith Longhoma of Shungopovi and Eva Hoyungowa of Hotevilla. I was saddened by the fact that the eyesight of both weavers had diminished so much within just a year that they had ceased making any basketry. Fortunately, Eva Hoyungowa has taught her daughter Rebecca well. She now weaves attractive plaques and is improving her skill under her mother's continued tutelage. Both Edith and Eva's eyesight could probably be greatly improved with successful cataract operations. However, neither of them mentioned that this possibility had been suggested by the eye doctor who visits the Hopi clinic. The health service Native Americans receive on their reservations is lacking in many respects.

Diminishing supplies of natural materials have also affected basket weaving. When I heard that Evelyn Seletstewa in Mishongnovi had made two large baby cradles, I was curious to see them. When shown them, however, I was surprised to find that Evelyn had used commercial reed material exclusively for the wefts. It gave the cradles quite a different appearance from her previous cradles, made of sumac. Evelyn claims she cannot find sumac anymore and that she can sell these cradles, with their reed dyed brown, just as well to young Hopi mothers. Considering the scarcity of sumac and the financial needs of her family, this substitution with commercial fiber is understandable, but it is also sad evidence of the loss of traditional plant material in Hopi basket weaving.

The Origins of Hopi Basket Weaving Techniques

The Hopis' history spans so many centuries that their cultural traits and religious and social contexts—and presumably many of the techniques they use to produce their artifacts—reach back into a past that history does not record. Books and articles on southwestern archaeology do suggest that there are certain similarities between prehistoric and modern basketry but it is not my intention to present a thorough analysis of the origins of Hopi basket weaving techniques. Rather, I want to explore briefly one possible line of evidence for the introduction of some basket weaving techniques among the Hopis. Since this evidence is based largely on the oral traditions about Hopi clan migration, supplemented by some archaeological data, my conclusions are subject to revision if and when new archaeological information on basket making is recovered from the Hopi region.

Of the three types of basket weaving practiced by the Hopis today, only plaiting shows almost no change in techniques from those used by the Anasazi who occupied the area in prehistoric times. Thus, techniques used in the plaited yucca sifter baskets made by the Hopis today are virtually unchanged from Anasazi examples. The technique of contemporary Hopi wicker basketry, in contrast, was absent from Anasazi material culture. Though some Anasazi sandals were woven from yucca leaves in a wicker technique, the work bore little resemblance to present-day Hopi wicker basketry. Similarly, contemporary Hopi coiled basketry differs substantially from Anasazi coiled basketry in technique and basic materials.

COILED BASKETRY

I would first like to compare the differences in technique and materials between Anasazi and contemporary Hopi coiled basketry. Anasazi coiled basketry has a foundation of twigs (rods) that have had their outer bark peeled off. Several variations of

rod foundations existed, but the most common one consisted of two rods with some split-leaf material placed on top of them. This is called a two-rod-and-bundle foundation, and it was used throughout the Southwest from Basket Maker times through the Pueblo periods. It was used on the Hopi Mesas until sometime between A.D. 1750 and 1800 (Morris and Burgh 1941). The coils were usually small (about a third of an inch in diameter), and the coiling stitches were made of very fine splints that did not interlock and that were made of a variety of plant materials that split easily.

Contemporary Hopi coiled basketry, in contrast, has a foundation of fine, unsplit galleta grass stems to which very fine yucca leaf fibers are occasionally added. Hopi coiled-basket weavers never use any twigs in their foundations, and the sewing splints are made exclusively from the yucca plant. The stitches are made of very fine splints that are noninterlocking, very regular, and placed so densely that the foundation material is invisible. The coils are much thicker than in Anasazi baskets and can range from one-quarter inch to almost an inch in diameter, depending on the size of the plaque or basket the weaver is making. The foundation of these coils, which consists of a bundle of fine grass stems or threaded leaf material, is called a bundle foundation.

Due to the fact that there has been only limited archaeological activity on the Hopi Mesas, basketry items from before the late nineteenth century have not been recovered from either Second or Third Mesa. Only Walpi on First Mesa sheds some light on the period when the Anasazi type of coiled basketry was made among the Hopis and bundle foundation basketry was introduced.

Walpi was partially excavated and then restored from 1975 to 1977. Under the leadership of archaeologist E. Charles Adams, and in consultation with Hopi elders from Walpi, eighty-five rooms were excavated and restored or rebuilt and afterward reoccupied by their owners. From the earliest rooms, dating from Walpi's founding in 1690 to 1800, archaeologists found five coiled plaque or tray fragments that are indistinguishable from Anasazi coiled basketry of the Pueblo III period (A.D. 1100–1300; Adovasio and Andrews 1985). Four of them have a two-rod-and-bundle foundation, and the remaining example has a single-rod foundation. All are close coiled, and all have noninterlocking stitches. Also found in these early rooms were fragments of bundle foundation and close-stitched, noninterlocking coiled basketry fragments. Both techniques existed in Walpi simultaneously until about

A.D. 1820, after which weavers made only bundle-foundation coiled plaques, and these had considerably larger coils than those with a rod foundation. Adovasio and Andrews point out that basketry was never made in great quantity in Walpi but that among coiled basketry by far the most common type was the plaque. Based on the rooms where they were found and evidence of negligible use, Adovasio and Andrews suggest that the plaques were used primarily for ceremonial purposes.

The predominant type of basketry in the Walpi assemblage was the plaited sifter basket, though the archaeologists found some fragments of cradles and possibly burden baskets made in the wicker technique. However, not a single fragment of a wicker plaque was found. While Hopi coiled and plaited basketry was probably influenced by Anasazi basket weaving techniques, the joining of the various Hopi clans in one location, the Hopi Mesas, introduced new techniques and sometimes alternative uses for available plant materials. Every newly arrived clan brought not only new ceremonial rituals that benefitted all Hopis but also new technology that affected the manufacture of arts and crafts.

The oral tradition that Hopi clans migrated from all directions and finally arrived at the Hopi Mesas is one of the fundamental truths of Hopi life. Hopi society consists of about twenty-five clans, and each clan has its own migration history. It is of particular interest to Hopi elders when archaeological evidence supports their oral history, and it is an accomplishment for archaeologists when their excavations help to establish links between prehistory and history. Most of the excavated evidence consists of architectural features, pottery, stone, and perhaps shell and bone artifacts. However, because they disintegrate quickly in soil subjected to rain and wind, organic material such as wood, basketry, and textiles (called perishable artifacts) are rarely preserved in sites that have been exposed to the elements for centuries. Thus the hope of finding prehistoric basketry remains is slim indeed. Most of the small number of fragments that have survived have been charred by fire, which shields them to some extent against further decay.

Caves and rock shelters offer a better chance of finding basketry fragments because they shelter perishable artifacts from the elements. Prehistoric caves are most numerous in the mountainous areas of eastern and southeastern Arizona and southwestern New Mexico, where they have formed in canyon walls, often high above remote rivers and their tributaries. Early archaeological

work in these areas resulted in the recovery of some basketry. C. B. Cosgrove's report on excavations in caves along the Upper Gila River and in the Hueco Mountains in New Mexico and Texas (1947) and Walter Hough's report on excavations in sites and caves in canyons on the Upper Gila and Salt Rivers (1907), as well as his publication *The Culture of Ancient Pueblos of the Upper Gila River Region* (1914) document basketry items that help to establish the origins of present-day Hopi basket weaving techniques.

Emil Haury's report on his 1932 excavation in Canyon Creek Ruin, a late Mogollon cliff dwelling from the first half of the fourteenth century (Haury 1934), provides detailed information on basketry specimens made using the same techniques as in modern Hopi coiled and wicker basketry. Haury found three types of coiled basketry in Canyon Creek Ruin: crude coiling covered with mud to form a storage bin; fragments of coarse coiling, possibly part of a granary, and a small jar made using the same technique; and close-coiled stitches used to form a small plaque four inches in diameter. Haury identified the sewing material as beargrass and the technique as noninterlocking stitches, with seven to eight stitches per inch. The coils are small, averaging four coils to the inch. Of importance is the fact that in all three types of coiling techniques found in Canyon Creek Ruin, the foundation is a grass bundle very similar to the bundle foundation used today by Hopi coiled-basket weavers. The Akimel O'odham (Pimas) use split cattail strips as a foundation, and the Tohono O'odham use threaded beargrass. It is interesting that the location of Canyon Creek Ruin is on the southern edge of the Mogollon Rim and is almost halfway between the low desert country and the Hopi Mesas in northern Arizona.

Evidence for earlier bundle-foundation coiled basketry in southern Arizona came from Ventana Cave, a large rockshelter in the southeast side of the Castle, or Cimarron, Mountains on the Tohono O'odham Reservation west of Tucson. It was excavated by Emil W. Haury and Julian D. Hayden in 1941 and 1942. The cultural deposits go back several millennia, but Haury and Hayden found no pottery or basketry prior to the first century A.D. at Ventana. Most of the basketry and pottery was found only in the four uppermost layers, which contained artifacts of the Hohokam culture. With the help of intrusive pottery sherds from the same levels, they dated the basketry to between A.D. 800 and 1400. Most of the basketry is coiled, though a few fragments are

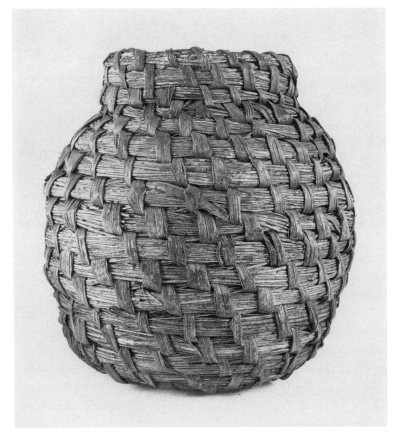

A loose-coiled storage basket from Canyon Creek Ruin, a fourteenth-century cliff dwelling in a side canyon of Canyon Creek below the Mogollon Rim. The foundation of the coils is composed of shredded fibers, presumably beargrass. (1993; height: 7.5"; ASM collection no. GP 16975)

plaited and even fewer are twined. Over a time span of about 600 years, nine different foundation techniques, including bundle foundation, were used for the coiled basketry, more or less contemporaneously. Weavers employed both interlocking and noninterlocking stitches, and usually used finely split yucca leaves as the sewing material for the bundle foundation. However, finely split cattail (the plant used by Akimel O'odham basket weavers) also served as bundle material. Throughout the Ventana Cave sequence the coils were small, ranging from a quarter to three-eighths of an inch in diameter.

A southern origin for bundle-foundation coiled basketry is possible. Lynn Teague (1992) reports that prehistoric textile and basket weaving techniques used in southeastern Chihuahua, northern Durango, and western Coahuila in Mexico parallel those of historical northern Pimas. It is unfortunate that many archaeological sites in northern Mexico have been lost to agriculture because with them it might be possible to establish a

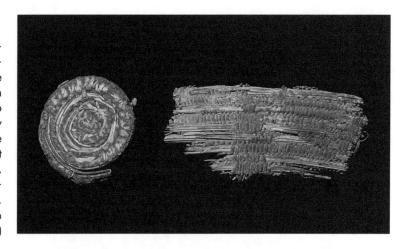

Two coiled basketry fragments with bundle foundations from Ventana Cave on the Tohono O'odham Reservation. They date to the fourteenth-century layer of deposits in the cave. The round fragment is 2 inches in diameter, and the basket wall fragment is 4.5 inches long. (1993; ASM collection no. A-8801-x)

stronger prehistoric connection between northern Mexican cultures and those in southern Arizona, southern New Mexico, and southwestern Texas.

Even today, one of the northwestern Mexican Indian tribes, the Seris of Sonora, produce coiled basketry with a bundle foundation. They make very finely executed close-coiled baskets, usually in the shape of bowls and jars. The jar-shaped baskets can be very large. Seri baskets have smaller coils than Hopi basketry, but they share the same technique of close-stitched coiling over a bundle foundation, working from right to left. The material for the foundation and for sewing is made of split branches from the *torote*, or elephant tree (*Jatropha cuneata*), a low tree that grows along the coastline. Seris ornament their baskets with beautiful geometric designs using splints dyed rust red, brown, and black.

The so-called Big Bend Culture in Texas also produced early bundle-foundation coiled basketry. In the 1930s Frank M. Setzler, the head curator of the Department of Anthropology at the U.S. National Museum of the Smithsonian Institution, excavated material ascribed to this culture. The cave deposits included burials, with the bodies wrapped in plaited mats and placed on beds of grass. Setzler did not find any pottery in the caves, but he did find coiled basketry with a single-bundle foundation and interlocking stitches. The sewing material was yucca leaf splints. Setzler called this type of basketry "coiled basketry fragments predominantly of the split stitch with a single bundle foundation" and suggested that the deposits represented a "transitional stage between the Basket Maker III and Pueblo I periods" (A.D. 700 to 800; Setzler 1933).

All the evidence for close-coiled bundle-foundation basketry

in the prehistoric horizon of southern Arizona, southern New Mexico, and southeastern Texas suggests an origin somewhere in Mexico. James M. Adovasio, of the Department of Anthropology at the University of Pittsburgh, has conducted extensive research in prehistoric North American basketry, and his conclusions shed light on the origin of this type of basketry. Adovasio (1973) notes that Richard S. MacNeish had suggested as early as 1967 that close-coiled, bundle-foundation, noninterlocking-stitch basketry was the first type of basketry made in the Tehuacán Valley in central Mexico. He proposed that it appeared as early as 6500 to 4800 B.C. and eventually spread northward. To test this theory, Adovasio investigated the early basketry in the state of Coahuila in northern Mexico, which he believed provided the "longest and most complete sequence" of basketry outside of the Great Basin in the United States (Adovasio 1973, 7). In the Coahuila sequence, twining, plaiting, and coiling dated back to 7500 to 4000 B.C. The early coiling foundation was usually a single-rod base, but basket weavers gradually changed to multirod and bundle foundations. By A.D. 500, five varieties of bundle foundation were more numerous than the seven varieties that employed a single-rod foundation, but weavers used both techniques simultaneously. Simple geometric designs now appeared on coiled basketry. In later centuries, bundle-foundation manufacture diverged from the single-rod foundation, and in certain localities basket weavers used only bundle foundations in coiled basketry. Single-rod coiled and twilled baskets and mats were produced throughout the period. Adovasio agrees with MacNeish about the northward diffusion of close-coiled, noninterlocking-stitch bundle-foundation basketry from central Mexico but argues that it was most likely preceded by twining and single-rod coiled basketry. No basketry fragments predating 6500 B.C. have been found in central Mexico.

Based on this research, present-day Hopi weavers of coiled basketry apparently employ basically the same technique as that used for millennia by basket weavers in central and northern Mexico. This conclusion finds some support in Hopi migration stories, which suggest that some clans came from the south. For example, one migration story tells of the destruction of the village of Palotquopi in a big flood (Nequatewa 1936; see also references to Palatkwapi in Voth 1905). Its location seems to have been in southern Arizona or northern Mexico. The stories sometimes refer to the abundance of crops from fields watered by irrigation canals that drew water from a river. Among the clans living

in Palotquopi was the Patki (Water) Clan, which was the most prominent clan. Others were the Corn Clan, the Sand (or Lizard) Clan, and the Sun/Forehead Clan. Voth reports that the members of the Sand Clan brought with them the Lalkont women's society and their ceremonies, including their basket dance, the Soyal ceremony, and the Soyal Katsina. According to the legends as reported by Edmund Nequatewa, the people of Palotquopi also had a Butterfly dance, which is a social dance.

When I asked one of my friends whom I have known for more than twenty years and who belongs to the Sun/Forehead Clan in Shungopovi if she could tell me who had introduced the basket dance to the Hopi Mesas, the tone of her voice told me she was surprised I did not know. "We, our clan," she said, "brought this with us when we came from the south, when we had to leave because of the big flood." Her clan had lived in Homol'ovi near present-day Winslow, Arizona, and was the last to arrive on Second Mesa. They were given the name Sun/Forehead Clan because when they had arrived on top of Second Mesa the rising sun hit their foreheads just when they climbed over the mesa edge and were greeted by the villagers. It is a wonderful story.

Even though a mythological big flood exists among many ethnic groups, I find it interesting that the O'odham of southern Arizona also have a legend that in many aspects parallels the Hopi legend. I first heard it when I worked with Emil W. Haury at Snaketown, the large Hohokam site south of Phoenix. On a warm, sunny winter day in 1964, "Doc," as we called Professor Haury, told us a story that he had been told by a Pima thirty years earlier when they were excavating Snaketown for the first time. This story tells of floodwater so high that even the Superstition Mountains were almost flooded. Birds of all kinds and sizes flew to the highest ridges of the mountains to escape. Some of the large birds on the ridges dipped their long tails into the water. Suddenly the waters stopped rising and receded, leaving a white line on the birds' tails where the waters had reached. There was also a white line on the high cliffs of the Superstition Mountains. The Pima say that the birds were the turkeys and that the white line on the cliffs facing west can still be seen today. In the Hopi legend told by Nequatewa, the old men turned into turkeys who were sitting on a beam inside a house on high ground. The floodwater did not reach the beam, but the birds' tails had dipped into the water, leaving a white mark.

The flood legend of the Tohono O'odham, who are located farther south than the Akimel O'odham, also parallels the Hopi legend of sacrificing two children to stop the water from rising. Two children (in some stories four children) were sacrificed to a water snake to save the entire community. A shrine erected in their honor is still maintained near Anegam on the Tohono O'odham Reservation, and periodically ocotillo branches are added to the surrounding walls of the shrine. Offerings of food and personal items are still made so that the memory of the event is kept alive. The true location of Palotquopi remains a mystery, however.

The northern movement of the clans that made bundle-foundation basketry may be documented by recent Arizona State Museum excavations at Homol'ovi II, a large prehistoric Hopi pueblo near Winslow, Arizona. In 1994 researchers discovered a small piece of charred coiled basketry with a bundle foundation. The coils, which are very finely sewn, are no more than one-half centimeter in diameter. Though in several years of digging at Homol'ovi II this was the first fragment of basketry recovered, only a week later an entire coiled plaque with a rod-and-bundle foundation and other fragments of coiled-bundle-foundation basketry, also thoroughly charred, were found in the same burned kiva. It seems that, bit by bit, the progression northward of coiled basketry with a bundle foundation can be tied to northward-migrating Hopi clans. Several women in Shungopovi, all of whom belong to the Lalkont Society, told me that the Water Clan is in charge of the annual Lalkont ceremony and basket dance. Echoing Edmund Nequatewa's and my friend's words, it is possible that the Lalkont women's society was established before, or at least during, the southern clans' northward migration. If so, they may also have brought with them coiled basketry with a bundle foundation and possibly the idea of the ceremonial importance of plaques.

WICKER BASKETRY

Wicker basket weaving does not appear among basketry or basketry fragments of the Anasazi culture. As mentioned at the beginning of this chapter, the Anasazi used a wicker weaving technique only for the manufacture of sandals made of yucca leaves, and even then they used a technique unlike present-day Hopi wickerwork. Attempting to find and follow traces of the "wicker

road" is not easy, and the available evidence is based more on archaeological discoveries than on Hopi oral traditions.

One of the most exciting discoveries Emil Haury made at Canyon Creek Ruin was a wicker plaque that is identical to present-day Hopi wicker plaques. The only difference is that this plaque, which is more than 660 years old, shows no remnant of any color design. The technique used to manufacture it, however, from the beginning at the center (the *yayni* in Hopi) to the finishing of the rim, is nearly the same as that used to manufacture wicker basketry on Third Mesa today. Several other fragments of wicker plaques were also recovered, as well as larger pieces that appear to have come from large burden baskets. Haury noted that this kind of wickerwork is not found in basketry from Pueblo III caves, and he believed that it was a Pueblo IV innovation (Haury 1934, 80–81). Wicker basketry made with this technique and dating from A.D. 1326 (the beginning date for the Canyon Creek Ruin) is so well constructed and finely executed that the technique probably originated earlier than the fourteenth century. Perhaps it was developed by the Mogollon culture of southeastern Arizona and southwestern New Mexico or derived from sources farther south.

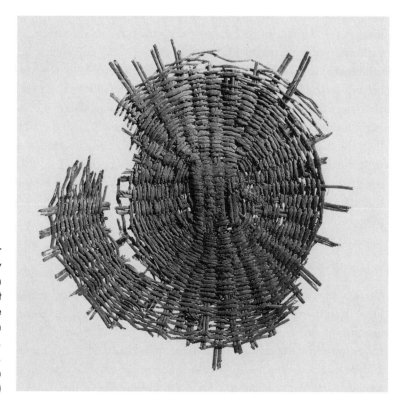

A fragment of a wicker plaque from the early fourteenth century in Canyon Creek Ruin. It is woven in the same technique as modern Hopi wicker basketry. Vertical dimension: 11.5″. (1993; ASM collection no. GP-53528)

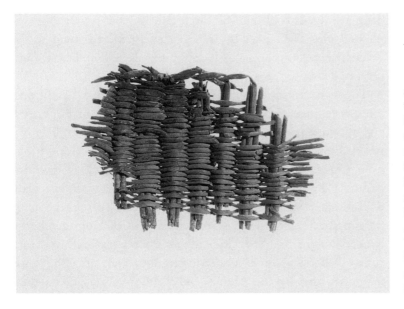

A fragment of wicker weave from the early fourteenth century in Canyon Creek Ruin. Six warp elements show the same rim-finish technique as modern Hopi wicker basketry. One stem of each warp element is bent to the left to be incorporated into the rim. The other stems are broken off. Length of fragment: 4". (1993; ASM collection no. GP-17216)

Its subsequent survival in the hands of Hopi basket weavers in an unchanging form for more than 600 years may argue that its origins date back into prehistoric times even earlier than A.D. 1326.

Some Hopi clans may have originated in the east and brought the wicker basket weaving technique with them on their migration to the Hopi Mesas. There is some evidence that Hopi culture was influenced by the prehistoric Mogollon culture. In his 1914 report, *The Culture of the Ancient Pueblos of the Upper Gila River Region*, Walter Hough described cliff ruins and caves along the Blue River and its tributaries in eastern Arizona. In the cave deposits he found numerous caches of offerings that are similar to Hopi artifacts. Hough describes ceremonial caves that had deposits of *pahos* (prayer sticks), baskets, cane cigarettes, miniature pottery, and miniature bows and arrows. Bear Creek Cave, on a tributary of the Blue River, had particularly interesting basket pahos made using the coiled technique (Hough 1914, 123–25). Most of these are three and a half to four inches in diameter and have a hole in the center to accommodate a support rod. Unfortunately, Hough did not describe the type of foundation used in these basket pahos. The coiling of the splints is very interesting because the coil stitch that secures a coil to the preceding one occurs only at intervals, which means that the intervening stitches are looped around the foundation without being stitched to the previous coil. This coiling technique is reminiscent of techniques described by some Second Mesa women who weave small plaques for men's initiations. These plaques are only about four inches in

diameter. I was told that the important number four was incorporated into the basket by securing every fourth stitch to the preceding coil, with the rest looped around the foundation. I was not privileged to see such a plaque.

The basket pahos from Bear Creek Cave are of additional interest because they are painted on the outside in black, red, green, and a natural color (Hough called it splint color; 1914, 125). Often the designs are only in red and black. Motifs range from zigzags to stepped, triangular, or diamond cloud interpretations. The inside of these small baskets is either left plain or painted in solid red (derived from ochre?). In their geometric simplicity, these designs are reminiscent of Hopi geometric wicker designs and the cloud designs used sparingly in Hopi coiled basketry about a hundred years ago. They are also similar to motifs used by the Akimel and Tohono O'odham on their basketry.

Hough's description of the basketry from the cave deposits along the Upper Gila and Salt Rivers is not very specific, but he does mention the various techniques. They include twining for clothing, "wicker in basketry and sandals, checker twilled and diaper pattern in mats, plain and ornamental weaving in sandals and coiled weaving in several varieties" (Hough 1907, 25). Of the plants used for weaving he notes "Rhus trilobata and willow; strips of yucca, dasylirion and like plants and fibers of the same, stems of grasses and rushes and other splints of reed and other vegetal products not yet identified" (p. 25). He continues: "The series [of basketry] from these sites is remarkable for diversity, and nowhere is found a like conjunction of so many methods of weaving" (p. 25). Unfortunately, no one has thoroughly studied this apparent abundance of basket material, which is located at the Smithsonian Institution's National Museum of Natural History in Washington, D.C.

Wickerwork basketry was also recovered from two other late prehistoric sites, Chavez Pass and Chevlon Ruin. Both are located on the Mogollon Rim in the vicinity of Winslow, and both date to the fourteenth century. They would have been on the path of Hopi clans migrating to the Hopi Mesas from the south. Both ruins were excavated by Dr. J. Walter Fewkes in 1896 and 1898. His report on the Chavez Pass Ruin does not elaborate on the basketry finds, but he mentions finding coiled and wicker fragments at both pueblos. The coiled fragments have rod foundations. At the Chevlon ruin the wicker basketry from graves is

identical to modern Hopi wicker plaques. Some of these were painted in green (malachite) or blue (azurite); others had dyed wefts that were designed to achieve these colors.

The custom on Third Mesa of applying a white wash (kaolin) to wicker plaques and then painting them with blue designs was practiced until forty or fifty years ago. Leigh Jenkins, the director of the Hopi Cultural Preservation Office in Kykotsmovi, told me that in some of the old houses in Oraibi and Hotevilla, plaques on the walls have faint remnants of a white wash and sometimes even fainter indications of blue paint. The images did not last very long because the paints or pigments used were very fugitive. Vera Pooyuma, the oldest woman in Hotevilla, told me that in her youth (about 1900 to 1910), plaques were decorated by men, who would paint the image of Sa'lakwmana (Shalako Maiden) with indigo dye on the whitewashed background.

Fewkes excavated the old Hopi pueblo of Sikyatki at the end of the nineteenth century and explored the ruins of Awat'ovi and two other ruined pueblos in the Jedito Valley. All of these pueblos had wicker, coiled, and twilled basketry (Mason 1904), yet in the burials at Awat'ovi, Fewkes found only wicker basketry. Mason points out that the wickerwork is just like the present wicker plaques made on Third Mesa.

Sikyatki, located on the southern flank of First Mesa, is famous for its beautiful polychrome pottery, which dates from A.D. 1400 to 1625. This pottery also shows up in the ruin of Hawikuh, a close neighbor of Zuni Pueblo in New Mexico. When Frederick Webb Hodge excavated Hawikuh from 1917 to 1923, he found a fifteen-foot-deep stratigraphic deposit containing Gila Polychrome (A.D. 1250–1400, which indicates a connection or influx from southeastern Arizona), Kechipawan Polychrome (1375–1475), Sikyatki Polychrome (1400–1625), Matsaki Polychrome (1475–1650), and finally Hawikuh Polychrome (1630–1672). After being occupied for more than 400 years, Hawikuh was abandoned in 1672 following a very damaging Apache raid. Hodge found basketry in fifty-two burials. Although his field notes say nothing about the weave or technique used in making the items, he did refer to "trays," "shallow and circular containers," and "flat baskets similar to the present day Zuni baskets." On another occasion he mentioned a mortuary deposit of an "osier basket as made at Zuni today." Apparently, more plaques were deposited with the more recent burials, and the plaques were more commonly associated with the burials of women than with those of men or children. The

plaques or baskets were placed in the graves to hold corn, squash seeds, piñon nuts, and bundles of plant fibers that could have been used in basket making. Hodge's field notes were finally published in 1966 in an edited form (Smith, Woodbury, and Woodbury 1966). In this publication a photograph of burial number 63 (p. 31) shows a large wicker plaque placed over the deceased's face, and it appears that several wicker plaques covered the body. Hodge reports that in most of the seventy burials the dead were either wrapped in matting or placed on mats that in some cases were folded into four layers. Hodge refers to the matting as "checker-weave," which presumably is plaited basketry.

Kechipawan, the ruin of another pueblo near Hawikuh, had coiled basketry with a two-rod-and-bundle foundation and wicker basketry that looks like present-day Hopi wicker plaques. One of the fragments has six beginning warp segments, which could indicate a large plaque. Another fragment had only two or three, which is the usual number for small baby plaques. The inhabitants of Kechipawan may have made small plaques for their babies and toddlers just as the Hopis do today.

Wicker basketry has probably been made by Zuni basket weavers as long as it was made in Hawikuh or Kechipawan. The technique of wicker weave may in fact have traveled with the spread of Gila Polychrome pottery from east central Arizona to the pueblos of Chavez Pass and Chevlon Ruin, and also to the Zuni region, where it seems to have been particularly favored by the people of Hawikuh and its neighbors. From Zuni the technique could have made its way to Sikyatki and Awat'ovi. The route may have been the reverse, with the wicker technique reaching Third Mesa with groups migrating from the Chavez Pass or Chevlon villages. It may then have been reinforced much later by the influx of women from Awat'ovi after that pueblo's demise in A.D. 1700. It is unclear why the weaving of wicker plaques never became popular on Second Mesa, being instead relegated only to the production of piiki trays, burden baskets, and cradles. The use of plaques was almost entirely ritual and ceremonial before plaques became commercial items in the twentieth century. At one time the two women's societies, Lalkont and O'waqölt, whose members constituted the sole basket weavers, had a great influence over where certain plaques were made, and to a great degree this is still true today. What is puzzling, though, is the lack of wicker plaques in the old room deposits of Walpi. Archaeologists found wicker fragments of cradles and what look like large

burden baskets but not a single wicker plaque or plaque fragment. However, in A.D. 1700 some Awat'ovi women and children were brought to First Mesa, including Walpi, and they could possibly have brought the wicker plaque weaving technique with them.

It is unclear exactly where the Hopi wicker weaving technique originated many centuries ago. Future research may produce the answer. The Mayo Indians of lower Sonora, who live near the Río Mayo, make wicker basketry from peeled willow twigs, but their baskets look very different from Hopi wicker basketry. In Mayo wicker the wefts are widely spaced, and the warps are clearly visible. Mayo wicker basketry looks to be of European origin in its technique and form. It consists of wide-mouthed "easter baskets" with large handles; rough, high-sided baskets; and European-style baby bassinets with large hoods. All these, I am told, are for sale and are seldom used by the Mayos themselves. Even though they are wicker baskets, they do not seem to have any connection with Hopi wicker basketry.

Glossary

Akimel O'odham. Pima.
Angaktsina. Longhair Katsina.
Angwushahay'i. Crow Mother Katsina.
a'qaw'u. Sunflower seeds (*Helianthus* sp.).
Awat'ovi. A Hopi village abandoned in 1700.
hahawpi. A wedding plaque. Third Mesa.
Hahay'iwuuti. Katsina Mother Katsina.
ho'aphoya. A small burden basket, also known as a fruit basket.
ho'apu. A burden basket.
hohoisi. Hopi tea (*Thelesperma megapotamicum*), used for a red or orange dye.
Hopi Guild. The Hopi Arts and Crafts Silvercraft Cooperative Guild, on Second Mesa.
Hopi Show. The common name for the Hopi Craftsman's Exhibition, which is now the Museum of Northern Arizona Heritage Program's Hopi Marketplace.
Katsina. A spirit being of the Hopi world (plural: Katsinam).
Kóoninkatsina. Havasupai Katsina.
Kóoninsuta. Powdered hematite.
Lakonmana. A woman in the Lalkont society.
Lalkont. A Hopi women's society.
Lakontaqa. A man who functions in the Lalkont society.
maa'óvi. Snakeweed.
Mamrawt. A Hopi women's society.
mooho. *Yucca angustissima*, used as sewing material for coiled basketry.
ngöla. A coiled baby plaque. Second Mesa.
O'waqölt. A women's society.
pahaana. A white person.
paho. A prayer stick.
Palhikwmana. Butterfly Maiden Katsina.
piiki. Wafer-thin cornmeal bread.
pik'inpi. A piiki tray.
poota. A Second Mesa coiled plaque.
potawya. A miniature coiled plaque.
Powamuya. The Bean dance.

qahavi. Willow, sometimes used as the weft in utilitarian wicker basketry.

qötsa'inpi. A coiled wedding plaque. Second Mesa.

sakwa. Azurite or indigo, used as a blue dye.

Sa'lakwmana. Shalako Maiden.

Sichomovi. Middle Village, First Mesa (also called Sitsom'ovi).

siita. Navajo tea (*Thelesperma subnudum*), used as a red dye in coiled and wicker basketry.

Sikyatki. An abandoned Hopi village.

si'önga. Natural white alum.

Sitsom'ovi. Middle Village, First Mesa (also called Sichomovi).

siváapi. Rabbitbrush (*Chrysothamnus* spp.). The stem is used as a weft in wicker basketry.

siwi. *Parryella filifolia*, a bush whose stems are used as the warp in wicker basketry.

söhö. Galleta grass (*Hilaria jamesii*), used as the foundation material in coiled basketry.

somiviki. Food wrapped in small corn husks.

suuvi. Scrub sumac (*Rhus trilobata*), used in utilitarian wicker basketry.

taapu. A baby cradle.

tapuwya. A miniature baby cradle, used as a toy.

Tawa Katsina. Sun Katsina.

tiikive. A day of dance.

Tohono O'odham. Earlier called the Papago, a Native American group in southern Arizona and northern Sonora, Mexico.

tos'inpi. A coiled plaque for sweet cornmeal. Second Mesa.

tsayánpi. A parched-corn sifter made in a wicker technique.

tutsaya. A sifter tray basket, or any basket made of yucca leaves.

tuuma. Whitewash, or kaolin.

wukopotasivu. A large, deep coiled basket. Second Mesa.

yayni. The beginning of a wicker plaque.

yungyaphoya. A small wicker plaque for a baby.

yungyapsivu. A large wicker basket.

yungyapu. A Third Mesa wicker plaque. This term is applied to any wicker plaque except a small baby plaque.

Bibliography

Adams, E. Charles. 1985. "An Introduction to the Walpi Archaeological Project." In *Basketry and Miscellaneous Perishable Artifacts from Walpi Pueblo, Arizona*, by J. M. Adovasio and R. L. Andrews, ed. R. C. Carlisle, 1–34. Ethnology Monographs, no. 7. University of Pittsburgh.

———. *Synthesis of Hopi Prehistory and History*. 1978. Final Report for the National Park Service, Southwest Region.

Adovasio, James M. 1973. "Prehistoric Basketry of Western North America and Mexico." Paper presented at the Proceedings of the 9th International Congress of Anthropological and Ethnological Sciences.

———. 1974. "Prehistoric North American Basketry." *Nevada State Museum Anthropological Papers* 16:100–145.

———. 1977. Basket Technology. Aldine Publishing Company, Chicago.

Adovasio, James M., and R. L. Andrews. 1985. *Basketry and Miscellaneous Perishable Artifacts from Walpi Pueblo, Arizona*. Ed. R. C. Carlisle. Ethnology Monographs, no. 7. University of Pittsburgh.

Adovasio, James M., and J. Gunn. 1975. "Basketry and Basketmakers at Antelope House." *The Kiva* 41:71–80.

Aikens, Melvin C. 1970. *Hogup Cave*. Anthropological Papers no. 93. Department of Anthropology, University of Utah, Salt Lake City.

Allen, Laura Graves. 1989. "Wicker, Plaiting and Coil." *Plateau* 53:5–7.

Bartlett, Katherina. 1948. "Hopi Yucca Baskets." *Plateau* 21:33–41.

Bell, Willis H., and Edward F. Castetter. 1941. *The Utilization of Yucca, Sotol and Beargrass by the Aborigines of the American Southwest*. Ethnobiological Studies in the American Southwest no. 7; University of New Mexico Bulletin no. 372, Biological Series, vol. 5, no. 5.

Breunig, Robert. 1989. "Cultural Fiber Function and Symbolism in Hopi Basketry." *Plateau* 53:8–13.

Brew, John O. 1937. "The First Two Seasons at Awatovi." *American Antiquity* 3:122–137.

———. 1939. "Preliminary Report of the Peabody Awatovi Expedition of 1937." *American Antiquity* 5:103–114.

———. 1941. "Preliminary Report of the Peabody Museum Awatovi Expedition of 1939." *Plateau* 13 (3): 37–48.

Colton, Mary Russell Ferrell. 1965. *Hopi Dyes*. Museum of Northern Arizona Bulletin 41. Flagstaff.

Cosgrove, C. B. 1947. *Caves of the Upper Gila and Hueco Areas in New Mexico and Texas*. Papers of the Peabody Museum of American Archaeology and Ethnology, Harvard University, vol. 24 (2).

Cosgrove, H. S., and C. B. Cosgrove. 1932. *The Swarts Ruin, A Typical Mimbres Site in Southwest New Mexico*. Papers of the Peabody Museum of American Archaeology and Ethnology, Harvard University, vol. 15 (1).

Courlander, Harold. 1982. *Hopi Voices: Recollections*. Traditions and Narratives of Hopi Indians. University of New Mexico Press, Albuquerque.

Douglas, Frederic Huntington. 1939. *Types of Southwest Coiled Basketry*. Denver Art Museum Leaflet 88. Denver.

———. 1940. *Twined, Wicker and Plaited Basketry*. Denver Art Museum Leaflet 99–100. Denver.

Dunnington, Jean. 1986. "Emily Quanimptewa, Hopi Basket Maker." *American Indian Basketry and Other Native Arts* 19:22–25.

Ferg, Alan, and Jim I. Mead. 1993. "Red Cave: A Prehistoric Cave Shrine in Southeastern Arizona." *Arizona Archaeologist* 26 [Arizona Archaeological Society].

Fewkes, Jesse Walter. 1896. "A Contribution to Ethnobotany." *American Anthropologist* 9:14–21.

———. 1899. "Hopi Basket Dances." *Journal of American Folklore* 12:81–97.

Fewkes, Jesse Walter, and J. G. Owens. 1892. "The Lalakonta: A Tusayan Dance." *American Anthropologist* 5:105–129.

Fowler, Catherine S. 1986. "Subsistence Practices." In *Handbook of North American Indians*, vol. 11: *Great Basin*, edited by W. L. d'Azevedo, 64–97. Smithsonian Institution Press, Washington D.C.

Guernsey, Samuel James, and Alfred V. Kidder. 1921. *Basket Maker Caves of Northeastern Arizona*. Papers of the Peabody Museum of American Archaeology and Ethnology, Harvard University, vol. 18, no. 2.

Harvey, Byron, and Suzanne de Berge. 1969. *Hopi Miniature Baskets*. Arequipa Press, Phoenix.

Haury, Emil W. 1934. *Canyon Creek Ruin and the Cliff Dwellings of the Sierra Ancha*. Medallion Papers 14, Gila Pueblo, Globe, Ariz.

———. 1975. *The Stratigraphy and Archaeology of Ventana Cave*. University of Arizona Press, Tucson.

Herold, Joyce. 1984. "Basket Weaver Individualists in the Southwest Today." *American Indian Art Magazine* 9 (2):46–53.

Hodge, Frederick Webb. 1937. *History of Hawikuh, New Mexico*. Publications of the Frederick Webb Hodge Anniversary Publication Fund, vol. 1. Southwest Museum, Los Angeles.

Hough, Walter. 1907. *Antiquities of the Upper Gila and Salt River Valleys in Arizona and New Mexico.* Bureau of American Ethnology, Bulletin 35. Smithsonian Institution, Washington, D.C.

———. 1914. *The Culture of the Ancient Pueblos of the Upper Gila River Region.* U.S. National Museum, Bulletin 87. Smithsonian Institution, Washington, D.C.

———. 1932. "A Cache of Basket Maker Baskets from New Mexico." *U.S. National Museum, Proceedings* 81 (2933): 1–3.

James, George Wharton. [1909] 1972. *Indian Basketry.* Dover Publications, New York.

Jeancon, Jean Allard, and Frederic Huntington Douglas. 1931. *Hopi Indian Basketry.* Denver Art Museum Leaflet 17. Denver.

Laird, W. David. 1977. *Hopi Bibliography: Comprehensive and Annotated.* University of Arizona Press.

Lehner, Donald J. 1948. *The Jornada Branch of the Mogollon.* University of Arizona Bulletin 19 (2); Social Science Bulletin 17. University of Arizona, Tucson.

Lister, Robert H., Paul C. Mangelsdorf, and Kate Peck Kent. 1958. *Archaeological Excavations in the Northern Sierra Madre Occidental, Chihuahua and Sonora, Mexico.* University of Colorado Studies in Anthropology 7. Boulder.

Loud, Llewellyn L., and M. R. Harrington. 1931. *Harrington Lovelock Cave.* Ed. A. L. Krober and Robert H. Lowie. University of California Publications in American Archaeology and Ethnology, vol. 25, 1929. University of California Press, Berkeley.

Lowie, Robert H. 1925. "A Woman's Ceremony among the Hopi." *Natural History* 25:178–183.

Martin, George C. 1933. *Cave Shelters of the Rio Grande West of the Pecos River, Valverde County: Shumula Caves.* Witte Memorial Museum Bulletin 3 (3). San Antonio, Tex.

———. 1935. *Big Bend Basket Makers.* Southwest Texas Archaeological Society Bulletin 1. San Antonio, Tex.

Martin, Paul S., John B. Rinaldo, and Elaine Bluhm. 1954. *Caves of the Reserve Area.* Fieldiana: Anthropology, vol. 42. Chicago Natural History Museum, Chicago.

Mason, Otis Tufton. 1904. *Aboriginal American Basketry: Studies in a Textile Art without Machinery.* Annual Report of the U.S. National Museum. Smithsonian Institution, 200–230, 243–253, 353–358, 400–550. Washington, D.C.

Mauldin, Barbara. 1984. *Traditions in Transition: Contemporary Basket Weaving of the Southwestern Indians.* Museum of New Mexico Press, Santa Fe.

Miller, Sheryl F. 1989. "Hopi Basketry: Traditional Social Currency and Contemporary Source of Cash." *American Indian Art Magazine* 15 (Winter): 60–71.

Mori, Joyce, and John Mori. 1972. "Modern Hopi Coiled Basketry."
 Masterkey 46 (1): 4–17.

Morris, Earl H., and Robert F. Burgh. 1941. *Anasazi Basketry: Basket
 Maker II through Pueblo III: A Study Based on Specimens from the San
 Juan River Country.* Carnegie Institution of Washington, Publication
 533. Washington, D.C.

Nequatewa, Edmund. 1993. *Born a Chief: The Nineteenth Century Hopi
 Boyhood of Edmund Nequatewa, as told to Alfred F. Whiting.* Edited by
 P. David Seaman. University of Arizona Press, Tucson.

———. 1936. *Truth of a Hopi.* Museum of Northern Arizona Bulletin
 No. 8. Reprint. Flagstaff, Ariz.: Northland Press, 1985.

Parsons, Elsie Clews. 1921. "Getting Married on First Mesa." *Scientific
 Monthly* 13:259–265.

Roberts, Frank H. H., Jr. 1931. *Ruins at Kiatuthlanna in Eastern Arizona.*
 Bureau of American Ethnology Bulletin 100. Smithsonian Institu-
 tion, Washington, D.C.

Robinson, Bert. 1991. *The Basket Weavers of Arizona.* University of New
 Mexico Press, Albuquerque.

Sayles, E. B. 1936. *Survey of Chihuahua.* Medallion Papers 22, Gila
 Pueblo, Globe, Ariz.

Setzler, Frank M. 1932. "A Prehistoric Cave in Texas." *Smithsonian Ex-
 plorations 1931,* 133–140. Smithsonian Institution Press, Washington,
 D.C.

———. 1933. "Prehistoric Cave Dwellers of Texas." *Explorations and
 Fieldwork of the Smithsonian Institution in 1932,* 53–56. Smithsonian
 Institution Press, Washington, D.C.

———. 1934. "Cave Burials in Southwestern Texas." *Explorations and
 Fieldwork of the Smithsonian Institution in 1933,* 35–37. Smithsonian
 Institution Press, Washington, D.C.

Smith, Victor J. 1932. *Relation of the Southwestern Basketmakers to the Dry
 Shelter Culture of the Big Bend.* Bulletin of the Texas Archaeological
 and Paleontological Society, no. 4. San Antonio, Tex.

Smith, Watson, Richard G. Woodbury, and Natalie T. S. Woodbury.
 1966. *Frederick Webb Hodge's Excavation of Hawikuh, 1917–1923.* Mu-
 seum of the American Indian, Heye Foundation Contributions,
 vol. 20. New York.

Stappert, Gisela. 1992. "Kunst und Asthetik der Hopi Indianer."
 Eine geschlechtsspezifische Betrachtung. *Mundus Reihe Ethnologie,*
 Bonn.

Stephen, Alexander M. 1936. *Hopi Journal.* Ed. Elsie Clews Parsons.
 Columbia University Contributions to Anthropology, vol. 23 (2).

Stevenson, James. 1884. "Illustrated Catalogue of the Collections Ob-
 tained from the Pueblos of Zuni, New Mexico and Walpi, Arizona
 in 1881." *Third Annual Report of the Bureau of American Ethnology,*
 511–594. Smithsonian Institution, Washington, D.C.

Tanner, Clara Lee. 1968. *Southwest Indian Craft Arts*. University of Arizona Press, Tucson.

———. 1983. *Indian Baskets of the Southwest*. University of Arizona Press, Tucson.

Teague, Lynn S. 1992. "Textiles in Late Prehistory." *Proceedings of the Second Salado Conference, Globe, Arizona, 1992*. Ed. Richard C. Lange and Stephen Germick. Arizona Archaeological Society, Phoenix.

———. 1993. "Prehistory and the Traditions of the O'Odham and Hopi." *The Kiva*, 58:436–454.

Thompson, Laura, and Alice Joseph. 1965. *The Hopi Way*. Russell and Russell, New York.

Titiev, Mischa. 1901. *The Oraibi Soyal Ceremony and the Oraibi Powamu Ceremony: The Stanley McCormick Hopi Expedition*. Field Columbian Museum Publication 55, Anthropological Series 3 (1). Chicago.

———. 1944. *Old Oraibi: A Study of the Hopi Indians of Third Mesa*. Papers of the Peabody Museum of American Archaeology and Ethnology, Harvard University, vol. 22 (1).

Voth, H. R. 1901. *The Oraibi Powamu Ceremony*. Field Columbian Museum, Anthropological Series, vol. 3, no. 2.

———. 1903. *The Oraibi Oaqol Ceremony: The Stanley McCormick Hopi Expedition*. Field Columbian Museum Publication 84, Anthropological Series 4 (1). Chicago.

———. 1905. *The Traditions of the Hopi: The Stanley McCormick Hopi Expedition*. Field Columbian Museum Publication 96, Anthropological Series no. 8. Chicago.

Weltfish, Gene. 1932. *Preliminary Classification of Prehistoric Basketry*. Smithsonian Miscellaneous Collections, vol. 87, no. 7. Smithsonian Institution, Washington, D.C.

———. 1940. "Cave-Dweller Twill-Plaited Basketry." In *Report on Archaeology of Southern Chihuahua III*, by Robert M. Zingg, 72–82. Contributions to the University of Denver, Center of Latin American Studies, 1. Denver.

Whiteford, Andrew Hunter. 1988. *Southwestern Indian Baskets: The Pueblos*. Studies in American Indian Art. University of Washington Press, Seattle.

Whiting, Alfred F. 1939. *Ethnobotany of the Hopi*. Museum of Northern Arizona Bulletin 15. Flagstaff.

Zingg, Robert M. 1940. *Report on Archaeology of Southern Chihuahua III*. Contributions to the University of Denver, Center of Latin American Studies, 1. Denver.

Index

About the Author

Helga Teiwes was born in Büderich, near Düsseldorf, in Germany, and she learned photography in a Düsseldorf studio. She earned a master's degree in photography in 1957 and worked as an industrial photographer in Düsseldorf until her emigration to the United States in 1960. She worked in New York City for four years as a commercial photographer and transparency retoucher and then served as a field photographer for a large archaeological excavation at Snaketown in Arizona. In 1966 Teiwes was appointed to the position of museum photographer at the Arizona State Museum at the University of Arizona. Her work at the museum included documenting the life of southwestern Indians, an interest she has also pursued privately for the past thirty years. Her photographs and accompanying essays have been published nationally and internationally, and she has made two documentary films. Her photographic study *Navajo* was published by the Swiss publisher U. Bär Verlag in 1991 and published in English by Facts on File in 1993. Her book *Kachina Dolls: The Art of Hopi Carvers* was published by the University of Arizona Press in 1991. In November 1993, Teiwes retired from the Arizona State Museum, and she now works as a freelance photographer and writer in Tucson.